Imaging the City

Imaging the City
Art, Creative Practices and Media Speculations

Edited by Steve Hawley, Edward M. Clift and Kevin O'Brien

Series Editor: Graham Cairns, AMPS

intellect Bristol, UK / Chicago, USA

First published in the UK in 2016 by
Intellect, The Mill, Parnall Road, Fishponds, Bristol, BS16 3JG, UK

First published in the USA in 2016 by
Intellect, The University of Chicago Press, 1427 E. 60th Street,
Chicago, IL 60637, USA

A catalogue record for this book is available from the
British Library.

Copy-editor: Emma Rhys
Cover designer: Gabriel Solomons
Front cover image © John Zissovici
Production managers: Gabriel Solomons and Jelena Stanovnik
Typesetting: John Teehan

ISBN 978-1-78320-557-8
ePDF ISBN 978-1-78320-558-5
ePub ISBN 978-1-78320-559-2

Produced in conjunction with AMPS (Architecture, Media, Politics,
Society)

Printed and bound by Hobbs, UK

Contents

Section Two: Applications – Traditional Technologies of Perception and the Imagination

Section Three: Interventions in Design and Experience – New Media and Technologies in the City

Acknowledgements

The editorial team would like to thank the Brooks Institute for their support on this book series.

Foreword

Graham Cairns

As Marshall McLuhan identified as far back as 1964, today's global village is a place of simultaneous experience; a site for overlapping material and electronic effects; a place not so much altered by the content of a medium, but rather, a space transformed by the very nature of medias themselves. For some, this is little more than the inevitable evolution of urban space in the digital age. For others, it represents the city's liberation from the condition of stasis. For scaremongers, it is a nightmare scenario in which the difference between the virtual and the real, the electronic and the material, the recorded and the lived, becomes impossible to identify. In every case, corporeal engagement is placed at one remove from the physical world.

In this context, *Imaging the City: Art, Creative Practices and Media Speculations* brings together the work of designers, artists, dancers and media specialists who cross the borders of design and artistic practices to investigate how we perceive the city; how we imagine it, experience it; and how we might design it. It breaks disciplinary boundaries to provocatively open the field of urban analysis and thought to the perspectives and approaches of creatives from non-urban disciplines.

The book is split into three sections that cover theoretical, research and practice-based approaches to documenting, recording and impacting upon the city through various media formats. It includes examinations of how our perception and engagement with urban environments are changed by interactions with new media, and actual case studies of art practices and projects that engage with the city.

Its authors are international and bring insights from art practices and their engagement with the city from Australasia, Northern Europe and South America. They offer an original mix of insights on the work of new digital artists and more traditional visual media creatives. The book thus reveals fascinating glimpses of practices that are frequently overlooked in academic publications. The result of this approach is that this book represents one of the first overviews of the role of artists, and in particular digital artists, in the domain of urban design and documentation that explicitly places them on a par with colleagues from standard architecture and urban fields.

Together with the two other books with which Intellect launches its Mediated Cities series, *Digital Futures and the City of Today: New Technologies and Physical Spaces* and *Filming the City: Urban Documents, Design Practices and Social Criticism Through the Lens*, this volume represents a major publication initiative in the field of interdisciplinary urban and media studies. All three of these books stem from an international programme run by the research group AMPS (Architecture, Media, Politics, Society) and its associated

scholarly journal *Architecture_MPS*. The 'Mediated City Research Programme' is an ongoing international engagement of artists, designers, planners, architects, digital image makers, computer programmers, film-makers and photographers. Under its aegis, AMPS facilitates academic events, debate sessions, project collaborations and publications aimed at building up a major resource and network on the city and its relationship with medias and technologies.

As represented by the works collected in the Intellect book series, this underlying research programme operates internationally – drawing together researchers from several continents and over thirty countries. More specifically, it draws on work and ideas developed from AMPS events in Los Angles and London over the past two years and adds to that work with essays developed by other artists engaged in these themes. Both this book then, and the AMPS 'Mediated City Research Programme' more generally, are not only international in outlook, but also inherently and deliberately cross-disciplinary – calling on the views, expertise and working practices of multiple sectors.

Marking a unique cross-border, cross-sector contribution to the field of hybrid scholarly research in areas of architecture, urbanism, planning, media studies, communication and the digital arts, this expansive AMPS programme and its association with Intellect's Mediated Cities series, is perfectly captured by the combination of works collected in this volume.

Introduction

Steve Hawley

Our experience of the large and unknowable city has always been mediated to us through emergent technologies. The first century fresco at the Baths of Trajan in Rome depicts an impossible bird's-eye view of the eternal city that must have been a revelation for the ancient Roman, and ever since, new devices and knowledge have enabled both the depiction of and encounter with the metropolis. The oil painting gave way to the photograph and then the city symphony films of the 1920s, as the city itself was galvanized first by gas lamps and then neon signs. But digital technologies and the Internet of things have widened immensely the possibilities for both design, and contemporary art and new media practice, and permeated the very ether of the city as once did gas pipes snake ubiquitously like a web beneath the city's streets.

This volume brings together those artists, dancers, media agitators and speculators who cross the borders of design and art practice to interrogate how we experience the city: how we might design it, provoke it and dream of it. The chapters break disciplinary boundaries as the boroughs and suburbs shade one into another, and it opens the field of urban analysis and thought to the lens of creative practitioners and others largely outside the disciplines of architecture and urban design.

The digital city enables, in fact demands, a compendium of different forms to reflect the multiple ways it can be imagined and experienced. Swipe right, pinch and zoom into a map, or tap and drag to see the streets and buildings through a screen, overlaid with pictures from the past. And so this is mirrored by the texts in this book, where some are academic in form, while others are more speculative, using language itself as a malleable creative stuff to try and grasp the un-graspable in the contemporary city.

It was in 1838 that Louis Daguerre took a ten-minute exposure with his new Daguerreotype photographic process, of the Boulevard du Temple, part of a fashionable area in Paris, filled with cafes and theatres, and people. The street was thronged with traffic and pedestrians, but they all moved too quickly to register on the plate, except for one man and a shadow. In the foreground, a man having his boots shined, stays long enough to appear on the photograph, isolated in the seemingly empty streets; the first ever photograph of a recognizable person, with the faintest blur of the shoeshine boy.

What is depicted here is an imagined city, transformed through chemistry and the leisurely time taken to expose the plate after it had been sensitized by halogen fumes, rather than the here and now of the bustling streets. As the neutron bomb was apocryphally supposed to do, all the citizens (bar one) have been erased into invisibility by their very

Figure 1. Louis Daguerre, *Boulevard du Temple* (1838). Public domain.

quickness during the exposure, leaving the buildings standing, and a reverie of Paris as an empty, even abandoned place. It is an imagined city with only one citizen – an implied ourselves – and the print powerfully brings to life the fantasy of crowded streets melting away to leave its contradiction, a deserted zone; a city of myth.

The technology used to create the image seems more like alchemy: a sheet of silver-plated copper, polished to a mirror, is actuated by iodine and bromine, and developed by fumes of poisonous mercury (god of commerce, messages and eloquence). And the near future is being transformed in an almost alchemical way through the invisible networks of the Internet, redefining the position of the individual standing in the flux, altering forever the business, communication and poetry of the smart city.

This book is split into three sections that cover theoretical-, research- and practice-based approaches to documenting and changing the city through engagement with new media. It includes examinations of how our perception of and participation in urban environments is altered by interactions with digital media, and actual case studies of art practices and projects that engage with the city.

Section One, 'Theories of Media, Memory and Imagination', examines how our cities can be documented and theorized by both traditional art forms and new media alike. The chapters of this section draw on representation through photography, archives, mobile apps, drawing and film. Since Jan Vermeer's *View of Delft* of 1661, the picture of the city has changed from a map-like overview to an accurate portrait, from Canaletto's

Venice to the numerous painters that followed the Dutch example. But the technology of representation had been changing rapidly, and changing art with it, as for example when the invention of paint in tubes led to Impressionism, and the cityscape could be painted directly from life. In 1860, James Wallace Black's *Boston as the Eagle and the Wild Goose See It* was the first aerial photograph that still exists, the forerunner of the drone shot, which has become pervasive in every contemporary documentary filmed outdoors; an impossible dream of flying and escape. In some ways, that dream view is now available, that once only existed in the mind's eye.

Lawrence Bird creates visual artworks from original screen-captured video mapping projects, using Google Earth's historical imagery function to collage and compare the same city/landscape at different periods. His work critically addresses and disrupts such imaging systems; the software technology structures the way we can imagine the city, and is part of multiple systems which themselves are part of the industrial commodification of urban design.

Steve Hawley also examines the myth of the city, as reflected in literature and film, in this case Manchester. Drawing from novels and a feature film, he shows that its dominant dystopian image in the creative imagination, at odds with the actual contemporary city, draws from the early-nineteenth-century writings of Friedrich Engels, when he described the wretched living conditions in the area of Little Ireland. Steve Hawley and Marion Hewitt's *Manchester Time Machine* (2012) is a transformative window onto history, the GPS-enabled app enabling the viewer to look at city scenes through their iPhone and see overlaid archive film at the same location over the last century.

John Zissovici follows Kandinsky in seeing the contemporary city as the source of and salvation from spiritual anxiety, caused now by the scripts and algorithms that regulate the 'technical images' of urban experience. For Vilém Flusser and Zissovici, these images, such as Google Earth and Street View, are radically different to what has gone before, but can be subverted as new ways of living with them are discovered, and the city unfolds on the screen under our fingertips with endless possibility.

In his celebrated 1971 book on Los Angeles, *Los Angeles The Architecture Of Four Ecologies* (Harper and Row, 1971), Reyner Banham said he learned to drive so he could read the city in the original. He delighted in the 'Four Ecologies' of LA, from the beach to the foothills, and saw it as a vision of the post-urban future.

Terry Flaxton uses Rayner Banham and his moving image gaze onto the city as a starting point; as our eyes try to watch the moving landscape, they 'saccade' or pull staccato fashion in short bursts to make sense of what we see. Referring back to his own research on how the camera captures and displays moving images, he speculates on the velocitization that has impacted on the human brain both in our response to the city at speed, but also the immeasurable streams of data we now scan every day.

In Jelena Stankovic's essay, she reflects on the idea of the city as it is remembered through our own and other people's memories and thoughts. Freud was surprised to feel when he first saw the Acropolis, 'so all this really does exist, just as we learn at school'. Stankovic uses the

example of Banja Luka's Titanic building, erased in the 1969 earthquake and not represented on any preserved map in European archives. By combining different photographs, she recreates the image of the building to reimagine the Banja Luka of that time.

Forming an intersection in the academic papers of the book and echoing Banham, Joshua Singer offers a 'free text'. In his eloquent contribution *City of Dreams and Algorithms*, he drives through the hills above the city, whilst searching for Google Images of that same cityscape on his smartphone. He speculates on the 'semiosphere' that organizes the world of objects and relationships around him, and that the grid of images on his portable screen is no less authentic an experience of the place than his lonely nocturnal drive. The pictures of beach, palm trees, Annette Funicello and muscle cars activate the urban landscape as a 'container of collective memory and desire'.

Section Two, 'Traditional Technologies of Perception and the Imagination', documents and contextualizes artistic research projects and experiments in how we see our surroundings and how this may alter the way we think about cities and design them. They are a combination of proposed undertakings and the documentation of realized projects.

The technologies that give rise to 'urban inscriptions' (Malcolm McCullough) – the layers of information that move out from the laptop to daily urban life, are not new: a century ago saw the invention of the neon sign that came to symbolize the modern city. From its first demonstration at the Grand Palais in Paris in 1910, and the Packard sign in Los Angeles in 1923, the American city in particular has been rewritten by dazzling words and images in the margins of its highways and centres, conjuring up an incandescent urban wonderland. Now neon has been replaced by LED screens and handheld portable devices, from which we can call up the immensity of images that depict the urban environment.

Kevin O'Brien considers the sociopolitical status of city tracts, in this case deriving from the nineteenth-century prohibition of the Aboriginal people of Australia from owning title to land. For the last ten years his *Sep Yama/Finding Country* project has researched in many forms this now overturned doctrine that the country was Terra Nullius – a land belonging to no one. Imagining the city emptying and dissolving back into country, the resulting large-scale images of depopulation are burnt, just as fire was once used to manage and alter the landscape.

Sylvie Vitaglione looks at experimental dance films shot on location in cities which, in a reminder of Daguerre, focus on the borders between the individual and the built environment. These films both react to and confront empty urban space, seeing it as 'something dangerous to be conquered'. As human bodies negotiate the non-places of the city, it becomes something between a playground and an obstacle course. Meanwhile, Dirk De Bruyn's film, *ThreshHold* (2014), documents the history and memories of the migrant Geelong City waterfront area in Australia. He combines innovative aerial photography from the 1920s (from the Airspy company) and industrial photographs with contemporary recordings from Google Maps, to make a unique depiction of the city. This powerfully echoes Flusser's notion of the hypermobility of media and the dissociation also experienced directly in real physical migration.

Ephraim Joris and Riet Eeckout argue for a specific drawing practice deeply rooted in sociopolitical history, which they have evolved in their work as architects. Their approach to architectural design can be characterized as 'relative authenticity', as in for example a 2003 proposal for the Cold Stores in Valletta, Malta, where an urban site was researched as a place of intersecting social, historical and technological agencies

Creating another break in the academic tone of the book, J. P Maruszczak and Roger Connah, under their creative anonym, the agent provocateurs Heron–Mazy (Anon), describe the dystopian Sick City using a plastic language which becomes itself 'part of change and resistance to change'. Their ostensible subject is the now demolished Big Town Mall in Mesquite, Texas, which when built in 1959 was the first enclosed air-conditioned mall in the Southwestern United States. Using the metaphor of the Zen archer (or architect), they propose a radical and ironic strategy for reimagining uses for the Mall, including an Extreme Weather Chaser's Centre, and the Museum of Redundancy.

Section Three, 'Interventions in Design and Experience – New Media and Technologies in the City', examines the actual practice-led use of new media as embedded components of the modern city; tools and methods through which we can adapt to the increasing mediatization of our urban environments.

This intersection between digital awareness and the city does not just affect the affluent First World; there is a plan to monitor urbanization in Dar es Salaam with the *OpenStreetMap* app, and even a smart slum, as Stellenbosch, Cape Town develops solar-powered domestic energy and allows the residents to purchase electricity through their mobile phones. In the city as a space of permanent friction, new media have capacities to reinforce relationships between citizens, bringing together communities, creating radical provocations and playful games. Antwerp, through MLab, has given its smartphone users their own designated text walking lanes, where they can walk while texting or looking at their mobiles, without the risk of bumping into someone and dropping their phones. Meanwhile Bristol has the Pervasive Media Studio, who for the last few years have given out Playable City Awards – in 2014 to *Shadowing* by Jonathan Chomko and Matthew Rosier, who gave memory to Bristol's city street lights, using new technologies and video projection to enable them to record and play back the shadows of those who passed underneath.

Ivan Chaparro, as part of the *Social Repair Kit* project, has engaged in practice-led research as 'social choreography' in a marginal neighbourhood in Bogotá. Just as crowdsourcing and flash mobs incorporate non-professional performers in their participatory choreography, his dérive games encourage participants to document their barrio of Belen, and the results are incorporated into a custom-built web app using Google Maps. Certain places identified as sacred by an elder of the community are then reinterpreted with reverence, for example by cleansing the space of litter, which is finally marked by a reflective ceremony.

Natalie Rowland examines the relationships between mobile technologies and the city environment, with reflection upon the work and experiences of the author in the field of digital choreography. She considers how these technologies can complement and

enhance the movement of people in the city. She draws on the thoughts of Elizabeth Grosz suggesting that 'the most significant effect of the increased use of the chip and screen in day to day life is the way that our "perceptions of materiality, space, and information" (Grosz 2002: 76) are changed'.

Michael Jemtrud's inquiry revolves around a research-creation project, the *Mobile Urban Stage. MUSe* is a deployable technologically enabled artefact that interactively senses its immediate environment; reciprocally communicates with an associated web artefact and social media network; and actively claims and structures a physical and virtual space for performances and public gathering. It is a data-driven, reconfigurable device that includes interactive sensing and multimedia technology (lighting, sound, projection) that structures and facilitates *in situ* public events.

When they tried in the early twentieth century to imagine what urban space would look like, it is interesting to observe what was omitted, rather than predicted. In a postcard from 1910, the small English market town of Leominster in the future is shown overshadowed by a giant monorail, as in the skies people make their way around in their personal aerial transport devices (balloons). Almost no one predicted the Internet until it was almost upon us, let alone the networked possibilities that have given rise to the transformation of the urban experience.

Daguerre's photograph of the Boulevard du Temple survived in the museum in Munich – even through the bombings of the city until after World War II, when an over-keen museum curator tried to clean it. But the mercury amalgam on the polished silver was very fragile, and the unlucky curator erased the whole image. Just as the citizens had been rendered invisible by the long exposure, now the very image itself had been obliterated, luckily after it had been copied on a more conventional photograph. And the hyperspeed of modern representational technologies make it difficult to recreate that image in the present day. Almost no one stands still for ten minutes in the contemporary city, but then again almost no one did in 1838.

In Chris Paul Daniels's 2013 film of Nairobi, *Premier/Divisions*, his camera shoots from a fast car multiple election posters plastered like sheets of stamps on every wall and building, at a time of tension and potential election violence in the city. But at exactly the right speed, the images seem to still and freeze, and become small animated films, a process that reminds us of early cinema and brings up-to-date Daguerre's speculation on motion and the isolated human body.

In the mediated city, digital art practices present to us new perspectives on the city's fabric, and redefine our relationship with it, both as an individual, and as we link together into communities. This book is one of the first overviews on the role of artists in the domain of urban design, and shows how the networked city can be imagined for the future.

Figure 2. Chris Paul Daniels, *Premier/Divisions* (2013). Video still. © Chris Paul Daniels.

Section One

Theories of Media, Memory and Imagination

Chapter 1

Territories of image: Disposition and disorientation in Google Earth

Lawrence Bird

Introduction

The image of the city today is fraught. In the past, the image has been understood as fundamental to our cognitive apprehension of the city, to the expression of its meaning, and to our imagination of its future. Today its image may have entered new territory, increasingly technologized – and commodified – in a transformation that seems to enable these longstanding roles of the urban image, but might also shut them down. The following pages attempt to understand that new condition by examining urban and geographical images harvested from Google Earth, images interesting for their content – patterns of development, occupation and land use, urban infrastructure, built environments and landscapes – but also their form – as media-based archives of time and space. This chapter attempts to sketch out what we might find interesting in such images, by drawing on Keller Easterling's ideas on infrastructure, and Bernard Stiegler's on the industrialization of knowledge.

Conditions of media today pose specific challenges to those who design cities, their landscapes and their buildings. The designer's means of visualizing and imagining her works have become highly systematized and industrialized in frameworks: frameworks whose use is essential to the work of any designer who does not want to be professionally marginalized. They include software suites, mostly proprietary, for the creation and processing of images and models; platforms for the capturing of images and design-related information, for example Geographic Information Systems (GIS); resources for storing and transmitting knowledge about a vast array of industrial products and processes; and technical and legal protocols for the transposition of these ideas into technical drawings, contract documents, and from there into built form. Such frameworks of (very often visual) knowledge dovetail with analogous systems structuring the production and design of space: industrial standards, building codes, zoning documents, policy frameworks, systems of construction and materials delivery. The new imaging technologies can be powerful tools of documentation, research and visualization. But their power harbours a danger also: like the tools of city-making, the tools of city-imag(in)ing imply an engagement in massive and immensely-scaled technological networks that commodify the image even as they make it available to us. Today a key question for a designer is how she might seek out agency within machinery of such scale and complexity; how she might find space and respite from, even within, this flood of instantaneous and systematized information.

Google Earth epitomizes these new technologies of imaging and image delivery. They provide extensive and rapidly updated visual documentation in an intuitive graphical user interface (GUI), with much of the imaging crowdsourced, a great deal of it algorithmically generated and all of it available for free – or more precisely, at the cost of the commodification of the user's own usage patterns. As a popular and relatively accessible form of GIS, Earth is a useful tool for harvesting information about urban space, as well as (in inter-operation with 3D modelling tools) the visualization and design of architecture and urban areas.

The still images reproduced here are drawn from a set of visual artworks which attempt to critically address such imaging systems and their engagement of the planet. These works were/are original works of screencaptured and projection-mapped video, originally harvested at HD resolution. The stills reproduced here have been recaptured at a much higher resolution for print publication, and they are direct captures from Google Earth Pro; they have not been manipulated or Photoshopped. It matters to the original pieces that they are composed of *moving* images; they record a slow progression across the Earth's surface and project a liquid patina onto the materiality of architecture. But to focus the analysis, this chapter will address only stills.

The original video projects might be understood in the context of a growing number of artists who employ aerial, satellite and 'street view' images in their practices; for example, Mishka Henner and Jon Rafman. One of the videos cited here, *Transect* (Bird 2014), tracked the Prime Meridian and Antemeridian in a full circuit of the planet; the second, *Edge* (Bird 2015), follows the municipal boundary of Winnipeg, a Canadian city which problematizes the definition of 'the urban' at a number of levels. *Transect* was a projection mapped on the courtyard facade of the Queen Anne Court at the Royal Naval College in Greenwich, England, in August and September of 2014. *Edge* is an ongoing project. The two form part of a trilogy with *parallel* (Bird 2013), a work tracking the 49th latitude, the border between western Canada and the United States; *parallel* was installed in the group show 'Movable Borders' at Furtherfield Gallery, UK (2013). Each of these works follows an arbitrary political or locational line across the surface of the earth, a gesture which suggests submission to technical mapping systems and all that they imply. However, rather than revealing anomalies in digital imagery of the earth and its landscapes, the projects aim instead for a critical undermining of attempts to organize the world and render it up to scientific, political and economic ends – direct and indirect articulations of the Enlightenment project. Google's Earth finds its origins in that project, as do the infrastructures that preoccupy Easterling; and the industrialization of memory discussed by Stiegler is the most current development of that project.

Figure 1. Lawrence Bird, *Edge* (2015). Video stills. Courtesy of Google Earth. © 2015 Digital Globe.

Disposition

The first image we will address is taken from the project *Edge*, which traces the municipal boundary of a prairie city (Figure 1). To the left we can see the farmland beyond the city limits; to the right, a new housing development begins to fill the urban landscape. As do other forms of GIS, this image and its attendant data can provide technically useful information. But the video is more interesting on other levels. Harvested with Earth's 'historical imagery' function toggled on, it splices together several images captured at different points in time – different seasons over several years and, as it happens, at different stages in the development of the cityscape. Stiegler will help us understand the engagement with time implied by images like these; but before we turn to his work, we will look briefly at how they articulate properties of the contemporary city identified and discussed by Easterling.

Easterling describes a city, even a planet, defined by infrastructure. She describes the complex overlay of regulations, standards and protocols that create our environments today in terms of *disposition*. Disposition is the tendency of the infrastructure of any environment to push us, and to push the growth of the city, in one direction or another. It

is a contemporary realization of the modern infrastructural paradigm based on technical efficacy and, through that, the achievement of economic and political ends. Our cities bear witness to early and contemporary iterations of this phenomenon: rail lines dating from the nineteenth century; and roadways, industrial zones and housing subdivisions dating from our own time. These spaces are cultural, experiential, and political, and they influence, if not determine, our social lives: 'Like an operating system managing activities in the background, space is a technology, a carrier of information, and a medium of polity' (Easterling 2014: 240).

For Easterling this operating system is governed by rules which are today not proper to nations, or to international alliances of nations, but to transnational agencies governing the technical parameters of infrastructure – for example, telephony in Africa, or more globally the protocols imposed by the International Standards Organization (ISO). These protocols generate tendencies that dispose the environment towards certain possibilities, often indirectly and apparently without intention. Infrastructure is thus not passive; it has a form of agency; and it promotes a form of polity. Easterling examines specifically the creation of quasi-autonomous zones as enclaves in cities around the world – from Canary Wharf in the United Kingdom to Guangdong in China. In these spaces, laws are suspended in the sense that Giorgio Agamben has discussed: human beings are reduced to sub-human status; democratic governance is superseded by governance on behalf of multinational corporations (Agamben 1998).

While *disposition* serves political and economic agendas, its control is far from absolute; it is in its own turn malleable. For Easterling, the skill of an urbanist lies in detailing and developing the *active forms* that shape and constitute disposition. These include *multipliers* (elements which multiply throughout an environment influencing its form: from tract houses to cell phones); *switches* (elements which serve as gateways and tipping-points in processes: highway interchanges for example); *topologies* (frameworks across which messages can move in specific ways: the city grid); and *governors* (growth protocols: plans and zoning guidelines). We can identify some of these active forms in Figure 1, in which the suburban tract homes are caught in the act of multiplying across a landscape governed by political divisions, zoning regulations, industry standards and strategies of infrastructural layout. The new development creates a topology that will guide circulation and social relationships, and that is in many ways oblivious to the topologies that preceded it; it represents a radical change in disposition, though perhaps sharing a pragmatic attitude towards the commodification of land.

Easterling makes the case that as a designer works on the placement and orientation of such active forms in a dispositional system, she is a *performer* whose first task is to activate a number of corollaries or counterparts to infrastructural disposition that offer the potential of departure from its scripts and agendas. These, Easterling says, explicitly undermine the technical optimization that infrastructures ostensibly have as their aim. These departures are, paradoxically, built into the movement towards standardization; as evidence of this she offers the observation that the more rationalized the spatial products

of infrastructure become, the better suited they seem to be to the irrational fictions of branding. Even infrastructural protocols themselves evince this tendency: Easterling gives as an example the flagship standard ISO 9000. This protocol refers not to any technical standard of any product, but to the organization of the company that produces it – its quality in terms of internal organization and client service. As such it is less standard than it is 'superbrand' (Easterling 2014: 178). For Easterling, the management fads and gurus which have sprung up around the search for 'quality' are further evidence of how standardization (in the form of corporatization) slips into fantasy (Easterling 2014: 193).

Developing this notion, she discusses infrastructural systems' tendency to generate and support master narratives: narratives which structure a world-view. Totalizing world-views and the stories that buttress them also tend to be characterized by contradiction. They can, for example, include narratives of intellectual property and, within the same technological trajectory, narratives of sharing; narratives that are both technological and quasi-religious (from the cults of Saint-Simonianism to Apple); and narratives of freedom (from regulation) that promote slavery (to labour forces) (Easterling 2014: 207). In other words, the infrastructural instrumentalization of the world paradoxically generates fantasies; it seems to generate (rather than eliminate) narrative, and those narratives are rife with contradictions.

Dissensus, discrepancy

Easterling identifies two means by which the contradictions inherent in such stories can be exploited to disrupt *disposition*: *dissensus* and *discrepancy*. These exploit the contradictions already noted. The first refers to contradictory or inadmissible evidence inherent in the scripting of space or structure: 'Space can embody dissensus when it scripts an interplay for multiple opposing or counterbalancing players and when it returns to that game of the laws and people that the market has erased or excluded for its convenience' (Easterling 2014: 235).

Dissensus exploits parallel scripts and players to empower those disenfranchised by the system. Discrepancy is related, and refers to 'the misregistration between stated intentions and undeclared activity [that] makes more palpable active forms and the underlying dispositions they shape' (Easterling 2014: 240). For Easterling, as infrastructures and their components – active forms – develop, their elaboration renders visible the contradictions between their stated goals and the agendas they actually fulfil. They can also make apparent another form of discrepancy – between infrastructural agendas and sociopolitical counterpoints, forces working at odds to them.

Such contradictions can be identified in Figure 2, which displays several elements of infrastructure in the city of Tema, Ghana, captured during the tracking of the Prime Meridian in *Transect*. These include the military installation and former detention centre Michel Camp (through which the Prime Meridian runs), adjacent informal

settlements, and the roadways and highway cutting these environs off from the camp. The image articulates a complex polity in which a military installation can both threaten (Immigration and Refugee Board of Canada 1994) and be encroached upon by its social environment. Today, the sway this infrastructure of power holds over its sociopolitical environment is weakening. The former site of political detention is decaying; new pathways across its boundaries have emerged, making military property vulnerable to theft (Coffie 2012). An informal infrastructure is evolving that underlines the social and political contradictions within this piece of city; it undermines police power, and is visible in the informal settlement and its formal and informal pathways encroaching upon the camp. This expression of agendas finds an interesting resonance in the composition of this image: as satellite tiles butt up against each other (the edge between them displaced approximately one minute of longitude west of the Prime Meridian), the contradictions between two territories of image become apparent. The two tiles show different days, and at the border between them a cloud is cut, as though by a knife; an impossibility of course, and one which expresses a contradiction within the imaging system itself. Notably, as did Figure 1, this image also folds the passage of time into its representation of space.

Figure 2. Lawrence Bird, *Transect* (2014). Video stills. Courtesy of Google Earth. © 2015 Digital Globe.

These urban discrepancies resonate with current discourse on media. As already mentioned, Easterling sees the city as an operating system that conveys information and creates a polity. And as she puts it, for the designer (or activist), 'Exposing the workings of this operating system – in free zones, broadband technoscapes, or global standards – is as important as rehearsing the skills to hack into it' (Easterling 2014). She expresses here one of the paradoxical vulnerabilities of infrastructural systems. The designer plays out stories that draw on the natural production of fantasy that emerges from infrastructure; she develops the multiple potentials for meaning that emerge in the gaps between parallel but distinct political and economic agendas. The cracks that emerge between these agendas are amplified by the heterogeneity of technological, and in particular digital, innovation. As Easterling puts it, 'The hacker/entrepreneur does not value purity but rather relies on multiple cycles of innovation, updating platforms, and tracking changeable desires that supersede, refresh, or reverse the products and plans they introduce into the world' (Easterling 2014: 232). Undermining of systems is, paradoxically, built into any advancing technological landscape – as it is into the urban landscape.

So it is not a coincidence that these images, which record elaborations and disruptions in the infrastructure of a city, also evince ruptures in its image. These images are sewn together by the machinery of Google Earth from multiple satellite images taken at different times. If Earth is an image database, by ambition providing a nearly-real-time and seamless documentation of the world, it is also an archive of images from the past whose display underlines the seams resulting from the inadequacies and disruptions within the database itself. If Earth offers us a fantasy of global knowledge resonant with the totalizing drive of other infrastructural systems (including what Easterling points out is their support of totalizing narratives), it also offers us a potentially darker phantasm related to the engagement of time, and one which paradoxically works against totalization. Stiegler will help us understand this.

Disorientation

Digital systems like Google Earth have been seen by some as a threat to our humanity. Bernard Stiegler takes an opposing position. The key thesis in the re-reading of Martin Heidegger through technology, which is Stiegler's *Technics and Time* (1998; 2009), is that the technical is and always has been in fact *constitutive* of our humanity. We are incomplete and strive to complete ourselves through prosthetics: a technical support for our individual becoming, and our becoming as a species, which he refers to as *epiphylogenetic* – outside of any inborn nature we might be imagined (erroneously) to have. As he puts it, we are caught up in an *Epimethean complex*. This term refers to the forgetfulness of Epimetheus, for which the work of his brother Prometheus – his imagination, his anticipation of the future, and his inauguration of technical and technological projects – compensated. For Stiegler, Epimetheus's failure is representative of humanity's failure, and Prometheus's

successes represent our fulfilment through recovery from that failure: recovery through technology (Stiegler 1998).

In the second volume of *Technics and Time*, subtitled *Disorientation* (2009), Stiegler develops ideas on the implications of this complex in current conditions of media. He develops his argument primarily in response to the writing of Derrida and Husserl. The prosthetics of which he speaks in *Technics and Time, 1* (1998) have, in historical times, included the recording of history: our memories are insufficient, and to complete them we have employed an array of mnemonic tools. In short, there is no original or originary time, no pure experience or memory. We access history only through prosthetic forms of recording that include all technologies. Stiegler understands industrialized media in the context of a long evolution of technical frameworks supporting memory, whose first substantial manifestation was orthographic writing.

Différance, Delay

In *Disorientation*, Stiegler's underlying preoccupation is the relationship between orthography (whether in text or image) and *différance* – the term Derrida used to refer to written language's failure to pin down meaning, eternally deferred as it slips elusively between differing definitions, resulting in the inherent instability of meaning. A common assumption in our time is that contemporary conditions of media amount to the occlusion of *différance*, for it implies the flattening or reduction of all knowledge to mere information. Stiegler opposes this position. Not only does he assert that media technologies generate *différance*, he actually seeks to identify how this happens, arguing that the human experience of time and being, in all its ambiguity and indetermination, is generated paradoxically out of our tendency towards orthography – our attempts to record and communicate with precision. As he puts it, he aims to demonstrate 'how the straight line becomes the bent' (Stiegler 2009: 13).

This position puts him at odds with many commentators on media. It has become a commonplace that the industrialization and apparent totalization of knowledge, combined with the speed of 'real-time' transmission, threaten the conditions in which *différance* can emerge. Stiegler underlines this threat with reference to Lyotard's seminal *The Postmodern Condition* (1984). Knowledge becomes data, with consequences that are not just epistemological but also existential and cultural. The immense scope and scale of today's mnemotechnological systems (including the infrastructure of Google), their reduction of information's value to capital, and the prevalence of instantaneity and speed in the transmission of data result, for many, in the denaturing of knowledge and writing, that is, its erasure of delay and *différance*.

These changes threaten the human subject, as important subjective functions – components of cognition – move outside of us.

20

Evolving from the history of tools for the orientation of knowledge – an array of prostheses accommodating our *originary hypomnesia*, through computer-assisted reading systems, to an exteriorization of the cerebral cortex's functions and perhaps even the entire nervous system – the result is a displacement of memory from the *who* [his term for the subject] into the *what* [the subject's technical support]. (Stiegler 2009: 81–82 [original emphasis])

Our dependence on tools from organizations like Google is just one instance of this.

How bad is this situation? Might there yet be some process in play which allows us to 'keep in reserve a work of knowledge that would still be open to the indeterminacy of knowing?' (Stiegler 2009: 136). Can we still *imagine* in these circumstances? What do they mean for our contemporary subjectivity? To answer this, Stiegler embarks on an analysis of our foundational engagement with memory and technology in the production of *différance*. As he articulates the question: 'What schematization (the activity of the "transcendental imagination") is still possible in such conditions? This is the very question of the *who* within the occultation of différance' (Stiegler 2009: 91).

To do this he begins with orthography's basic capacity to generate *différance*; he addresses this with reference to the image and to text. Drawing on Barthes's writing on photography, he emphasizes that the photographic image has built into it delays: between the opening and closing of the shutter, between exposure and development. As he puts it,

the photograph contains an objective melancholy binding time and technique together; yet throughout the entire history of visuality, time and technique have been constituted solely through the refraction of their instrumental and technical surfaces: différance as a single movement of spacing and temporalization. (Stiegler 2009: 18)

Through Lacan he demonstrates the more general significance of the image, making the case that a preoccupation with the image (*imago*) derives from the mirror stage of human development. The mirror stage is:

a particular case of the function of the *imago*, which is to establish a relationship between the organism and its reality [...] altered in humanity by a certain dishesion within the organism itself, but a primordial Discord [...] The *mirror* is a drama whose advent is precipitated by an insufficiency of anticipation – and which for the subject, caught in the lure of spatial identification, fabricates the phantoms that are succeeded by a fragmented image of the body into a form we call orthopedic of the totality. (Lacan, cited in Stiegler 2009: 26–27 [original emphasis])

In short, our attempts to reflect the world – to record and mark it orthographically – have built into them our failure to do so. The lag between the epimethean and promethean movements, built into the imagination, production and use of technics, is what generates

différance. Text, no less than any other expression of the orthographic tendency, produces such gaps and ruptures (Stiegler 2009: 61).

To complete his analysis, he tackles a long-standing bias within phenomenology against the technical. Following Derrida and Paul Ricoeur, Stiegler discredits Husserl's understanding of primary, secondary and tertiary memories. These refer to degrees of separation from direct experience: from our retention of immediate experience, to its recollection, to its recording and recollection through reference to (orthographic) documentation. For Husserl's phenomenology these are all pale shadows of direct experience, and usurpers of its value. For Stiegler, it is in fact through tertiary memory – memory supported by a technical framework – that we become fully human.

As an illustration of this, and developing what he criticizes as Husserl's own inadequate analogy of the musical note (inadequate in its isolation from melody), Stiegler uses as an illustration the reading of a poem; it is worth noting that this choice of illustration owes a lot to Ricoeur's discussion of St Augustine in *Time and Narrative* (1984). Stiegler makes the case that reading a poem always recalls a previous reading, and a previous reading which is recorded (textually and technically); it is in fact the temporal relationship between the different readings which constitutes it (anew), as poetry and as what he terms a *temporal object*. The temporality of a poem implies, in his language, that

> in return, the modification of the already-there [the record of the past, the prior reading], in a strange maieutics, itself constitutes the passage of a new poem. This maieutics is possible only as an après-coup of originary epimetheia [knowing but forgetting], which is itself composed of retentional finitude [the limited capacity of memory] as prom-etheia. (Stiegler 2009: 204)

That is, the temporal oscillation between poem as read, poem as written, poem as thought and felt, is constitutive of poetry. Poetry cannot be separated from its expression in orthographic writing and other forms of prosthetic memory, which embed our experience of the poem in our experience of time.

For Stiegler, technical support is integral to memory too, and he opposes Husserl thus:

> primary memory [retention, production] can no longer be any more opposed to tertiary memory than to secondary memory [recollection, re-production]: the already-there qua *what*, the third world-historial, is constitutive of a temporality always already emerging from its strict intimacy. (Stiegler 2009: 199–200 [original emphasis])

He thus validates not only textual memory, but also all forms of record keeping, including by implication architecture. These infrastructural supports are important instances of this particular rendering of tertiary memory. Indeed, if memory is always about memory *loss*, about forgetting as much as it is about remembering (the epimethean complex), tertiary

memory is even more integral to our being than the original experience: it represents our recovery from that loss (Stiegler 2009: 222).

This argument reinforces his earlier case that orthography is not the enemy of *différance*. In fact, it is the engagement of the technological – the interplay of the *what* with the *who* – from which is generated *différance*. And delay is not in any straightforward way erased by industrialized memory; rather, it is provoked by it. We might sense this in our own experiences with technology failing at its limit of speed and capacity: communication feeds breaking down, images and audio fragmenting into noise, from which we might seek to piece together or invent an elusive, indeterminate meaning. It seems as though the closer we get to the instantaneous communication of information, the more turbulence we produce, the more disruptions, delays and deferrals in time. As Stiegler puts it, referring to our attempts to annihilate space through 'real-time' communications, in fact 'Real time is a derealization of time, as if time were really real only in remaining unreal, chronically diachronic, asynchronized, late for itself' (Stiegler 2009: 124). There are other, related, impacts on our engagement with time – for example, the rapid obsolescence of media substrates, which impose a recurring need to 'migrate' data from one medium to another: to displace it, which implies deferral (and even error). In sum, as he puts it: 'deferred time is in the process of co-opting real time's power'. A related complication as devices for the manipulation of digital material become ubiquitous is that we are all able to record, play back, skip ahead, replay and rewind. The new information space gives us a power over time which, while never freeing us from its rule, enables our potential to manipulate it. Indeed, 'Only an originary, "cinemato-graphic" possibility for pausing over the images of life, of ages and epochs, frees these special effects such as slow motion, fast motion, condensation – idealizations by which something new appears in a transcendental history' (Stiegler 2009: 231). As these phenomena become integral to our perception of events, so also do they become inseparable from our own acts, as we know from the role media now play in not just the reporting but also the instigation of political events.

Conditions of real time and the montages of memory and currentness generate objects which mark and bear traces of the passage of time, are entwined with it in a complex relationship, and produce historical events. Stiegler identifies these as *temporal objects*. They produce a specific condition of time:

A combination of new texts/data and instruments make an entirely new mobilization of the *already-there* [the historical] conceivable. Citation and arrangement of the various elements furnished by available patrimonic and informational sources open the possibility of a qualitative leap from a new reading and writing at 'light-time' laminated onto an other, deferred time. (Stiegler 2009: 148 [original emphasis])

Time is laminated.

These objects tend towards a specific form of expression: the visual and spatial. Stiegler observes that the technical support, which 'enacts as a secondary memory in which the

past can be re-composed [...] enacts as image-consciousness, strictly speaking, namely, by its transcendent representations such as icons, drawings, photographs, tracings of all sorts, and other mondo-historial what's' (Stiegler 2009: 221 [original emphasis]). These *whats* include Google Earth and other satellite imaging infrastructures. The temporal condition Stiegler has described is easy to read into the images represented here: they laminate differing times, collaging and splicing them together. They superimpose images from different seasons, and from different stages in the development of a city, in one space: a seamed space. Stiegler refers to Prometheus's (de)fault – his failure, our failure as humans, for which technology makes up – and we can identify a fault in this accidental superimposition, its failure to complete a strictly orthographic image, or in Lacan's terms orthopedic. It is precisely in this that the significance, and the beauty, of these images lies. The epimethean complex involves both looking forward – at what is imagined, at our bodies projected forward by prosthetics – and looking back – at what we missed. And that is what we see in images that display both the past and projections forward: roads laid out in anticipation of houses yet to come.

Figure 3. Lawrence Bird, *Edge* (2015). Video stills. Courtesy of Google Earth. © 2015 Digital Globe.

The physical landscape (or cityscape) itself is strangely implicated in this maieutics, for it too bears the traces of the past. In Figure 3, for example, as years and seasons pass, the foundations of demolished farmhouses (branching out to the left of the central road) remain visible to satellites, even if invisible to passers-by.

Farmhouses are demolished as small farms are agglomerated into large plots – overcome by technical and economic changes – while suburban houses gradually multiply across the land. Season succeeds season as snow blankets the landscape. Google Earth's machinery layers one year onto another. It becomes impossible to pull apart what the images are doing from what the land itself is doing. These spatial imaging systems display the emergence of differences and gaps that underline the passage of time: they are instances of Stiegler's temporal objects, associated with textual and technical infrastructures oriented towards time and memory. We recognize an affinity between these layers of time articulated in fragments of image, and fragments of land use and ownership; we might infer similarities in the processes that generate them. The digital environment is shown not to have left behind entirely the analogue environment; rather,

Figure 4. Lawrence Bird, *Transect* (2014). Video stills. Captured over Cleethorpe, UK, along the Prime Meridian. Courtesy of Google Earth. © 2015 Digital Globe.

it reconstitutes it. And these processes do not generate homogeneity. In fact, despite the aspiration to unite the entire surface of the world under one intuitive navigational scheme, labelled with a coherent and universal system of symbols and markers, in Google Earth as in other platforms a plethora of information, cross-referencing and inputs (often user-generated) provoke a condition of heterogeneity: of heterogeneous times laminated onto each other.

These images reinforce Stiegler's argument that *différance* and delay are not only not in any straightforward sense *erased* by technical memory, even industrialized memory: they are actually *provoked* by it. As was the case with memory, our orthography of space – while threatening to efface difference – proves to be a 'saving danger' (Heidegger 1977: 28). Indeed, 'Contemporary technics have initiated the opening to another world, emerging in and as a new gap, a very large gap as required for the making of an "epoch"' (Stiegler 2009: 95). This gap opens at the intersection of (spatial) database and (temporal) archive, as they generate territories of land and image.

Deterritorialization and a new (political) subjectivity

There is a politics to this. The emergence of text, in the earliest instance, was profoundly related to the production of urban space. Heidegger, Stiegler points out, connects the appearance of writing with the emergence of history and the *polis* and a plethora of civic institutions and places. The introduction of writing in the Greek city was political, legal and public – its primary function was to enable the inscription of laws. One result of this was the recession of the king (before the emerging democratic tendency) and the 'public's becoming profane'. The city's laws were founded through text, but that very act undermined their originary law. This amounted to the emergence of another form of difference within the city: political difference. As a result, even '[a]t their inception, the city and the connection to space are programmatically (dis)integrated: territorialization is also always deterritorialization' (Stiegler 2009: 90).

This tendency is amplified today with a radical dematerialization of knowledge and the end of one of its traditional characteristics: the transmission of cultural patrimony basing historical unity on territorial unity (Stiegler 2009: 111). As did Easterling, Stiegler notes the role of non-national institutions in the infrastructures of knowledge behind this tertiary memory. Their flight from national control results in a battle of standards between multinational groups, emancipated from territory (Stiegler 2009: 107). As places become indistinguishable, and our behaviour and works become detached from territories, there is on the one hand a complete loss of context. Yet on the other, even as the local is undermined by the generic, new localities are generated – hybrids of space and image. This tendency is reinforced by phenomena like wikis, crowdsourcing, modes of communication which are at once oral, visual, textual and hypertextual. So in the political and geographic arena also, these processes provoke rather than occlude *différance*.

Stiegler hints at (but does not clearly define – like any good storyteller he promises to tell us more in a sequel) a specific new kind of subject proper to this condition. It is a subject negotiated between the *who* and the *what*, between the specific and the generic, between forgetting and recalling. As he puts it:

> The orthographic *what*'s différance is a modality of the *who*'s différance – and it thus transpires that the elucidation of différantiation must take into account not only the supplementary specifics of the *what*'s epoch, but the articulations of the *who* that it generates each time. (Stiegler 2009: 64 [original emphasis])

That is, the technical support, the *what*, and the subject, the *who*, are constructed together; they depend upon each other. And the *who*

> is Epimetheus […] it is textual (which is not to say solely linguistic: this text is the assemblage of textures into which memory has been woven): this is what teaches Epimetheus the *what*'s successive Promethean orthothetizations. I shall thus call it the *idiotext*. (Stiegler 2009: 64)

The term suggests both the Greek sense of one without professional knowledge, ill-informed, but also perhaps one in the dual and paradoxical condition of being torn from context (idiosyncratic) and profoundly local (idiomatic). So its relationship to place matters; this new subject has a specifically spatial dimension: 'The idiotext attempts to think place, the (re)constitution of place, and giving-place as such: the opening of a spatiality in the event's temporal having-place. This effort "has place" within the "context" of what I have characterized as decontextualization' (Stiegler 2009: 243).

It is (we are) resonant with the kind of space we have been considering, (de)territorialized and mingled with time; and with the temporal objects that record and generate them. As we are renegotiated in new localities, through and within our supporting *what*s, we seem to be placed radically outside ourselves, in a shared subjectivity which is also technologized:

> The *I*'s alterity, which is more profoundly that of a *we* that the *I* always already is itself, is still more profoundly the play of programmatic suspensions organized by the organizing of the inorganic through the technical tendency […] and this constitutes epiphylogenetic development's reification. (Stiegler 2009: 95 [original emphasis])

If a satellite image shows us what was once only seen by the eye of God, perhaps it is now best understood as that image beheld by the new subject, both *I* and *we*, and composed in part of the *what* circling the Earth at an orbit of 35,000 kilometres.

Conclusion

The foregoing might suggest to us a new, or renewed, role for the image of the city today: understood as what Stiegler terms a *temporal object*, that is, one whose constitution depends on a re-reading of preceding accumulations of image, contributed to (wiki-like) by a *polis* of globally distributed local scribes, generated out of a technical engagement of memory, generating a condition of *différance* through a laminated temporality, and contributing to the creation of (while also created by) a new subject – a new kind of citizen. To return to Easterling, the ruptures of *dissensus* and *discrepancy* and the tales they engage/create/disrupt can be understood as subsets of a larger movement, Stiegler's *disorientation*. And we might elaborate slightly on another idea from Easterling which is implied also by Stiegler but explored in greater depth by one of the writers to whom he acknowledges a debt in *Technics and Time, 2*: Paul Ricoeur.

Figure 5. Lawrence Bird, *Edge* (2015). Video stills. Courtesy of Google Earth. © 2015 Digital Globe.

That is the importance of stories. Ricoeur draws on Aristotle to identify the importance of narrative in sewing together our being – a being torn apart, as St Augustine observed, by our impossible experience of time (Ricoeur 1984). Perhaps the intersection of database and archive expressed in these hybrids of collage/montage can be understood best as a latent narrative, one which deterritorializes and reterritorializes space through a prosthetic both serving and failing memory. Figure 5 suggests this. In this image, captured along the border of the prairie city, we see again the product of two superimposed satellite tiles. The first, on the left, shows us fields ploughed and marked by the hands and machinery of mankind: a form of prosthetics proper to an earlier era. To its right is another field, a pixelated digital field generated by Google's Earth's processing of an older, lower-resolution image. In this second field we can begin to identify more closely a landscape proper to the prosthetics of our own time, perhaps one to be inhabited by the idiotext of which Stiegler speaks. If we were to cross the boundary from one of these fields into the other, who would we find? What stories might take place there?

References

Agamben, G. (1998), *Homo Sacer: Sovereign Power and Bare Life* (trans. D. Heller-Roazen), Stanford: Stanford University Press.

Bird, L. (2013), *Parallel*, https://vimeo.com/64061190. Accessed 30 May 2015.

——— (2014), *Transect*, https://vimeo.com/lawrencebird/transect. Accessed 30 May 2015.

Bird, L. (2015), *Edge*.

Coffie, A. B. (2012), '1BN Michel Camp deteriorating; soldiers want immediate renovation', http://edition.myjoyonline.com/pages/news/201207/89477.php. Accessed 30 May 2015.

Deleuze, G. (1986), *Cinema: The Movement Image* (trans. K Tomlinson), Minneapolis: University of Minnesota Press.

Easterling, K. (2014), *Extrastatecraft: The Power of Infrastructure Space*, London: Verso.

Heidegger, M. (1977), *The Question Concerning Technology* (trans. W. Lovitt), New York: Garland Publishing Inc.

Immigration and Refugee Board of Canada (1994), 'Ghana: Information on the Michel Camp detention centre of the Bureau of National Investigation (BNI) and on the Achimota Forest annex detention centre, including its location, and number and type of prisoners', http://www.refworld.org/docid/3ae6ad2323.html. Accessed 30 May 2015.

Lacan, J. (1977), 'The mirror stage as formative of the function of the I', *Ecrits* (trans. K Smith), New York: Norton, pp. 1–8.

Lyotard, J. F. (1984), *The Postmodern Condition: A Report on Knowledge*, Minnesota: University of Minnesota Press.

Ricoeur, P. (1984), *Time and Narrative* (trans. K. McLaughlin and D. Pellauer), Chicago: University of Chicago Press.

Stiegler, B. (1998), *Technics and Time, 1: The Fault of Epimetheus*, Stanford: Stanford University Press.

————— (2009), *Technics and Time, 2: Disorientation*, Stanford: Stanford University Press.

Chapter 2

Manchester as a mythical city: Reflections in art and locative media

Steve Hawley

Introduction: City and myth

A question: why is there a statue of Carl Gustav Jung, in Matthew Street in Liverpool, given that the eminent Swiss analytical psychologist never ever visited the city?

Matthew Street was historically the centre of Liverpool's fruit and vegetable market, but it achieved iconic fame as the home of the Cavern, the club where the Beatles played numerous times in the early 1960s, drawing a line between the two halves of the twentieth century. At the same time as those early performances in 1962, Jung wrote in his memoir *Memories, Dreams, Reflections* (2005) of a dream he had had of Liverpool many years before. He saw 'greyish-yellow raincoats, glistening with the wetness of the rain', but had also a vision of unearthly beauty, as he equated the city in his dream as 'the pool of life'– Liver-Pool. Jung's Liverpool was both a real city, but also a powerful marker in his unconscious, stretching between two contrasting poles of grey bleakness and life-enhancing energy.

Cities exist in reality and in the imagination, and sometimes there is a gulf between the two singularities. In his dream Jung was walking through Liverpool on a dark night, obscured by rain, fog and smoke, when he saw what his companions could not, a magnolia tree on an island radiant with reddish blossoms in a shaft of light. The dream had a powerful internal meaning for him at that time in his life, existing apart from the city he had never seen, but making sense of his world.

Some cities seem to have the power of myth, of inhabiting the unconscious, whereas others do not, and this is not always the product of a city's size. Of course London, New York, Berlin, inhabit an inner space and have a numinous presence through their appearance through history or film, or literature or music. A city is always more than its buildings and streets, it is also its stories, its energies, its ideas. But some smaller cities also inhabit the space of myth.

Just what creates the myth of the city is shifting and intangible; often it is through its narrative, the interlocking stories either fictional or real that fasten together to make a picture of place. Some cities have this power and some do not. Why is Manchester mythical but Birmingham not? Detroit is but Cleveland not? This may be subjective to an extent, but often there is a remarkable consensus on the imaginary city.

Figure 1. Carl Gustav Jung. Image: John Bradley (2010).

Wayfaring the dystopian city

Over the last few years the author has made a number of works that use artists' video or new media to look at the city in the collective unconscious. In 2009, *Not to Scale* was filmed in model towns around Britain to uncover a sinister aspect to nostalgia. *Stranger than Known* (2015, with Tony Steyger) looked at Southampton, a city without identity, known more for the people who sailed from it in the Mayflower or the Titanic than those

left behind. And in the iPhone app *Manchester Time Machine* (Manchester Metropolitan University and North West Film Archive 2012), created with archive film from the North West Film Archive, technology and locative narrative are used to examine history and identity in Britain's second city.

This chapter looks at how the city is represented and shaped by technology, and how the myth of Manchester as a dystopia has arisen, reflected in both the iPhone app but also in two novels and a feature film. All involve navigation of the city's streets and landmarks by the viewer, or by the protagonists of the fictional representations.

The atmosphere of the city suburbs, as represented in the Babbacombe model town in Torquay, is both benign and slightly sinister. As Sam Jacob says, 'Model villages are not just models of real places, though they are obsessively concerned with looking like a scaled-down reality. They are also models of ideas, shrunk to fit comprehension' (Jacob 2006). There are no miniature Polish immigrants here (or immigrants of any kind), just Gulliver-like visitors in search of a lost England, a minutopia. This vision of the suburban as uncanny, especially when filmed in *Not to Scale* with no full-scale people in the frame, but real trees in the background, hints of Jacob's interpretation of Ruskin, that 'dissatisfaction is the natural condition of modern man in the modern cityscape, and

Figure 2. Steve Hawley, *Not to Scale* (2009). Video still. © Steve Hawley.

that the picturesque fills a vacuum we feel is forming within us as our morality shrinks: the picturesque is about loss' (Jacob 2012). There is a disjunction between the overt and slightly twee perfect place that never was, and the identity of a place that as you turn a corner has hints of menace – the village of the damned.

Southampton on the other hand, on Britain's south coast, is a city struggling to find an identity. Southampton became a city 50 years ago on 7 February 1964, when it received a letter from the Home Office advising that her Majesty the Queen had been graciously pleased to raise the town to the 'title and dignity of a city'. The letter then asked for a cheque for £72.13s.6d and warned that this would not confer the title of Lord Mayor 'in view of misunderstandings which have arisen in the past'.

The great port was now a city. It had a university, a large population, a long history of embarkation, and now a Royal Charter. But where did that leave the Southampton of the imagination? The beautiful medieval city had been largely erased by the terrible bombings of World War II; the romance and drama of the flying boats of Imperial Airways, not to mention the Mayflower and Titanic, were about transit, about departures and fugue, the flight from the familiar, and not the city's people who were left behind. If the city is not just a collection of buildings and streets and people but also a myth, then what is Southampton's myth?

This was the starting point for *Stranger than Known*, which tries to uncover the real and imagined places and stories existing through change and erasure, as buildings are torn down or blown up, leaving visual and historical traces in the urban fabric or in the memory. Sometimes it is possible to use technology to see the city anew, as the makers of the 'city symphonies' did in the 1920s, to visualize the familiar stones and water and people in order to piece together its romance again, re-examining the familiar to render it strange and potent.

High-definition cameras, ultra-slow-motion video and camera drones aspire to offer a vision, the myth of a city that is seen in everyday experience. There have been no psychoanalyst's dreams of Southampton, no literary references (Jane Austen stayed there but she described it only once in her stories, and then as stinking of fish [Austen 1790]). And no films apart from *Carry on Cruising* (Thomas, 1962) and the newsreels of ocean liners departing to and arriving from the most mythologized city on earth, New York.

The question arises as to how the wanderer of the city can express its uniqueness and spirit through the lens of a camera. In the 1920s, with the rush of energy after World War I that gave rise to modernism, the city-film or 'city symphony' was the response of film-makers to headlong changes in architecture and identity in the contemporary metropolis. In films made between 1921 and 1929, such as Sheeler and Strand's *Manhatta* (1921), Ruttman's *Berlin: Die Sinfonie der Großstadt/Berlin: Symphony of a Great City* (1927), Vertov's *Chelovek s kinoapparatom/Man with a Movie Camera* (1929) and Joris Ivens's *Regen/Rain* (1929), the camera takes on the the role of a *flâneur*, and acts as a mechanical eye. Images of people, vehicles, streets and industry were captured in fragments, producing a collage of impressions which looked at the city from far away and from very close-up.

Figure 3. Steve Hawley, *South Home Town* (2015). Video still. © Steve Hawley.

Sometimes the people and streets were filmed from a moving car, or a tram, invoking the speed of the modern. Often emergent filmic technologies were also used, such as time-lapse, and double exposures, as in *Man with a Movie Camera*, which gave a picture of Odessa in the modern technological world. Depicting urban space in this new world needed new techniques and genres, hovering often between voyeuristic documentary and fiction. However, the city-film is still being made in different guises up to the present, as in Peter Greenaway's 1969 *Intervals* shot in Venice, Bruce Baillie's *Castro Street* (1966), John Smith's *The Girl Chewing Gum* (1976) and Patrick Keeler's masterly *London* (1994).

The eye of the *flâneur* is still at the forefront, but new technologies have given rise to new ways of examining the urban experience. They allow glimpses of buildings and people as if the wanderer could slow time itself, or fly to impossible places, to look backwards in time and notice with a start, the forgotten, the unremarked. Slow motion reveals the unknown surface, as the camera movement in a painterly arc shows both the banal and strange at the same time. The drone in its impossible view for the first time reveals images as in the dream of flight, landscapes so close and so far away, the smallest detail and the vast panorama. Spectacle.

But filming the city in its present, or the emphasis of the city symphonies on modernism, do not uncover the layers of history that peel away to reveal the buildings, and the people who created its past. That was the starting point for *Manchester Time Machine*, an iPhone app created in collaboration with Marion Hewitt, the director of the North West Film Archive, and app developer Darren Dancey, which explores the narrative of Manchester over the last one hundred years. This is the first app to combine archive film with GPS to enable the negotiation of historical Manchester, overlaying the present with a century of filmed history, from the Whit Walks of 1911 to a student demonstration in 1971.

Manchester is Britain's second city after London, and the world's first industrial city. From the late eighteenth century, it was known as Cottonpolis, as its fortunes were inextricably linked with the calico industry and the cotton plantations of the southern states of America. In the 1990s, the industry had gone, and the city centre was in seemingly terminal decline, saddled with a threadbare 1960s shopping centre amid the handsome cotton warehouses of the nineteenth century. But in 1996 the IRA exploded a huge bomb in the city centre, which whilst causing no fatalities, destroyed much of the post-war concrete architecture and kickstarted the city's revival.

The centre of Manchester today, post the IRA bomb and subsequent reconstruction, is a regeneration success story. The textile warehouses of Princess Street, built to resemble Florentine palazzos, burnish red on a summer's evening, as the crowds stream between the lights of Chinatown and the night-time culture of Canal Street and the Gay Village. But the Manchester of the imagination as represented in literature and film, is a profoundly different place, a city of 'ruins, dust, deserted streets, blocked canals' (Wolff 2012), and of rain and decay. A post-industrial Hades.

This Manchester of the unconscious, is understood in reality and in its cultural depictions through traversing its streets and bus routes, through 'wayfaring' (in Tim Ingold's [2011] formulation) the lymph systems that connect the parts of the city together. And both real and imagined places exist through change and erasure, as buildings are torn down or blown up, leaving visual and historical traces in photographs, or film, or in the memory – the palimpsest of layers of meaning that subtly interact to create a textured picture of the whole.

As de Certeau notes, the city can be accessed in two ways: from outside through the map or from within as a pedestrian (de Certeau 2002). But the city can also be accessed through its myth, its resonance in the imagination; and the depiction of Manchester through *Time Machine*, whilst appealing to a nostalgic rewriting of the urban landscape, has echoes in three other works that have depicted the city as a blackened and faintly evil dystopia. I will examine these four linked media representations from the 1950s to the present, including the iPhone app, but also two novels, and a feature film. All involve navigation of the city's streets and landmarks by the viewer, or by the protagonists of the fictional representations. Far from showing a real picture of Britain's second city. These literary and filmic versions of Manchester show it to be a dark place of the imagination, and that this mythical Manchester still persists in the unconscious as a grey and depressed zone.

In Michel Butor's 1956 novel *L'emploi du temps* (translated as *Passing Time*), W. G. Sebald's *The Emigrants* (1992) and the British film noir *Hell Is a City* (Guest, 1960), Manchester appears in turn as a malevolent entity, a place of terminal decline and a metaphorical Purgatory. Even in the 1950s, this was not a recognizably accurate depiction of the city: instead it relates to a view of Manchester which goes back to the mid-nineteenth century, when Engels wrote about the condition of the working class.

Friedrich Engels had been sent to Manchester in December 1842 by his father, to work for the family firm of cotton merchant Ermen & Engels, and to rid him of his radical views. If that was the aim then it did not succeed. He met Karl Marx several times in Chetham's Library, where the table by the window around which they sat and discussed socialism still exists. He wrote in his seminal text, *The Condition of the Working Class* (1845) about the squalid conditions endured by the inhabitants of Little Ireland, just south of where Oxford Road Station stands today, before the slums were swept away following redevelopment – 'The atmosphere is polluted by the stench and is darkened by the thick smoke of a dozen factory chimneys' (Engels 1845 [1958]: 73).

Manchester has a place in the collective unconscious which starts with Engels and combines the real and imagined buildings, the weather, the character of the people, its post-industrial landscape and its history, but this is also perhaps redeemed by music in the 1980s, and its sudden transformation through what became briefly the most famous club in the world, the Haçienda. The Manchester of myth as represented in fiction is a dark place, but in order to fully experience that place, even in its darkness it must be traversed.

Thus all the works cited here involve the negotiation of the city, walking its streets, or traversing it via its bus routes. They reflect Deleuze's concept of the rhizomatic narrative, when narrative connections proceed not via a linear chain of events, like a single root, but more like a tuber root system, a net where any point can be connected to any other point (Murray 1997: 132). Whilst Deleuze may have meant this as a model for the conductivity of ideas, it also functions as a powerful metaphor for systems of non-linear narrative, the strategies of hypertext which computer systems eventually made possible.

It is in the cultural realm of psychogeography that walking and otherwise traversing the city becomes a kind of narrative. It is 'a whole boxful of playful, inventive strategies for exploring cities [...] just about anything that takes pedestrians off their predictable paths and jolt them into a new awareness of the urban landscape' (Hart 2004). To see and feel again in the streets is the aim, through the 'dérive' – movement without goal except to look anew and experience as if for the first time. Guy Debord, in 'Theory of the Dérive' (1958), said that the subject should 'drop their usual motives for movement in action [...] and let themselves be drawn by the attractions of the terrain and the encounters they find there' (Debord 1958).

Manchester Time Machine allows the user of the GPS and compass-enabled app to negotiate the streets and see Manchester in the past, the choice of 100 films picturing the city's history from multiple viewpoints. The films chosen tell a story, not a linear

chronicle of the city, but instead a patchwork GPS narrative of place, that can be followed by the user on foot.

The opening of the Manchester Ship Canal in 1894 had triggered a boom in building cotton warehouses and civic buildings, and early film-makers captured a place and an atmosphere of spirit and pride. The brash optimism of the Edwardian era is represented through filmed scenes of bombastic police marches; the crisp white dresses of young girls parading on Whit Walks down Market Street; and the seemingly chaotic mix of transport technologies in the streets, as horse-drawn cabs jostle with steam lorries, electric trams and the early examples of the soon-to-dominate motor car, which narrowly avoid crowds of scurrying pedestrians. There are hints at how emerging technologies fostered that optimism. A float passes the Town Hall in 1920 advertising the Midland Cinema, and 'films where you can see yourself on the screen'. But the ebullient self-image of Manchester turns darker with the Second War and the destruction of the Christmas Blitz of 1940, reducing much of Corporation Street and Piccadilly to rubble.

The narrative arc of Manchester, which seemed to have clawed its way out of the slums of the world's first industrial city, turns darker as that industry is left behind. A ghostly illuminated tram passing by the Town Hall on VE day in 1945, and the destruction by fire of Paulden's department store in 1957, seem like symbols of the city's decline, and by the twentieth century the persistent image is of rain, smog and inner decay. Partly this

Figures 4 and 5. Steve Hawley and Marion Hewitt, *Manchester Time Machine* (2012). Video stills. Images: North West Film Archive.

was true of most British industrial cities of the time, but whereas London was driving forwards through youth, music, fashion and creativity to the iconic era of the Swinging Sixties, visitors to Manchester saw only a bleak absence of life. The most recent film clip shows a student demonstration on Oxford Road in 1971, close to where Engels had described the appalling living conditions of 130 years previously. The clashes between police and demonstrators seem to show chaos, a city out of control.

Just twenty years previously, the French teacher and later novelist Michel Butor (he became linked with the nouveau roman group, which included Alain Robbe-Grillet), travelled from France to Manchester to work as a language assistant at the University, a few hundred yards further down the Oxford Road. Although written thirty years before hypertext, Butor's *L'emploi du temps* prefigures the form in a fascinating way, and although set in the fictional northern British town of Bleston, is plainly based on Manchester.

The protagonist, Jacques Revel, comes to work at the Bleston company Matthews and Sons, and seems to get trapped in the city, which reflects the grey post-war grimness of Britain as a whole, and the North in particular. His journeys criss-crossing the city by bus are represented in inordinate detail, and the web of bus routes that lie upon the city becomes a net which renders him unable to escape. His treasured possession is the bus map, purchased by him from the woman he would come to love, Ann Bailey (Butor 1956 [1965]: 38), and the routes become a figurative rhizome which is reflected in the episodic structure of the novel.

It is ostensibly a diary of the year he spends in Bleston/Manchester, written retrospectively, but whilst there is increasing complexity, there is very little narrative resolution, and the novel does not so much end, as stop dead. Jacques hates Bleston, hates the soot-blackened buildings, the insipid food, the cold reserve of the people, but more than that he comes to feel that the city has ensnared him, and as mysterious fires erupt across Bleston, that it is somehow decaying from within.

The description of the novel's English translation, *Passing Time*, on the back of the original John Calder edition gives a jauntily upbeat view of the story: 'the atmosphere of a British industrial town is perfectly captured, and this French view of England will delight British readers.' But most readers must have been appalled by Jacques's frozen welcome, and state of helpless entrapment in a place he had come to see as a labyrinth, with no way out. One of those readers was the acclaimed German author W. G. Sebald, who also came to Manchester to work at the University, but in the late 1960s, and whose view of the city was if anything even more damning than Butor's. His Manchester is stagnant and on the brink of ruin, a vision of unremitting gloom, without light or hope.

Sebald, who had seemed until his untimely death in 2001 to be a possible winner of the Nobel Prize for literature, made his name with a series of novels which mix fiction and essay with what seems like documentary autobiography. He said of his works, 'the big events are true while the detail is invented to give the effect of the real' (Jaggi 2001). In his 1993 novel *The Emigrants*, Manchester features in one of the four stories about Jewish emigrants from Nazi Germany. The unnamed yet Sebald-like narrator befriends Max

Ferber, a painter (based on Frank Auerbach) who works on his paint-encrusted canvases in the decaying Salford Docks, a mocking nod to the optimism of the Ship Canal opening 60 years before. Max, like Jacques Revel, is trapped in Manchester/Bleston, but this time forever; 'Manchester has taken possession of me for good. I cannot leave, I do not want to leave. I must not' (Sebald 1993: 169).

Sebald read Butor's novel during his two stays in the city in 1966–68 and 1969–70, and wrote a long poem, 'Bleston: A Mancunian Cantical' (Wolff 2012: 3) while he worked there. Obviously influenced by Butor, it prefigures *The Emigrants* in its bleak views of '"Soot covered trees", starlings "huddled together on the sills of Lewis's big warehouse", and ships offshore "waiting in the fog"' (Wolff 2012: 4). Sebald's view is so unremittingly gloomy that his experience of Manchester (like Butor's, from the point of view of a European immigrant) must have been blended with the inner melancholy which permeates all of his novels. Or as has been suggested (Wolff 2012: 4), his picture is a projection of post-war German guilt, felt by the survivors (Sebald was a Bavarian Catholic) and exemplified through his Jewish refugee characters. When Max arrives at Ringway Airport and takes a night-time taxi ride into the centre of Manchester he comments, 'One might have supposed that the city had long been deserted and was left now as a necropolis or mausoleum' (Sebald 1996: 151). This is not the squalor noted by Engels, but a city on the point of corruption and death.

But Sebald's view is loosely corroborated by the 1960 Val Guest film, *Hell Is a City*, a late British Hammer film noir, filmed on location in and around Manchester. Here the city is seen as a changing but decrepit landscape, still scarred from the war, where what threatens to erupt is not a mysterious conflagration but simmering female sexual tension. A killer is on the loose, and the opening night-time travelling shots from a police car, over a brassy jazz score, make Piccadilly seem like the centre of Chicago or New York. But overlaying this is a working-class northern landscape of billiard halls, bookies, and illegal pitch-and-toss games on bleak hills surrounded by factory chimneys.

Most of the action takes place in the city centre, and as with the novels, there is a strong sense of traversing the streets and rooftops, literally in the spectacular denouement. The protagonist Inspector Martineau clambers at roof level rather improbably from Castlefield to the eaves of the Refuge Assurance building on Oxford Road (now the Palace Hotel), to overpower the armed villain Don Starling. As they grapple high above the streets, in the background Oxford Road station is clearly being rebuilt, a telling example of erasure and renewal of the city's fabric.

Don Starling's getaway car is American, but far from a glamorous symbol of 1950s excess, this one is a seedy pre-war Buick, fitting in well with the overall rundown atmosphere of the film. And when he drives outside Manchester to dispose of the body, the countryside is not as in most films of the era, a place of health and escape. More the windswept moors are cold and forbidding, an eerie prefiguring of the chilling events of the Moors murders which would occur within a couple of years of the film's release, and which also contribute to the dystopian myth of Manchester.

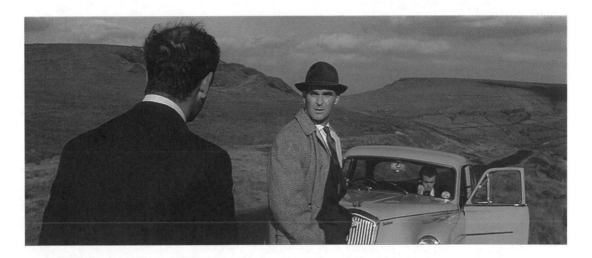

Figure 6. *Hell Is a City* (1960). Film still. © StudioCanal.

Some of the locations for *Hell Is a City* have been swept away, but there are muffled traces which show through faintly, despite the rubbing out of the buildings. The robbery of a bookmaker's van takes place in a fictional Higgitt's passage, off Corporation Street in the city centre, which was in reality a narrow alley called Cromford Court. The whole area was redeveloped shortly after the film was made, to become the vast Arndale shopping centre, and then again in the 1990s after the devastation of the IRA bomb, but the name Cromford Court still survives as one of the 'streets' in the Arndale, a muted footprint of a lost history. And at least one Manchester landmark appears in nearly all of these cultural texts, and is unchanged to the present day: Strangeways Prison, the symbol of the corruption of Manchester/Bleston, with its characteristic hexagonal shape. Butor refers to Bleston's 'safeguard, a six pointed star with the penitentiary in its centre, the image of which had appeared to me like a black crystal [...] A negative of the gleaming mark imprinted on Cain's forehead' (Butor 1956 [1965]: 254).

Sebald's narrator goes to the one-time Jewish quarter around the 'star-shaped complex of Strangeways prison' (Sebald 1996: 157) on his increasingly long walks on Sundays, overcome by 'aimlessness and futility' (Sebald 1996: 156). He roams the city and is always amazed how anthracite-coloured Manchester 'displayed the clearly chronic process of its impoverishment and degradation to anyone who cared to see' (Sebald 1996: 156). And at the end of *Hell Is a City*, we see the forbidding exterior of the prison, as a knot of bystanders stands outside, and a *Manchester Guardian* placard proclaims 'Starling to Hang'.

There are numerous echoes in these sources of the internalized image of Manchester. In *The Emigrants*, Max Ferber lodges at 104 Palatine Road, the same house that the

austere and often tortured philosopher Ludwig Wittgenstein stayed in when he came to study aeronautics at the University in 1908 (Sebald 1996: 166). The fires that consume Bleston from within are paralleled by the 1957 destruction of Paulden's department store off the Oxford Road by fire, which is one of the film scenes in *Manchester Time Machine*.

Always the overwhelming connotation of the city's traverse is less the freedom of discovery of the 'dérive', or the pleasure of navigation of the story, but rather the pacing of the floor of the trapped prisoner, in a condemned cell, unable or unwilling to escape. Jacques Revel feels he cannot break free of Bleston, and refers to the parallel of Theseus in the Minotaur's Labyrinth (Butor 1956 [1965]: 299). Sebald's narrator returns from visiting Max Ferber in hospital, walking through the Hulme estates regenerated in the 1970s, but already decayed again (Sebald 1996: 231), past derelict warehouses to the Midland Hotel, which the owners would be surprised to know was 'on the brink of ruin' (Sebald 1996: 233). And yet there are premonitions of the new myth of Manchester that would arise in the 1980s.

Don Starling is cornered by Inspector Martineau in a two-storey Castlefield building, just around the corner from the fictional Hotel also where Sebald's narrator comes to lodge, eight years later. In the background through the railway bridge, can be glimpsed the yacht-building showroom that would become what *Newsweek* called in the 1990s the most famous club in the world. The Haçienda was born from the profits of the Manchester band New Order, who in their earlier incarnation as Joy Division, prior to the suicide of their singer Ian Curtis, had brought gloom and grey raincoats to the exuberance of punk. The ecstasy fuelled reincarnation of both the music and the spirit of the city in the yacht showroom was the start of the re-mythologizing of Manchester.

Manchester today has largely assimilated its Victorian past; the world's first industrial city has co-opted its cotton warehouses into attractive apartment blocks, or restaurants and bars. Lewis's department store, where Inspector Martineau meets a streetwalker at the end of *Hell Is a City*, is now a branch of Primark. Where Sebald's Max Ferber found Manchester deserted, this would be unrecognizable to the tens of thousands of revellers who swell the night-time economy and the pubs and cafes every weekend (many of them students living in the city centre, some in converted Victorian mills).

Conclusion: The frozen image

Manchester Time Machine, like the other texts quoted here, maps the city through its past, but also points to another, internalized Manchester. There is a direct path that leads from Engels and the misery of Little Ireland, through the despair of Butor and Sebald, to the pessimism of Joy Division and Morrissey. The famous Anton Corbijn photograph of Joy Division in the Hulme estates (the same ones that Sebald's narrator trudges through) freezes an image, a myth of Manchester that paradoxically resonates as truthful, even as it is at odds with the bright lights and swarming crowds of the literal city.

Technology can mediate the city, both in its present and in its past: the city symphonies and the inner world of the novelist are two facets of the construction of the city in the mind's eye. It is interesting to note how the camera drone with its birds-eye view creates a new mediation of the urban experience, not from ground level via the negotiation and navigation of a warren of streets, but as a vast model of a city scene from an *Alice in Wonderland*-like viewpoint. The camera drone gives us the impression that we are striding above a model town, a controllable and spectacular experience, just as the tilt/ shift photograph can render real cities to look like models.

The four literary and filmic sources quoted all show that the frozen internalized image persists as a disconnect between the everyday Mancunian experience and the city's place in the imagination, perhaps to a greater extent than in other cities. Jung could dream of Liverpool, and despite never being there his vision became form, permanently fixed in bronze on Matthew Street. The myth of Manchester mixes the real buildings of today with layers of real and imagined history, a film of soot from two centuries of industrial chimneys, that may have been removed in reality, but persists in the unconscious.

References

Austen, J. (1790), 'Love and Freindship [*sic*]: Letter the Fourth', http://www.mollands.net/etexts/loveandfreindship/laf4.html. Accessed 1 June 2015.

Butor, M. (1965 [1956]), *L'emploi du temps/Passing Time* (trans. Jean Stewart), London: Jupiter.

Certeau, M., de (2002), *The Practice of Everyday Life*, Berkeley: University of California Press.

Debord, G. (1958), 'Theory of the Dérive', *Internationale Situationniste*, 2 December.

Engels, F. (1958 [1845]), *The Condition of the Working-Class in England in 1844* (trans. and ed. W. O. Henderson and W. H. Chaloner), Stanford: Stanford University Press and Basil Blackwell.

Guest, V. (1960), *Hell Is a City*, London: StudioCanal.

Hart, J. (2004), *A New Way of Walking*, http://www.utne.com/community/a-new-way-of-walking.aspx Accessed 1 June 2015.

Hawley, S. (2009), *Not to Scale*, UK. https://vimeo.com/11456814.

—— —— and Steyger, T. (2015), *Stranger than Known*, UK. https://vimeo.com/115925976.

Ingold, T. (2011), *Being Alive: Essays on Movement, Knowledge, and Description*, New York: Routledge.

Ivens, J. (1929), *Regen/Rain*, Amsterdam Filmliga.

Jacob, S. (2006), 'Legoland', *icon 035*, May, http://www.iconeye.com/component/k2/item/2510-legoland-%7C-icon-035-%7C-may-2006?tmpl=component&print=1. Accessed 1 June 2015.

——— ——— (2012), 'Just what is it that makes yesterday's homes so different, so appealing?', *Loud Paper*, 4: 2, http://loudpapermag.com/articles/just-what-is-it-that-makes-yesterdays-homes-so-different-so-appealing. Accessed 1 May 2015.

Jaggi, Maya. (2001), 'Recovered memories', *The Guardian Profile*, 22 September. http://www.theguardian.com/books/2001/sep/22/artsandhumanities.highereducation.

Jung, C. G. (2005), *Memories, Dreams, Reflections*, London: Fontana Press.

Manchester Metropolitan University and North West Film Archive (2012), *Manchester Time Machine*, Version 2 [Mobile application software], https://itunes.apple.com/gb/app/manchester-time-machine/id500576541?mt=8. Accessed 1 June 2015.

Murray, J. H. (1997), *Hamlet on the Holodeck*, Cambridge, MA: MIT Press.

Ruttman, W. (1927), *Berlin: Die Sinfonie der Großstadt/Berlin: Symphony of a Great City*, Berlin: Fox Film.

Sebald, W. G. (1996), *The Emigrants* (trans. Michael Hulse), London: The Harvill Press.

Sheeler, C. and Strand, P. (1921), *Manhatta*. New York.

Vertov, D. (1929), *Chelovek s kinoapparatom/Man with a Movie Camera*, Kiev, Kharkov, Moscow and Odessa: VUFKU.

Wolff, J. (2012), 'Max Ferber and the persistence of pre-memory in Mancunian exile', in Jean-Marc Dreyfus and Janet Wolff (Guest eds), *Melilah*, Supplement 1: *Memory, Traces and the Holocaust in the Writings of W.G. Sebald*, http://www.manchesterjewishstudies.org/storage/melilah/2012/s2/6.pdf. Accessed 20 December 2013.

Chapter 3

From under your skin

John Zissovici

Introduction

We, the things and their image, are all one.

Lucretius

Technical images are phantoms that can give the world, and us, meaning.

Vilém Flusser

At the beginning of the twentieth century, Wassily Kandinsky described a fictional city jarred from its foundations to convey the spiritual state of a society whose most basic belief system is suddenly called into question by radical ideas changing their world. He described 'a great city built according to all the rules of architecture and then suddenly shaken by a force that defies all calculation' (Kandinsky 1969: 57, author's translation).

What Kandinsky could hardly have anticipated was that today this 'force' that fundamentally alters the way we see, imagine and engage cities, rather than defying all calculation, would be *purely a function of calculation*: the scripts and algorithms that regulate the assembly of bits into images of cities and enable our navigation through them. Even less foreseeable was that by the beginning of the twenty-first century, this image of a city would no longer be merely an apt metaphor for a certain spiritual anxiety, but both its source and potential exit strategy from it.

Today we understand that in 'reality', everything that makes up the world is a swarm of particles in a constant state of change and decay because we can 'see' this swirl of particles with the aid of sophisticated apparatuses. In other words, what we call reality, the way we see the world, is, like vision itself, a learned shared illusion. We are not born able to distinguish things, to see the space between things, or to position them in three-dimensional space. These are acquired skills that take years to master and coordinate with our behaviour.

Technical images

Mirroring this world of bits and pieces, images made by cameras and other devices are also an organization and assemblage of bits. For Vilém Flusser, these technical images constitute a radical break from all previous forms of image-making because technical

images require an apparatus to create them. Technical images are 'an attempt to consolidate particles around us and in our consciousness [...] to make elements such as photons and electrons, on the one hand, and bits of information on the other hand into images' (Flusser 2011: 16). Flusser described technical images as 'envisioned surfaces', and 'particulate phantoms', which themselves can multiply and interlock into a veil of technical images that surround us.

It is thirty years since Flusser's observation that '[w]e live in an illusory world of technical images, and we increasingly experience, recognize, evaluate and act as a function of these images' (Flusser 2011: 8). In the media-saturated twenty-first century, these actions as a function of images have only become more intense.

Like our shared reality, technical images only work if they are seen from a distance. Getting too close to technical images exposes their particulate structure, whatever its scale, and ruins the illusion. Yet it is exactly at the moment when the image fails to simulate another reality – with the collapse of the illusion – that we can see 'beyond' the image to its structure, and speculate about the technical image and its relationship to the world.

Kandinsky's apocalyptic metaphoric image, and Flusser's equally radical notion of a technical image world, find an apt manifestation in the latest 3D-navigable version of Google Earth. Google's stated mission is 'to organize the world's information and make it universally accessible and useful' (www.google.com/about. Accessed 2 May 2014). With Google Earth's visual universe being an integral component of this aspiration, the virtual city becomes the ultimate destination for anything and everything. As the ultimate technical image that intends to represent the visible world, it is the ideal model for exploring new conceptions of the already highly mediated city.

> [L]ikenesses or thin shapes
> Are sent out from the surfaces of things
> Which we must call as it were their films or bark
> Because the image bears the look and shape
> Of the body from which it came, as it floats in the air. (Lucretius 1997: 102)

Lucretius' first-century notion of vision is a perfect description of the world Google Earth constructs for us to look at and move through. This ultra-thin image world is the result of algorithms and scripted operations that automatically assemble thousands of individual aerial photographs, 'bits', into a vast three-dimensional mosaic, what Google calls the 'Universal Texture', a continuous topographical surface map of all that we can see; the rivers, hills, cliffs, trees with foliage, streets and buildings onto which the appropriate visual information, culled from various sources, is automatically mapped. It appears as a visual cast of the world, a painted death mask, what we might call a *Surface City*, that corresponds precisely to what Italo Calvino – who believed that the brain begins in the eye – called 'the inexhaustible surface of things' (Calvino 2014: xii).

Figure 1. John Zissovici *EYE FULL*, (2014). Video stills. © John Zissovici.

For now, the Universal Texture is placed temporarily on top of its earlier manifestation an assembly of satellite images texture-mapped onto a topographically correct 'landscape'. The image mapping is not always precise, appearing sometimes more like patchy skin grafts. At times, the various modes of representation from different periods are exposed as redundant and conflicting information by the navigation system that sets no limits on where we can move once we have 'landed'. If we indulge our impulse for spatial practices in these virtual cities that, in the actual world tend towards the 'exploratory', if not downright transgressive, we make genuine discoveries of enigmatic realms that have been mostly purged from our experience of the homogenized actual city and, if Google Earth has its way, soon even from the virtual city.

Wielding the smartphone's touch-screen with three fingers, like the keeper of the 'subtle knife' who uses it to access parallel worlds by cutting openings into the skin separating them, as in Phillip Pullman's book *The Subtle Knife* (Pullman 2002), one can undertake countless such drifts against the grain, hurried explorations under the skin of Google Earth, to record its current state before it disappears forever. Guiding the mobile picture plane freely through the image city, unconstrained by traditional routes of movement, or even Google Earth's attempts at restrictions, one slices effortlessly through the excess layers of imagery that expose its forbidden transparent underside. The encounter on our field of expectations between Google's slicing picture plane and its

automated mapping practices is the contemporary version of Lautreamont's definition of the marvelous, 'as the fortuitous encounter on a dissecting-table of a sewing-machine and an umbrella!' (Lautréamont 1965: 263). The spirit and tripartite structure of this formula was adopted as a guiding principle by the Surrealists in their revolt against the rationality and banality of everyday life. This setup now liberates unprecedented spatial phenomena embedded in Google Earth's representational excess. These appear unexpectedly during our illegitimate unplanned journeys, virtual dérives, across the otherwise familiar image city, as phantasmagoric evocations, apocalyptic visions, which transform the surface city into moments of anxiety producing sur(real) face cities. Each image is a like a conduit to a long forgotten dream. Accessing them could occupy a greater part of our waking life in the city.

These new digital fictions that emerge from the constantly updated simulation of our actual changing world, are true science fictions inadvertently created in this case by the science of computation. They announce themselves and claim our attention just like the ones that conform to our expectations of the virtual city. They share the same language, that of the technical image. They confirm technology's ability to show us something new; something that we cannot yet see.

Figure 2. John Zissovici *EYE FULL*, (2014). Video stills. © John Zissovici.

Seeing is believing, at least if we *believe our eyes*. Images talk to us in their own language. How we interpret this language is as much a reflection of who we are as what actually seems to be said. Each image is a gift, but since they are given to us unintentionally, we are allowed to *look into its mouth*, if only to better understand what it is saying. Ultimately each of us would find a different way of seeing these images, of coming to terms with what we believe they can tell us.

But what do we actually see when looking at these images? Some knowledge of how they are made explains why we see what we see, which might be reassuring to some, but does not actually help us see what is actually on our screen. Are we looking at a new world, or is this a new way of seeing our present world, a way of seeing the new in our old world, a look into the future? What this chapter undertakes at this point is a brief examination of some of these images.

A picture is worth a thousand words

Let us examine one of these images in a reverse zoom, starting at the top of the image, the furthest point in space and moving backward and down the image towards the viewer. This is also the natural journey of the eye from the familiar towards its counterpart, the strange and unrecognizable, a receding into uncertainty. The fact that one tends to orient the device vertically, partly because it is easier to handle and control the image, creates the illusion of greater distance between foreground and background, while seemingly flattening the 'view', similar to Chinese landscape painting.

Underneath a bright blue sky a dense riverfront metropolis stretches from one side of the image to the other. Most will recognize Manhattan's skyline, and those familiar with the city that we are looking east towards the city from the New Jersey shore of the Hudson River. Our vantage point seems to be well over a hundred feet above water level, based on the amount of the river we see and on the few glimpses we get of the shore on our side. Moored at the edge of the river, two rows of barges containing some dark matter, possibly coal. Much closer to us, in the foreground, we can make out glimpses of yellow and white traffic markings on a road, and running parallel to it, two sets of railroad tracks separated from a paved strip by a scruffy border of shrubbery. This strip's thin jagged edge marks an emphatic limit. Below spreads a black nothingness dotted by tiny white spots: Google's version of the night sky.

The scene unfolding in the foreground nearest to us is less easy to make out partly because its edges and surfaces shift in and out of focus for no discernible reason. It stretches from one side of the frame to the other and we can clearly make out its front edge, which is sharply delineated against the black void and the surface with the tracks below. Its back edge closest to the city is at times less sharp, but still distinct. This floating strip hovers over the void and overlooks the shore below and the river and city beyond. At its centre is a roughly horizontal vivid blue concave distorted rectangular volume with

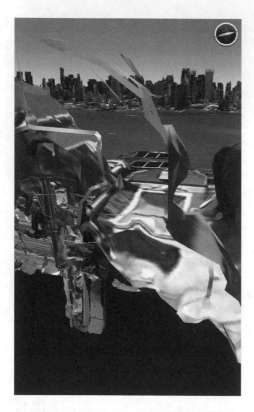

Figure 3. John Zissovici *EYE FULL*, (2014). Video still.
© John Zissovici.

a white frame. Its length is perpendicular to the river. Let's call this a pool. On its right a dark mass rises sharply to the edge of the frame. In front of the pool, on axis with it, is a reddish rectangle with its furthest corners chamfered, possibly a roof terrace. The back edge of the pool rises sharply at its middle and then drops off steeply into a light-grey landscape that recedes towards the bottom of the image, only to end abruptly in an uneven edge silhouetted against the night sky below. From the left side of the pool a blurry green surface slopes up steeply and blends into a grey metallic roof-like shape with bright highlights marking its horizontal folds, whose top edge blocks the view of the city beyond. The greenery below the roof folds invisibly and drops back down cascading in densely folded tropical shapes with tall leaves and openings through which we glimpse details of the industrial landscape below. The falling jungle finally coalesces in a vertical geometric volume, part primitive reed column, part concrete, or ruined masonry construction covered by stucco. This lowermost structure seems to be the source, the

stem of this independent world that hovers dangerously over the night sky with its tiny stars from which it might also draw energy and nourishment.

Finally, closest to us, thin planar shards, some clearly emerging from the landscape of the pool, larger ones entering our field of vision from outside the frame, like early efforts at digitally rendered smoke, reaffirm the thinness and uncertainty of all that we are seeing.

Even our position as viewer is called into question. We seem not to be 'standing' on solid ground, or at least to be separated from the scene we are looking at by an unfathomable gap. And how are we to understand that expanse of the night sky below us and possibly extending below the Hudson and Manhattan?

Street View

In its latest version, Google Earth, like Google Maps, offers us the little yellow human figure to place and follow directly into Google Street View, a calculated distraction to discourage us from discovering its limits and flaws by wandering into the part of the image world not meant-to-be-seen from the pedestrian's point of view. Street View's

Figure 4. John Zissovici *EYE FULL*, (2014). Video stills. © John Zissovici.

world is assembled from images automatically collected by the nine cameras radiating outward from a sphere mounted on the Google car that roams the roads and streets of cities. If one manages to short circuit the transition from Google Earth into the linear restrictive eye-level world of Street View, one is left to roam freely in the twilight zone between the two image worlds.

While looking for moments that embody the strangeness of this version of the virtual city, one quickly realizes the disconcerting effect of the sudden unexpected distortions of the normative Street Views. This new unfamiliar city, like our actual city, is a dynamic and evolving experience rather than a set of post cards, mementos of a new form of street photography. *EYE FULL* (Zissovici 2014) is a video captured directly from the screen of a 'smartphone' that comprises of three virtual exploratory eye movements in the thin-skin city of images. Except to assemble the three movements and add the sound and titles, there is virtually no editing. The image appears in the vertical format it was captured in from the device, partly a function of the way we hold our smartphones, but also reinforced by a preference for the vertical format for depicting the city, a format that is still unusual in the cinematic medium.

As our fingers touch the screen their movement transforms the image. The virtual navigation of the city has become a gestural experience. The form of the city itself is gestural, 'the surplus of an action' (Barthes 1985: 160), a term used by Roland Barthes to describe Cy Twombly's paintings. The touch, expanded into the groping gesture, activates 'the armature of permutational unfolding' (Barthes 1985: 61). The city unfolds at the touch of our fingertips on the screen in any direction, with almost unlimited possibilities. The touch itself is merely an intermediate phase. Already motion sensors that track the direction of our eyes, can also interpret our hand gestures into commands, a new kind of active sign language for communicating with envisioned surfaces floating in front of our eyes like Lucretius' 'thin shapes'.

In this transitional realm, Street View's flat or curved surfaces seem to have acquired the gravitational force normally associated with the ground. They either attract, or repel our gaze, leaving us at the mercy of an unreliable and unpredictable mode of navigation. Each gesture on the glass surface of the screen propels us further into the unprecedented and unfamiliar technical image world. Movement here is neither smooth nor continuous.

As we move further off the path along which the image world was constructed we are left with fewer and fewer opportunities to link ourselves spatially to the actual world. Each new vista results from the interaction of the computational apparatus that created the image and the tool we hijacked to interact with it. The views we encounter appear as linked anamorphic moments, only decipherable if we manage to rotate our position relative to it. One wrong move and we slide past the infra-thin image into another realm. Beyond the edge of the image a generic greyness fills the void, a stand-in for the 'night sky' below the perpetually sunny Google Earth. A multicoloured stretch of dense lines seems to congregate around some imaginary horizon. The grey is clearly a default colour, the lack of any desire to simulate a corresponding phenomenon of our normal life. We

Figure 5. John Zissovici *EYE FULL*, (2014). Video stills. © John Zissovici.

were never supposed to be here to witness the finite state of this world, its backside, so why would Google bother?

Occasionally, the image world itself appears to succumb to the gravitational attractions and repulsions of its various components. Certain layers get distorted into unrecognizably stretched patterns and textures, a new and often exciting 'reality' that we can either appreciate for its own beauty, or ponder for what it reveals about the morphing algorithms, the digital gravity that holds this world together once the shared eye-level point of view has been abandoned.

Even a desperate attempt to retreat into familiar terrain is rewarded with hallucinatory and revealing experiences. As we zoom back, it appears we have been occupying a semi-spherical realm whose centre is linked to the axis of our movement. But the boundary of the sphere is not fixed and planes of images parallel to our movement project beyond its limits. The colourful and carelessly 'drawn' horizon, likely the trace map on which the images are arranged, reappears in the grey beyond just when the notion of horizon should no longer apply. Here, at the unscripted convergence of normally irreconcilable scales and modes of representations, like plan views, perspectives with multiple vanishing points or orthogonal projections, the apparatus propels us beyond the imageable, towards the limit of the imaginable.

The frequent jump-cut-like displacements in unexpected directions disrupt the progress of the virtual camera towards its subject, the eye in the city, imparting a cut-up quality and an uneven rhythm or pulse to the whole work. This would seem to recall William Burroughs's experimental novels *Naked Lunch* (1959) and *The Ticket That Exploded*

(1962), or New Wave auteur strategies to disrupt the narrative momentum as reminders that we are watching a film, best exemplified by Godard's jump-cuts in *Breathless* (1960). In *EYE FULL* it is the technology of the medium itself that obstructs the progress of the story, or in this case, the movement of the virtual eye towards its goal, the watchful eye of the city. In that sense, cumulatively, these moving images, or more precisely, image movements, are a 'documentary' about a series of foiled attempts to approach an image in an image world, the repeated failures of our fingers to move the image in the desired direction towards the 'eye of the beholder', or the intertwined mechanics of propulsion and repulsion. The 'story', or at least what these eye movements might be 'about', can only be considered after the fact, or at least after the final 'THE END' too disappears from the screen. Could playing the eye movements backward reveal its mystery, like the 'turn me on, dead man' message heard when playing backward 'Revolution 9' on the Beatles's *White Album* (1968)?

As the distorted city, reduced to a tiny globe, slides out of view for the last time on the screen, we accept what we saw as a provisional actuality. In their fragmentary state these moving views suggest contemporary experiences of cities induced by our own current condition of distracted attention. We are constantly tempted by images on a multitude of screens that compete for our attention with the actual city at every turn. We encounter a city shaped by our intermittent vision disturbances, dislocation hallucinations, and an acute sense of a doubling of consciousness. Our movement in this world is an ongoing struggle to realign the axis of our estranged vision with the axis of the world. We are confronted by a sentient city that responds to our every move and in turn is made strange by our looking back at it. From 'the city that never sleeps', we have progressed to the city that never even blinks. Are these image movements merely symptoms of our current transitional state, or the premature manifestations of the fantastic that is constantly suppressed and purged from our actual and virtual cities? Have we gone where no eye has ever been before?

I have new eyes to see

As the flow of digital images on screens at home, the place of work, or in the streets of our cities are shifting our attention away from the actual world within which we – along with our images – still reside, the distinction between the actual versus the virtual is already rapidly dissolving to the dismay of those who still remember an earlier world. What we are looking at in these images is not just a new way of seeing the world, but one that can transform our world. To think of the world through the subverted structures given to us by Google, the company that is proposing new devices for seeing our world, is to anticipate and exploit the very technologies that we might otherwise either dismiss, or whose influence we are left to lament when it is too late. Whenever we look through our digital cameras we are looking not at the world but at a mediating image of the world.

We are already mostly seeing the world as an image on one screen or another. The radical potential of Google Glass and similar devices is not to have invented a camera that sees and can capture whatever we see, whenever we are looking, but for us to be able to see what that camera sees any time we wish, that is, the world as digital image. Our ability to look at the world *through* its digital image, enhanced or transformed by all that *we* can digitally bring to it in real time, any time, alters what and how we see our world, and constitutes the truly radical and magical potential of these new technologies.

Conclusion

'Our veil is not to be torn but rather woven more and more closely together' (Flusser 2011: 39). Google Earth's and Street View's visual anomalies and gaps mark the breakdown of the image's mirror-of-the-world illusion. These gaps don't merely expose the veil-like qualities of the technical image, but also the nature of its 'construction'. Here we 'see' the space between the 'pixels', the individual images that make up these image worlds, where a new reality breaks through. Since we understand that everything we see is an illusion, alternate illusions could be woven together to close the tears in the veil of illusion, like darning a sock with our own hair. This is a model of our new hybrid reality where the envisioned surface and the actual world occupy the same realm and we move seamlessly in, through and between them…

Imagine Google Earth's and Street View's image worlds as technical images overlaid on our actual world as we occupy and move through the two realms simultaneously. With control over the technical image in real time, we can choose how and to what degree our two particle worlds are woven together.

Our image world will recall the dome of the cave to which early man retreated to contemplate the world through drawing. But, like the spherical world in Street View, it will not make the world disappear, or be out of reach. It will be transparent and we will be able to manipulate the images on its virtual surface and navigate through it while we move in our world. It will bring back the multidimensional world of Merleau-Ponty's formulation where '[e]verything I see is in principle within my reach, at least within the reach of my sight, marked on the [touch-screen] map of the I can' (Merleau-Ponty 1964: 2).

The mingling of the digitally deformed with the digitally realistic version of the city in the current state of Google Earth constitutes a historical moment in which the true origins of the future can be found. As we are constantly reminded by daily news of the most recent technological developments in the area of augmented reality visualization, the image world will be similarly integrated into our everyday urban experience, as an added layer over the image of the city on the screen of our mobile viewing communication device, soon permanently mounted in our field of vision. The mediated city is already our reality and it will only become more so. Properly reimagined the hybrid city that intertwines the virtual and the actual should take its place as the ideal site for testing

in the collective imagination the possibilities of alternative urbanisms. We could soon be dreaming our cities into existence on-site, in real time and with our eyes wide open. What visions for our cities will we conjure up, bring to light and to life as envisioners of alternate hybrid realities, new phantasms? Better yet, what new ways of living with images can we manipulate into existence through our current child-like, though not childish, gropings in the technically sophisticated, though, in their aspiration, infantile simulations of Google Earth and Street View?

References

Barthes, R. (1985), *The Responsibility of Forms* (trans. Richard Howard), New York: Hill and Wang.

Calvino, I. (2014), *Collection of Sand* (trans. Martin McLaughlin), New York: Houghton Mifflin Harcourt.

Flusser, V. (2011), *Into the Universe of Technical Images* (trans. Nancy Ann Roth), Minneapolis: Minnesota University Press.

Kandinsky, V. (1969), *Du Spirituel Dans L'Art*, Paris: Denoel.

Lautréamont (1965), *Les Chants de Maldoror* (trans. Guy Wernham), New York: New Directions.

Lucretius, T. (1997), *On the Nature of the Universe* (trans. Ronald Melville), Oxford: Clarendon Press.

Merleau-Ponty, M. (1964), *The Primacy of Perception* (trans. James M. Edie), Evanston, IL: Northwestern University Press.

Pullman, P. (2002), *The Subtle Knife*, New York: Alfred A. Knopf.

Zissovici, J. (2014), *EYE FULL*, https://vimeo.com/104940913. Accessed 1 June 2015.

Chapter 4

City space mind space

Terry Flaxton

Introduction

It can be argued that the understanding of the modern mind and one of its principal expressions, 'the city', coalesced when the imaginations of Marshall McLuhan and Rayner Banham merged together to inform the contemporary psyche on what had happened to the world approximately 140 years after the introduction of electricity. Between the 1830s and the 1970s, *Homo sapiens sapiens'* conceptual tectonic plates were shifting, everything was moving, altering, paradigm-lurching.

To create a narrative to understand this level of change, this chapter shall spend some time developing the relationship between the act of creating metaphors and the relationship they have with the 'reality' they represent – because it is the author's belief that it is in this liminal boundary between the real and the virtual that we will find our current understanding of the world. Quantum physicists do not see particles, they see the traces that particles leave behind – in this way we might picture what the digital is, through the analogue-acculturated trained eye. As we have moved between the analogue, through to the early years of the digital and now find ourselves at the gateway to the meso-digital, not everything is clear, nor defined, so we have to look to late analogue practices to next create narratives that reveal some kind of truth of the situation we are in. The trouble we are going to have is that metaphor – and language itself – is a product of the latter end of the Stone Age and we may find that its frontal lobe analytic modality is not fit for purpose as we enter what will be referred to and explained at a later point as 'a velocitized state'. This kind of language is employed because it is a development of the common parlance of the cognitive neuroscientific realm which has been so proficient in publicizing itself, such that many arts and humanities researchers feel they need engage with this discipline. It shall be demonstrated that within this ideology it has been argued that we transcend frontal lobe behaviour rather than laboriously produce semantic ideas through the frontal lobes – and that in fact we should *entrain* with meaning, rather than analyse it, via what will be described as *velocitized behaviour*. Throughout, this chapter will try to invoke metaphors which create an impression of the experience of velocitization, which itself is both a sum of and a description of a barely recognized faculty that we've had since coming down from the trees some 2 million years ago.

So, with regard to the flux of factors which came together over time to create the churn from which our Digital Age evolved, we have to count as important the historically recent and continual developments in science and technology, not the least of which, communication

via telegraph, telephone, radio or television would describe our own ontological state for us. Primarily, the ability to externalize material acts at the 'click of a switch', to essentially bring 'light' into the world, came with electricity. But coming forwards a hundred or so years, if we are to listen to Marshall McLuhan, then the introduction of the media of electrical mass communication subtly massages the meaning of that communication, such that the information transferred says far too much about the medium itself – and little about what is originally being communicated. Now, with the Internet, or more specifically 'the rendering into a digital representation', the transformation of everything into *bits* to make it manipulable, actually turns information *into the medium*. Quantum physicists posit that it is probable that information *is* the true stuff of the universe, and arguably therefore, within this narrative, the foundation of *matter* is actually '*meaning*'.

So, as the electrical age developed towards some maturity, when Rayner Banham examined the LA cityscape using the idea of the moving-gaze rather than the static-gaze as a way to *read* LA, in *Los Angeles: The Architecture of Four Ecologies* (1971), what he identified as 'not fit for purpose' was simply that prior modes of 'reading' the city derived from static historical imperatives. These testified to the regard with which societies held themselves through their architectural works, which had stood grandly and proudly as monuments to the taming of the physical environment, and these too required us to stand in awe in front of the stone building which dwarfed us. In so doing we would learn the message they contained: that they were paid for with money that had been drawn towards the city and the building itself, by colonial or mercantile imperatives – including the thing that should never have been celebrated: the exporting and monetizing of human traffic. Banham (and McLuhan) realized that that older modality could no longer be used to read the human mythos (in Banham's world-view, exemplified by Los Angeles) and should never be again. For McLuhan, the answer lay within the means of expression – it would no longer be possible to relay the message *once the medium was recognized* – that effectively, meaning and medium are contemporaneous, interwoven and self-correlating. What was wonderful about this level of interpretation was that it was just that: a linguistically based elucidation of a non-linguistic experience that itself was to constitute the experience of the very early traces of the digital.

The subject of Banham's attention, Los Angeles, was and is axiomatic of later sprung-up cities where their functionality of increased speeds of experience dominate their foot-paced living experience. To read this new kind of city, Banham suggested a simple change in the way we look: we must regard the environment within which we exist from a moving viewpoint, so that osmotic modes of alignment of self to the destiny of a society, may not occur from a static position. Eventually, static osmosis would wither as we placed our attention onto moving forms – or velocitized forms of viewing. Banham realized that Los Angeles did not have the dominant vertical monumental forms that Madrid or Paris might have, architecture that rendered a person small in its presence, but it did have a horizontality that no prior city could match – but only if you moved fast enough through that environment could you then release the encoded power and impact of that landscape's horizontal meaning.

As you move and try to watch the moving landscape, your eyes saccade; that is, instead of sweeping across vistas, they stagger staccato-like in short bursts trying to fix the moving image into a series of instances. The word 'saccade' comes from the French and translates into English as 'a violent pull'. Your consciousness is pulled and then filtered through a rapid movement of the eye between fixation points that you then experience as a smooth transition. Like a goldfish through water we pass through an invisible medium – yet it is our sensory functions that make this invisibility apparently coherent, built as it is for transportation at a maximum of 23.5 miles per hour – our flat-out running speed (an interesting figure in relation to 24 frames per second). If the medium is the message, then we are both medium and message.

This way of conceptualizing the world is now concerned with our eye/brain/mind/gaze and so runs in parallel with new research in the production, display and consumption of moving images. These expanding parameters (HFR – higher frame rates; HR – higher resolution; and HDR – higher dynamic range) unencumber the production and display of images from the two-dimensional limitations of photochemical film, and propel image creation into three- and four-dimensional forms which now enable manipulation of space as well as time. In 1936, Walter Benjamin said: 'The camera introduces us to unconscious optics as does psychoanalysis to unconscious impulses' (Benjamin 1936).

If this was thought to be true in the analogue age, in the digital age we might ask: what do new forms of capture and display reveal about our unconscious state?

As architectural practices develop to encompass new forms of display – for instance, where the building itself is a display so that its 'image-skin' may regularly change – then the city, which is itself a recent development within the human narrative, may in fact have to assume faster-than-foot-pace conceptualization. Moore's Law, applied to the developing process of electronic or digital image capture, creates as profound a change as Lumière's invention of slow motion to those that first saw it. Increased capture-quality and capture-speed; handling and display of data; and the dissipation of bottlenecks in data flow, open new possibilities for how and why images are captured and displayed.

However, there is an underlying conviction in this research that something will be revealed about how these accelerations perturbate or excite the human perceptual system. Traditional forms of exhibition are already accommodating these developments with 4K projector systems; delivery of higher resolution television via terrestrial digital; and higher resolution narrowcasting via the Internet. Business as usual for the human project: but what might this mean for architectural image-making where often it is in movement around a fixed 'display'?

Moving image capture and display

We've now entered an era of electronic capture in preference to photo-chemical capture, and one of the paradoxes of digital cinematography is that in some senses it has greater similarities to photo-chemical film than digital video or televisual forms.

The historically determined optical pathway of digital cinematographic cameras is 35mm or above, its images are reconstructed from a progressively based, lossless data flow, with one full frame of information at a time. It holds the image in a latent state until it is rendered (or 'developed'), but unlike film, its materialisation is non-destructive of its prior material state. However unlike film, its inception as an image capture mechanism is no longer its sole intent as a medium. (Flaxton 2013: 216)

The last point is perhaps the most important: with the use of two triangulated camera's sensors we can map 3D space in real time. With the use of four or more imaging units within a white-light interferometer, we can map micro-space at unlimited definitions and so procure its details as data into computer space for deeper manipulation. Mapping space will allow us to create defined regions of our reality with greater and greater resolutions. If we can accurately map 3D space, then we can create events with gesticulation or voice and therefore trigger events, and other locations could then be mapped so that events could be created *there*.

Current research

In collaboration with the University of Bristol and BBC Research and Development, the author's current research strategy now centres on *our* physiological specificity. In

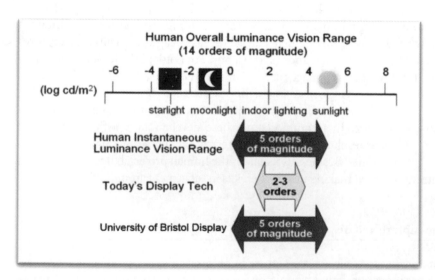

Figure 1. Human Overall Luminance Range (2013) (Flaxton).

November 2012 this research group completed the first HDR/HFR test shoot (50 frames per second and 200 fps), the results of which were published in a paper at the *International Broadcasting Convention* in September 2013.

If you look at this diagram (Figure 1) it shows that the human eye/brain pathway uses 5 of a 14 order of magnitude scale, sliding this instantaneous facility up and down the scale to deal with starlight at one end and desert sun at the other. Most contemporary displays currently show between 2–3 orders of this scale, but we now have a prototype which displays 5 orders and coincident with this, the BBC in turn have created a 200-frame-per-second projection system.

By combining variants of frame rate, resolution and dynamic range, we should be able to effectively produce 'the perfect picture'. By calibrating these different parameters to produce a combination that best resonates with our eye/brain pathway the proposition is that if we can manipulate *all* the factors of the construction of the digital image, then conscious immersion may follow (Price et al. 2013).

Cognitive neuroscientific world-view

But at this point in time, questions of 'what next on the horizon' do the subject an injustice. Cognitive neuroscientists argue that mammals and possibly all animate creatures, have within their minds a precise internal map of their immediate environment, that each creature manoeuvres within their world by first imaginatively representing their intentions in that world as a rehearsal for action.

Emeritus Professor Merlin Donald, Queen's University, Ontario, wrote *Origins of the Modern Mind* (Donald 2006) in which he argues that being in the world is an *aspect of mind* and that human communication developed through three scaffolded phases, built one upon another: 'Because evolution is conservative, the modern mind retains all previous stages within its complex structure' (Donald 2006: 8).

Donald argues that the *mimetic*, the first stage of development, came at a time when, say, an ape sees a group of other apes in the distance and comes down from her perch in the trees to show her fellow apes what she's experienced.

> The Mimetic Domain comprises gesturing, pantomime, dance, visual analogy, and ritual, which evolved early and formed an archaic layer of culture; based mostly on action-metaphor. Mimesis allowed for the spread of tool-making technology and fire-tending, through imitation and ritual. (Donald 2006: 8)

In telling her tale, she and her watchers physically developed a sympathetic mirror-neuron system so that we primates can empathize with each other's experience. These mimetic tales were told sometimes running flat out at 23.5 miles per hour to stimulate neuron pathways to help learn new ways to hunt.

Then, as recently as 150,000 years ago, *Homo sapiens sapiens* developed larynxes suitable to accurately render and replicate sounds that became more specific than pantomime in conveying details of the world. In uttering controlled sounds (prosody), our ape changed the physical construction of her own brain and skull. This is Professor Donald's second stage: 'Mythic culture is based upon spoken language, and especially on the natural social product of language: Storytelling. Mythic Culture, retains a subsidiary mimetic dimension, manifested in ritual costume and gesture, which is then epitomized in various forms of art' (Donald 2006: 8).

The third stage, the Theoretic, began 10,000 years ago when the hunter/gatherer settled down to farm. The mythic period had become so sophisticated that descriptions of the world were taken up by specialized members of the tribe, (i.e. Shamans), who were the beginnings of the bureaucracy of a priestly class. 'It started very slowly with the emergence of sophisticated writing technologies and scientific instruments, and then, after a long gestation period, became dominant in Western Society after the enlightenment' (Donald 2006: 8).

Theoretic Culture is symbol-based, logical, bureaucratic and heavily dependent on external memory devices, such as writing, codices, mathematical notations, books – and computers. Some neuroscientists call these sites Exograms and recognize them as having a similar importance to their sites of internal memory, Engrams. They then argue that as theoretic culture developed, internal memory becomes less important as we externalize the persona of our inner-selves and remake the world in our own image. Donald continues by saying that theoretic culture and language is still a minority culture that is 'disproportionately influential because of its place in the *distributed* cognitive systems that determine such things as our collective representation of the past and our tribal and class identities' (Donald 2006: 8 [original emphasis]).

The argument continues that because we have digested the lessons of the theoretic through the Victorian cataloguing and indexing period, we can now assimilate the practice of innovation itself, as it rewires brain pathways; a process which then leads us to experience a sense of comfortableness with very high speeds of change. A hint of Gnosticism now begins to creep into the cognitive neuroscientific argument: when the fundamentally conservative tendencies of evolution, *metacognitively* speaking, can be seen as inhibiting the progress of the species, then the paradigm change comes.

Velocitization, an appropriated term for the fourth stage of change, is a means by which we reach back into the picture that mammals have created in their heads *and change it*. In this stage we are outwardly manifesting the most important Exogram of all: *Data*. In this process one thing is clear, at least in terms of the neuroscientific narrative: this grand human project to become one with reality reconnects us with our environment in a surprising way. Here, Banham's proposition of developing our response to the city at speed, via the process of the saccade, is interpreted in cognitive neuroscientific language:

This process has undoubtedly accelerated the long-standing symbiosis of the brain with the external symbolic world it has created, and put pressure on the young to assimilate more and more technologies. There is no longer any doubt that this symbiosis of brain with communications technology has a massive impact on cortical epigenesis and, with the rise of mass literacy, that this effect is present in a very large percentage of the human population. The driver of this increasingly rapid rate of change, human culture, can be regarded as a gigantic search engine that seeks out and selects the kinds of brains and minds it needs at a given historical moment. (Banham, quoted in Donald 2006: 78)

There are echoes of both Darwinist and Gnostic sentiments in the above. The Darwinist can be seen in the use of the concept of natural 'search-engine' selection, yet this is balanced by the Gnostic belief that reality can be changed through faith – that mountains can and will be moved by the interior spirit of human sentience. The corollary statement in terms of 'new digital theory' would be that with the digital, the transformation of everything into *bits* to make it manipulable, actually turns information into the medium as we apprehend that activity. Whether in the act of creation of digital artefacts, writing or receiving e-mails, watching digital displays, playing with social media, or designing buildings or environments via computers, we then become the substance of the process itself:

Whether viewed in terms of the functional architecture of the brain, or the larger cognitive capacities of the human species, the trend toward externalizing memory and restructuring the larger social-cognitive system has generated a radical change in the intellectual powers collectively at the disposal of humankind. (Donald 2006: 8)

The original proposition that all sentient creatures create a version of reality in their own mind is now changed by the externalization of our world picture so that both now become commensurate with each other.

Waves of technology

To go one stage further in considering what the future might hold with regard to this narrative and its relationship to the idea of the city as a nexus for accelerated human development, it is proposed, to the reader that the advent of a technology – whether the invention of a wheel or its extension, the locomotive, or a silicon chip, or a suspension bridge, or the idea that a hominid should stand upright – can be thought of as arising within an overall system. Also, not only is this behaviour part of being human, but that it is what any sentient creature that has transcended its form can and will do – which is, to manipulate its environment. In so doing that creature not only changes its form but

also its technological imperatives – and then a behaviour that once begun of biological imperatives, was functionally developed and then driven by external feedback, such that these will imperatively reflect back into its physical development. This is epigenetic development (that is, arising from other than gene expression). So the technology that the creature develops comes as a response to the manipulation of the environment that in turn manipulates the manipulator at higher and higher levels of adaptation.

But thinking this through further, not only does technology come in waves, but these waves – after many millennia – are so ubiquitous, consistent and resonant, that deeper and deeper wave function develops so that as with a musical composition – be it humanly orchestrated, or acknowledged as occurring (as with John Cage's '4 minutes 33 seconds'(1952)) – harmonics develop in both the production of technological waves and also in the act of paying attention to the phenomenon.

Going back to the earlier proposition that 'we shall try to invoke metaphors which create an impression of the experience of velocitization' on the radio, recently a planetary scientist spoke about flying an instrument through a water plume on Europa – the far-flung moon of Jupiter. This was, he said, to take samples of 'sufficient resolution and dynamic range'. The use of this terminology was a surprise because although familiar to the author, its use was unfamiliar. In this chapter, this terminology is used to describe the expanding parameters of the moving image as resolution, dynamic range and frame rate. However, with a planetary-scientist's usage, the idea of taking measurements of 'sufficient resolution and dynamic range' is itself a game changer. This usage means that the metaphoric language of the digital has seeped through into scientific parlance.

The issue being raised here is whether or not words – the semantic paradigm – can usefully relay what we're now experiencing as happening on a sensory and velocitized level. Each innovative phase, be it an optical reality invoked in the Middle Ages where glass technology developed and advanced our view of the world and the stars, or a mechanistic reality relating to Newton's clockwork universe in the Principia onwards, until McLuhan's understanding in the late analogue age, that somehow the medium itself is the thing that is being said, that somehow, as Shakespeare knew four hundred years before, we are the stuff as dreams are made of – we too are the message, and the massage, and the triage in our current digital age, in an age which recognizes the epigenetic redirection of neural pathways to shape both our reality and our physiology.

Resolution and dynamic range

It is condended here that our inventiveness and material innovations, though as constant as the need to survive, also come in peaks and troughs – our technological imperative reveals itself in waves of innovation. We are waves of innovation and we are particles of innovation – the wave/particle duality being invoked to bring up the possibility that we together are also involved in the behaviour we observe outside of ourselves. It would

seem that the two imperatives compete, to survive and also to innovate or dream, and so are often in conflict because the need to survive becomes the need to survive well. We can obviously survive well, and survive well enough for many so that we now *consume* innovation. Consumption of innovation is now a part of the development of the self, such that who we are is integrally related to the perceived use of technology by one's own avatar – one's representation not only to others, but to oneself.

If you follow Larry Siedentop in his construction of the development of the individual in *Inventing the Individual* (2014), the argument leads you back to a definition of the pre-city-state individual who tended the fire and paid homage to their ancestors, forward through the nature of the individual during the period of city-state allegiances, where the priestly role encompassed many families in combined loyalty to each other (the dynastic priest) – forward to the development of monasteries in near modern times, through kingdoms and wars and nation-state configurations – through to the Enlightenment and now modernist and postmodernist formulations of the western liberal self. As you come to this moment, this history says to each of us: if the rights of the individual are in contention with the rights of the whole, then that self that seems so solid, can be seen to be transient and its definition constantly changing. It also says that architecture and its agglomeration – the city – grew and changed to reflect our internal and external narratives and that naturally, as soon as a city grew larger than a person's ability to run across it flat out and collapse in exhaustion, the city itself had to be reimagined. Benjamin and Calvi, Mieville and Dyer, Borges and Asimov, have done their bit to encourage us to imagine and reimagine and imagine once again – each time shedding the skins of the prior imaginings; now we have to maintain this behaviour in a state of trust that what we imagine shall become real. Real in the same sense that Los Angeles is real.

As explained earlier, in the author's own study area of capture and display of moving images, how we capture and how we display, and how we see what that process is, are so intimately connected. The connection is such that the resonation back and forth in the lab, where we construct this new technology, affects what we do and who we are at the same time. We invent something then look in awe at each other, at the fact that as we are inventing the form we start to see something we'd never seen before. We are either *learning* to see something we'd not seen before or we are changing both the technology and ourselves at the same time, so that we are actually seeing differently.

As this is happening our conviction is growing that we are about to experience a step-change in the peak of technological inventiveness. In every research lab the author has been into for the last twenty years, evidences activity that suggests that the human project is furiously working on the area of synthesizing the behaviour of the human senses to materialize those senses, such that we can then manipulate our own reality in a variety of ways – and of course those senses combined with the common sense, the mind; all of those contribute to the idea of a sensorium experiencing a 'reality'.

The sensorium

The word velocitization is used to convey that the developing rapidity of technological change requires a higher-level epigenetically encoded *agility* than the frontal lobe analysis can provide to cope with the increased waves of technological change.

You're on the freeway and comfortable with 85 miles per hour. You come to the off-ramp and you need to change down to 30 miles per hour. That takes adjustment – just as much as if you enter the off-ramp from the urban road system and get into a high-speed flow of traffic. This behaviour is frontal lobe based which relies on input of data supplied by the senses in the normal neuron flow of information developed over 2 million years to get from branch swinging, through running at 23 miles per hour, then that system having to adapt to the speed of a modern automobile. Test pilots have learned to utilize 'calmness' at high velocities to increase their adaptation to rapidity. We, the public, now have to learn the same thing.

You're coming up to a bend, some people brake. The advanced driver increases speed and therefore grip to accelerate through the curve. Same with the pilot – hurtle down vertically, hold your nerve, then accelerate to the ground to curve out and rise. With the driver at small multiples of running speed, braking enables frontal lobes *to feel* in control. With the increasing speeds of the data freeway, we need agile and adaptive methods to first engage with the on-ramp before sensing the rapidity of response required to engage – and then repeated behaviour will epigenetically modify your physicality to give you a post-frontal lobe comprehension of the world. No need to engage with 'try-this-and-if-it-fails-repeat-with-minor-changes' behaviour.

So what you might muse upon now – within the Theoretic Age, with a theoretic mind – is that we are within the beginnings of a new 'Prosody'. It's a step-change on from the linguistic which still uses the linguistic base we are familiar with in much the same way that prosody used the mimetic base and the mythic overlay to sing-song it's way to staccato word units. Now we may utilize in that same scaffolded way the sing-song behaviours of velocitization where we transcend the linguistic-oriented frontal lobes of the 'theoretic' – humming to each other our prosodic agreement to begin to formulate a 'language' that can articulate and convey the new staccato comprehension required by post-velocitization.

Conclusion

Merlin Donald has created the groundwork for the proposition of velocitized ideas within the theoretic domain, that is, the *reality* of what Donald described and its representation – and these words in text and in how life is lived within the velocitized period – will be two different things.

The city is both a set of Exograms and a cognitive distributive nexus, developed within the theoretic period, and so much of its arrival and design has been evolved through

a theoretic understanding detailed through text and drawing and finally replicated in brick, mortar, steel and glass. The hominid that ran flat-out was probably as immersed in the attentive detail of the physicality of running as we are at velocitized speeds through traffic – and for that matter data traffic – and that physical effort has now migrated to the seated form, with minimum physicality but just as much attentive energy, to the velocitized driver. When the passive self-driving car arrives, then things will once more change – we are after all within a scaffolded evolution.

Banham's reading of Los Angeles was of course theoretic, but importantly he and especially McLuhan were progenitors of a velocitized reading of the environment, where accelerating ideas within Euclidian space activate an ability to read the world as if it itself were formulated from data – because if we are to believe today's neuroscientists we are at the end of the human project to export memory into Exograms as we and the world are becoming one. But being at the end of something may mean we are at the beginning of another.

Recently, simple material forms like algae and lichen have been harnessed to produce electricity – and importantly *computation*. So it is a small stretch of the imagination to see the world and its biological materials as giving us energy and Exogramatic functionality to do what we do now in a destructive manner, sometime later in a self-sustaining and non-destructive behaviour. The information economy is a wrong-headed description of how data is flowing – data in itself strains to be free. It is only late-capitalist behaviour that resists not only the complete automation of work to free *Homo sapiens* for much more 'valuable' behaviour, but also its own eventual and complete decline. The system of money is frontal lobe based. The recent invention of virtual money is simply a stepping stone over into a world without an 'economy', which is of course where we began. It was a useful tool but not really relevant anymore as it promotes distortions such as extreme poverty and the idea of the criminal that is super rich – but that somehow that is OK. Clearly we will not tolerate this prior narrative to persist when we have such an attractive outcome in front of us. It is only a step further to follow McLuhan into seeing the world as the medium, the data encoder itself as we interweave with data, the material and consciousness, in a self-fulfilling interaction.

It was argued earlier that, for McLuhan, it would no longer be possible to relay that message *once the medium was recognized* – that effectively, meaning and medium are contemporaneous and interwoven. But the *digital* goes beyond theoretic insights and any attempt at remediation of it via theoretical constructs which are inherently resisted because *language* does not account for the *affects* of velocitization. What we can add in words, at the beginning of a new paradigm, with a form of *pre-mediation*, is that the idea of measurement is a hangover from a previous time – it is a conceptual and also a theoretical mistake to believe that we need to catalogue and index existence to *know* it. We need to get smarter and accept that conceptualizing reality via representations of reality are not reality itself – and in fact we do have a function that enables us to entrain with what is around us – we simply need to become acclimatized to the subtle velocitized

sense that we already are in possession of. To convert that into a metaphor that should work with McLuhan in mind, we need to be able to sense and understand the water we are swimming in and this can only be done by understanding what we actually are – and we need to start work on understanding our current ontology, now.

References

Banham, R. (1971), *Los Angeles: The Architecture Of Four Ecologies*, Los Angeles: Harper and Row.

Benjamin, W. (1936), *Das Kunstwerk im Zeitalter seiner technischen Reproduzierbarkeit/ The Work of Art in the Age of Mechanical Reproduction*, in *Video Culture: A Critical Investigation* (John Hanhardt, ed.), Rochester, 1986, 43 [Reprinted from *Illuminations*, translated by Harry Zohn, New York, 1969].

Donald, M. (2006), 'Art and cognitive evolution', in M. Turner (ed.), *The Artful Mind: Cognitive Science and the Riddle of the Human Mind*, Oxford: Oxford University Press, pp. 3–20.

———— (2010), 'The exographic revolution: Neuropsychological sequelae', in L. Malafouris and C. Renfrew (eds), *The Cognitive Life of Things: Recasting the Boundaries of the Mind*, Cambridge, UK: McDonald Institute Monographs, pp. 71–80.

Flaxton, T. (2013), 'Knowledge exchange as a practice', *Journal of Media Practice*, 14: 3, p. 216.

Price, Marc, Bull, David, Flaxton, Terry, Hinde, Stephen, Salmon, Richard, Sheikh, Alia, Thomas, Graham and Zhang, Aaron (2013), 'Production of high dynamic range video', *International Broadcasting Conference*, (2013) Amsterdam, http://www.visualfields.co.uk/HdrIBC2013v7.pdf. Accessed 1 July 2015.

Siedentop, L. (2014), *Inventing the Individual: The Origins of Western Liberalism*, Cambridge, MA: Harvard University Press.

Chapter 5

Mapping the city as remembered and the city as imaged
(Banja Luka)

Jelena Stankovic

Introduction

> In the same moment that we see objects we represent to ourselves the manner in which others would look at them. If we go outside the self, this is not to become fused with objects but rather to look at them from the point of view of others. [...] There are hence no perceptions without recollections. [...], there are no recollections [...], which can be preserved only within individual memory. [...], a recollection reproduces a collective perception, it can itself only be collective. (Halbwachs 1992: 168–69)

The mediation of our personal memories and other people's representations (received knowledge) affects thinking about how we remember and imagine the city through maps. This thinking is represented through the idea of the city as remembered and the city as imaged. In order to better understand the characteristics of these cities, Geddes' ideas of 'Out-world' and 'In-world' illustrated in *The World Without and the World Within: Sunday Talks with My Children* (2010 [1905]), are used as examples. For Geddes, 'Out-world' means a place '[where] we go from home and garden through village and town, country and city; over Border and beyond Channel; and when we have travelled Europe, Asia, and Africa, America and Australia' (Geddes 2010 [1905]: 5–12). This first-hand experience creates the city as remembered which is developed naturally through the process of adopting ideas from the people who we love (e.g. family and friends), or the people whose work is a part of our personality (e.g. favourite authors). Unlike 'Out-world', 'In-world' cannot be seen by 'bodily eyes [but] is more familiar, more real than the other; for all we know, or can ever know of the Out-world, or of each other, is in our minds' (Geddes 2010 [1905]: 5–12). The lack of first-hand experience creates the city as imaged that involves 'covering' a gap in our knowledge by using other people's representations.

Both cities are mediated through a balance of received knowledge and other people's memories, thoughts and ideas. Even our personal memory of the city is collective according to Halbwachs. This collective aspect of the city is usually not included in the maps that are more conventional – it remains invisible. The question which arises is how to make it apparent. Searching for a model for recording these cities into one single map involves a consideration of the collective aspects of memory already illustrated through texts, conversations, paintings, photographs and drawings. This model will be applied to Banja Luka City, Bosnia and Herzegovina.

City as imaged (other people's memory images)

> We live in a city, now most of us have lived in others, but all we ever know of these cities is the fragmented, the partial: as such 'our city' is the familiar and unfamiliar. [...] The city as image is never the city as imaged – every city presents to 'the world' what 'it' (via those who 'speak' for it) think 'the world' wants to see'. (Fry 2015: xvii)

Fry's words allow us to begin the consideration of the city as imaged. It is always mediated by other people's representations that are necessary for 'cover[ing] the gaps in our remembrances' – knowledge. There are always some pieces of information which are missing in the process of understanding of the city's past. We have not experienced the whole city first-hand and must therefore obtain information about it from other people. In his book *The Collective Memory*, Maurice Halbwachs (1980) explains it in this way: our memory of the city is only borrowed and not our own. We imagine it both through 'living history' – personal memories of others – and 'learned history' – obtained from different historical documents where other people's memories are already recorded. This means that the city 'endures [...] in region, province, political party, occupation, class, even certain families or persons who experienced [it] firsthand' but their stories and memories about the city significantly influence our imagination (Halbwachs 1980: 51). The lack of first-hand experience necessitates a borrowing of information about the city, for instance, through reading historical books and speaking with people who belong to that period. As Halbwachs said, '[we] can imagine [the city through others] but [we] cannot remember [it]' (Halbwachs 1980: 52). To explain this, Halbwachs pictured France during the twenty-year period that was followed by the Franco-Prussian War of 1870–71, through his parents, their friends and other adults that he met at that time. All of them assimilated the features of that period to make them a part of their personality. By searching 'peculiarities of the national milieu of that time' through the character of the people who lived through that time and the knowledge obtained from written historical documents, he recreated the image of France that was unfamiliar to him as a child. The fact is that in most cases we adapt other people's memories as our own due to their interchangeable use. It should be remembered that 'nothing is experienced by itself [or only by using our own memory], but always in relation to its surroundings, the sequence of events leading to it, [other people's memories] of past experience' (Lynch 1960: 1). We actually rely on other people's representations when we do not directly witness the city's events. Halbwachs explains it as such:

> During my life, my national society has been theatre for a number of events that I say I 'remember', events that I know about only from newspapers or the testimony of those directly involved. These events occupy a place in the memory of the nation, but I myself did not witness them. (Halbwachs 1980: 51)

The reason for this lies in the fact that we cannot act alone as we have to place ourselves into a certain group composed of others in order to fill the gaps in our knowledge. For instance, even though Halbwachs was physically alone during his visit to London, Charles Dickens was actually his companion for the walk. Some places in London such as 'St Paul's, Mansion House, the Strand, or the Inns of Court' reminded him of Dickens's novels which he had 'read in childhood' (Halbwachs 1980: 23). In this case, Halbwachs placed himself into the group of Dickens's characters in order to fill the gaps in his knowledge associated with these places. From his need to find the information about these places he visited in London, we can see that a boundary line between others, for instance writers, and us as readers might be blurred. This can be seen in Calvino's book, *If on a Winter's Night a Traveller* (1992). The main character in this book 'called himself "I" and this is the only thing [we – readers] know about [him], but this alone is reason enough to invest a part of [ourselves] in the stranger' (Calvino 1992: 15). Other people's memories of the city become ours in a mutually reinforcing sense, which can be defined by the term collective memory as one of three types of memory described by Halbwachs.

This can be seen in another example – Freud's experience on the Acropolis, which presents the overall knowledge gained from others until the moment he experienced it personally. As Freud said, 'I stood on the Acropolis and cast my eyes around upon the landscape, a surprising thought suddenly entered my mind: "So all this really does exist, just as we learn at school"' (Freud 1991: 449). In this situation, Freud placed himself in the group of others whose memories of the Acropolis were already recorded, for instance, in the textbooks he used in school. In that way, he filled the gaps in his knowledge regarding the Acropolis. By using other people's memories and representations, the Acropolis as imaged by Freud repressed his need for visiting the real one. The knowledge about the Acropolis which he obtained from others is different from the one he experienced first-hand. This was confirmed by Freud who observed that, 'seeing something with one's own eyes is after all quite different things from hearing or reading about it' (Freud 1991: 444–59).

In his book, *Ways of Seeing* (1972), Berger explains this phenomenon, noticing that 'Each evening we see the sun set. We know that the earth is turning away from it. Yet the knowledge, the explanation [imagination], never quite fits the sight' (Berger 1972: 7). This relationship between what we imagine and what we know can be seen in the painting, *The Key of Dreams* (1930*)* by René Magritte (1898–1967). By observing this painting, we understand what Berger was thinking about: 'the way we see things is affected by what we know or what we believe' (Berger 1972: 8). One imagines what the Other already knows and remembers.

Through the conversation between Polo and Khan, Calvino's *Invisible Cities* (1974) illustrates how one cannot help but to imagine the city with the help of another person who has experienced it first-hand. Polo's city corresponds to the city as imaged by Kublai Khan. Due to the lack of first-hand experience, Khan asked Polo to confirm if the city that he imagined had the same appearance as the one in reality. Polo answered that 'this

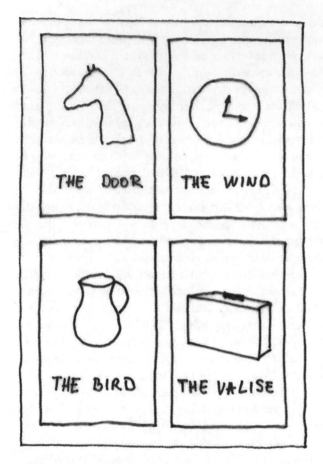

Figure 1. Representation of 'The Key of Dreams by Magritte' 1898-1967.
Drawing by Jelena Stankovic.

is precisely the city I was telling you about when you interrupted me'. Khan responded: 'You know it? Where is it? What is its name?' (Calvino 1974: 43). The need for naming this city is Khan's way to understand it, to cover the gap in his knowledge. This mediation of cognitions between Polo and Khan can be seen in the painting of *School of Guercino, Della Scoltura Si, Della Pittura No* (17[th]c: School of Guercino) , where 'a blind man [...] recognises with his right hand the bust of a woman who might well be blind' (Derrida 1993: 42). This blind man is symbolically presented as the one who borrows other people's memories and representations:

Figure 2. Representation of 'School of Guercino, Della Scoltura Si, Della Pittura No.
Drawing by Jelena Stankovic.

Our grandparents leave their stamp on our parents. […] Our parents marched in front of us and guided us into the future. The moment comes when they stop and we pass them by. Then we must turn back to see them, and now they seem in the grid of the past and woven into the shadows of bygone times. (Halbwachs 1980: 67)

The mediation of ideas, memories and thoughts among people is an unavoidable but necessary process for leading a normal life.

We cannot go beyond the information we have heard, the books we have read, the paintings we have viewed, the sculptures we have touched, or the maps we have explored as our imagination depends on others. In this manner, Calvino explains that:

'Reading' [engages] a thing that is there, a thing made of writing, a solid, a material object, which cannot be changed, and through this thing we measure ourselves against something else that is not present, something else that belongs to the immaterial, invisible world, because it can only be thought, imagined. (Calvino 1992: 72)

The city as imaged is actually a product of information that we used in our imagination. So it undergoes various changes as every person carries the burden of different remembrances which increase with the publication of new books, new paintings, etc. The city as imaged actually develops together with the sum total of all of our cognitions about the city's past. It is never the same and it is always different.

To understand better the theoretical writings on the city as imaged, Banja Luka City is used as a practical example. In 1969, it reached an important milestone caused by a devastating earthquake. Its citizens, together with numerous researchers and travellers who experienced it, remembered Banja Luka City before and after the earthquake. Their recollections give form to Said's idea of an 'imaginative geography' based on *Orientalism*, where the representation of the Orient was changed over time in the mind's geography of its citizens and external observers due to certain events in history. The changing representations of Banja Luka City might be seen in the fact that it was one of the cities of the former Socialist Federal Republic of Yugoslavia when the earthquake struck in 1969. Since 1995, it has become one of two administrative, political and culture centres in Bosnia and Herzegovina – the Republic of Srpska and the second-largest city in present-day Bosnia and Herzegovina. The rotation of political and social regimes caused changes in the name of the country, language, anthem, currency and even street names. Every change brought something novel but caused some element of forgetting of something that existed before. If we do not recreate the image of what was forgotten with the help of received knowledge and other people's memory and imagination, it will be erased from our memory as time goes by. Due to the frequent and often violent changes in all walks of life, Banja Luka has the need to create the city as imaged since the old Banja Luka no longer exists. This prevents us from forgetting Banja Luka entirely as the modern age encroaches.

In this chapter, the Banja Luka that no longer exists is explained through the iconic example of its longest residential and commercial building – a symbol and landmark of the city called the Titanic by its citizens. Historical documents about the Titanic show that the year of its building is 1953–54, while 1970 signifies the year when this building was completely destroyed and in fact flattened after its construction system was seriously damaged during the devastating earthquake in Banja Luka City in 1969. Since we are unable to explore the Titanic through personal experience, information about this building can only be obtained through texts, photographs, drawings and maps that are stored in the institutions of the Republic of Srpska and Bosnia and Herzegovina. Even today, most citizens of Banja Luka City cannot confirm the precise position of this

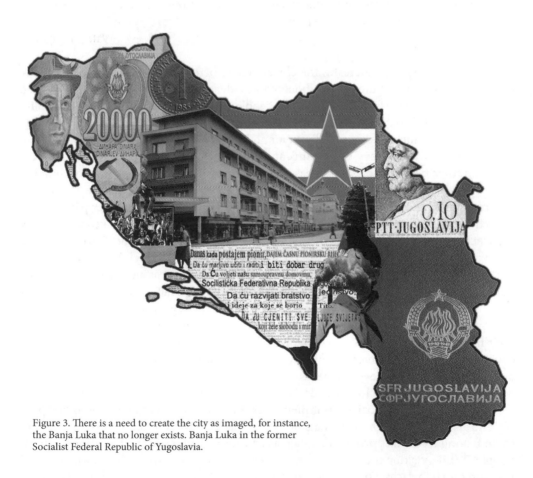

Figure 3. There is a need to create the city as imaged, for instance, the Banja Luka that no longer exists. Banja Luka in the former Socialist Federal Republic of Yugoslavia.

building with certainty because it has been erased from their memory (forgotten) in some way, alongside its destruction. However, through the process of gaining knowledge about the Titanic, surprising and unexpected information was discovered – the building is not even mapped on any preserved map found while exploring European archives and libraries. This confirms the presence of the phenomenon of forgetting in this territory. In order to reconstruct the Banja Luka that was forgotten, we need to place ourselves with the citizens of the former Yugoslavia who took the photographs of the Titanic and who are the product of that time.

City as remembered (our memories [our remembrances] = our photographs)

Everything remembered and thought, everything conscious, becomes the pedestal, the frame, the base, the lock of [our] property.

Walter Benjamin

This first-hand experience creates the city as remembered which is developed naturally through the adoption of memories, thoughts and ideas from the people who we love (e.g. a group of family, close friends, etc.), or the people whose work is a part of our personality (e.g. a group of favourite authors, artists, architects, philosophers, etc.). In Halbwachs's terms, our 'individual' memory 'relies upon, relocates itself within, momentarily merges with, the collective memory' as we think and remember as a member of the group (1980: 50–51). Other people's views and ideas exert a strong influence on our ways of thinking even though we are unconscious of their presence. As Lynch said, 'we are not simply observers of [the city], but are ourselves a part of it, on the stage with other participants' (Lynch 1960: 2). Our mind is full of thoughts and images of other people so we are only their 'echo'. We actually recall the city 'by situating [ourselves] within the viewpoint of one or several social groups and one or several currents of collective thought' (Halbwachs 1980: 33). By bringing different people into our mind, their views, ideas and memories become ours, forming a mutual or collective memory according to Halbwachs. This implies that our memory stays collective because of the fact that memory can only be achieved by continually re-entering into different social groups in order to re-establish contacts with their members. We have this remembrance of the city only if it is common to others who constantly, but at the same time silently, influence our thinking. As Halbwachs pointed out, 'in reality, we are never alone' as 'we always carry with us and in us a number of distinct persons', such as close friends, family, favourite authors, etc. (1992: 23).

To understand the mediation of memories, thoughts and ideas between other people and us, Halbwachs interprets a story about his visit to London with friends. All of them belong to distinct professions such as architects, historians, painters and business people. While visiting the city together, all of these people impose their own vision of London on Halbwachs. For instance, an architect explained to him the type and compo-

sition of buildings. An historian emphasized the historic significance of certain streets and buildings. A painter drew his attention to the

> colours in the parks, the lines of the palaces and churches, and the play of light and shadow on the walls and facades of Westminster and on the Thames [whilst] a businessperson [took] him into the public thoroughfares, to the shops, bookstores, and department stores. (Halbwachs 1980: 23)

Their varied descriptions and illustrations of London become preserved in Halbwachs's memory and help to lead him through the city even if he was not accompanied by them. Despite the fact that other people's views and ideas influence our memory, they do not need to be physically present while remembering. We are alone only in appearance, but our thoughts and actions are intermingled with other people. However, we are never aware of the fact that we remember the city through others because ideas derived from different social groups work in our memory as 'a screen over individual remembrance', according to Halbwachs. Our individual memory is mediated by other people's representations and presents a social construct.

Benjamin's essay, 'Unpacking my library', as featured in his book *Illuminations* (1992), shows that we can also recall the city previously experienced through our possessions. In his essay, he considers the relationship between 'a book collector' and 'his possession' as a process of collecting memories of different cities rather than a simple collection (Benjamin 1992 61). The city as remembered by Benjamin is one which is closely linked to his possessions – books whose details such as 'dates, place names, formats, previous owners, bindings, and the like' represent his memory images (Benjamin 1992: 65). As Benjamin wrote:

> Memories of the cities in which I found so many things: Riga, Naples, Munich, Danzig, Moscow, Florence, Basel, Paris; memories of Rosenthal's sumptuous rooms in Munich, of the Danzig Stockturm where the late Hans Rhaue was domiciled, of Süssengut's musty book cellar in North Berlin; memories of the rooms where these books have been housed, of my student's den in Munich, of my room in Bern, of the solitude of Iseltwald on the Lake of Brienz, and finally of my boyhood room, the former location of only four or five of several thousand volumes that are piled up around me. (Benjamin 1999: 68–69)

From here we can see that the books do not 'come alive' in the collectors or readers' hands but they are the ones which allow us to 'live in' them (Benjamin 1999: 69). By collecting and reading books, we recall the city, even though we are not aware of the fact that we sometimes arrogate writers' ideas and memories as if they are our own.

'The presence of others [in our thoughts] who see what we see and hear what we hear' assures us of the world and ourselves, but we are unconscious of their presence since we always seem to act alone in reality (Arendt 1998: 50). In other words, the collective aspect

of our memory is unconscious. This can be seen in Escher's illustration of *Relativity* (1953) where 'men are walking crisscross together on the floor and on the stairs; [...] some of them, though belonging to different worlds, come very close together but cannot be aware of each other's existence' (Escher 1983: 38). This confirms the mediation of ideas, thoughts and memories between us and other people – our 'individual' memory always remains collective. The city as remembered is the city which we remember through the viewpoints of other people who 'always already' shape our ways of thinking, including family, close friends, favourite writers, etc.

Figure 4. Representation of 'Relativity' 1953.
Representation by Jelena Stankovic.

Theoretical writings about the city as remembered are explained by using Banja Luka City as a practical example. The same point of view is taken but the images we develop as remembrances are quite different from the borrowed ones. The reason for this is that in the place of the destroyed Titanic, there is a central city square called Krajina where most important manifestations are held with a central motive, namely a massive polygonal structure of a department store named Boska. Unlike the Titanic which was built parallel to the main street forming a street front, the square has created a completely different atmosphere by forming open space. The location of the Titanic has undergone radical changes to the extent that if one does not know that the Titanic was there, s/he cannot conclude it is there from the present-day picture of this place. As we can see, there are differences between other people's memory images, as recorded before the earthquake in 1969, which we must borrow as the building no longer exists and our own memory is too short.

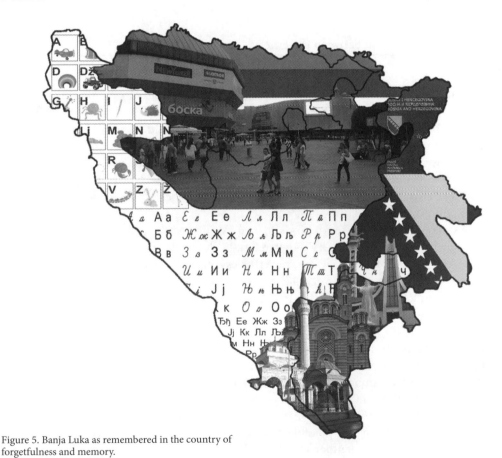

Figure 5. Banja Luka as remembered in the country of forgetfulness and memory.

The question to be posed is: what is Banja Luka as remembered? Is it the city which still exists in our memory and in which we are the direct witness of its various events? Will the status quo persist until a new change arises caused by the rotation of political and social regimes or a natural phenomenon? The cause of this phenomena lies on the fact that what no longer exists starts fading in our memory and enters into oblivion. However, do we have the right to forget it?

Banja Luka as remembered is a product of all experience and received knowledge that are integrated into our memory images. In this way, we tell the story about Banja Luka City which we already know and remember. This story is always connected with the frequent and violent rotation of political and social regimes occurring historically in this territory. For instance, Banja Luka is remembered in present-day Bosnia and Herzegovina, as the country of similarities and contradictions, forgetfulness and memory, love and hatred.

Mapping mediation between the cities

Despite the existence of these symbolic cities that exist in people's memories and imagination, they are usually not included in conventional maps. Other people cannot readily see and experience them since they are not mapped. They stay invisible. In this article, the main question has been to study how it would be possible to record them onto a single map so that they would become visible to others? Multiple representations of the city are needed to complement one another in order to tell a fuller story of Banja Luka and its uniquely volatile history. Searching for a model by which these cities will be mapped also involves considering the ways in which these cities are already recorded in texts, photographs and drawings.

As a writer, Calvino used words to map Venice as imaged and remembered. Even though his collective memory either refers to the visualization of distinctive spaces of Venice or several faces of Venice, nevertheless, each of his memories carries a woman's name. For Calvino, Venice might be the city named 'Zemruda' that depends on the mood of the beholders. Or it might be 'Irene', seen one way from a distance and another way if we come closer (Calvino 1974: 124–25). By putting himself into distinctive roles – from participant, observer, listener, reader, thinker, dreamer, to creator – Calvino textually maps Venice as remembered and Venice as imaged. In order to understand Calvino's different views of Venice, we have to bear in mind that each woman's name gives us various memory images of the city. Calvino creates a layered story about Venice permeated by the combined memory images of other people and his own. This story is not conventional – there is no clear beginning or ending as we can start reading it from any page. By exploring the possible views of Venice and seeking new ones, he encourages us to imagine and remember the city differently, which is not in accordance with the principles of a conventional story or a conventional map.

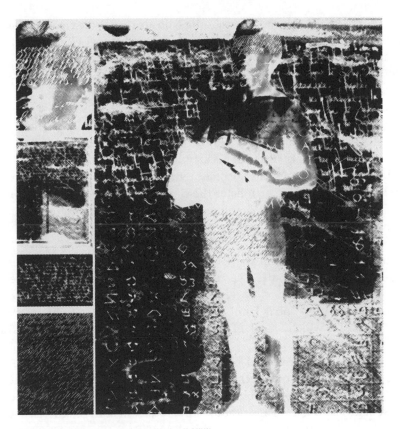

Figure 6. Representation of 'The Pedant' 1998.
Representation by Jelena Stankovic.

As a film director, Peter Greenaway uses 'pictorial knowledge' in his project *100 Allegories to Represent the World* (1998) to map the world that he imaged and remembered. This was possible with the help of other people whose different representations of the world he borrowed or whose influences affected his way of thinking in a direct or an indirect way. His different approach to mapping the world as imaged and remembered demonstrates how different is the world that he recorded from the one which we can usually see on the conventional maps. He explained this process of mapping the world as:

a list of one hundred characters whose presence in recognisable form is essential to make the dreams of theatre, painting, opera, cinema, literature and television visible. This list would certainly include the rich man and poor man, beggarman and thief, king and queen, detective and policeman, clown, idiot. (Greenaway 1998: 7)

Greenaway draws on the citizens of Strasbourg who are represented as 'basic lay figures' in this process of mapping. Their clothing through the mediation of knowledge, memories, thoughts and ideas among other people and himself can be one of the modes of mapping the collective aspects of the world. The aim is to represent to us the world that usually remains invisible on the conventional maps.

Aldo Rossi's drawings in the *Fragments* series from the late 1980s show how he 'records the real city as fragments of architecture in alien urban landscapes drawn from [his] memory' (Adjmi and Bertolotto 1993: 39). Therefore, the 'real' city is imaged through 'the repetition of elementary forms of his architecture' whilst the background of this real city – its landscape – presents 'the constant renewal of the language of the past' (Adjmi and Bertolotto 1993: 39). Rossi conflates the city as imaged and the city as remembered by depicting multiple viewpoints simultaneously through drawings. For instance, one of Rossi's views is explained in this way:

> I used to linger for hours in the large kitchen at S., on Lake Como, drawing the coffeepots, the pans, the bottles. I particularly loved the strange shapes of the coffeepots enamelled blue, green, red: they were miniatures of the fantastic architecture that I would encounter later. Today I still love to draw these large coffeepots, which I liken to brick walls, and which I think of as structures that can be entered. (Rossi 1981: 2)

For Rossi, the city as remembered is the one which is created through the process of recalling his memory images, which have evolved naturally and through the influence of others. The city as imaged refers to the process of borrowing other people's ideas and representations to get an inspiration for the architecture of the city. Besides his

Figure 7. Representation of 'Aldo Rossi's 'Untitled' 1989.
Representation by Jelena Stankovic.

Figure 8. The montage of memory creates a kind of ideal city – a Banja Luka that has continuity in its history.

own memories, visual education, reading and possessions from an early youth are the memories that he borrowed for imagining the architecture of the city. The two cities cannot work without each other due to their need for constant replenishment. The reason for that is that Rossi interchangeably uses his memory and imagination in producing the architecture of the city. As he explains:

> I seem to see all the things I have observed arranged like tools in a neat row: they are aligned as in a botanic chart, or a catalogue, or a dictionary. But this catalogue, laying somewhere between imagination and memory, is not neutral: it always reappears in several objects and constitutes their deformation and, in some way, their evolution. (Rossi 1981: 23)

These examples articulate two different ways of thinking about the process by which the collective memory reconstructs a city: there is the city that no longer exists, i.e. Banja Luka before the earthquake; and there is the city that has never existed, i.e. the ideal Banja Luka City. In order to understand the Banja Luka that we remember, it is necessary to explore the imaged description of the city that no longer exists and is a result of a discontinuity in the historical development of the city. The process of forgetting over time led to the loss, destruction and displacement of the collective memory of the city. Thus, the Banja Luka that no longer exists was actually produced as a need to understand a city with such a volatile history. We create an ideal city instead, a version of Banja Luka City that can have continuity throughout its history. This is only possible if we create a montage of our own memories and the memories of others. Our ideal Banja Luka has never existed but it might be the city that we hope for.

Conclusion

Geddes's example of two travellers – one who 'sails round the world, or climbs higher and higher upon its mountains' peaks, ventures farther into the icy North, deeper into the tropical forest', whilst the other 'is in his chairs and in his dreams', metaphorically describes the citizens of the city as remembered and the city as imaged (Geddes 2010: 3–4). One personally explores the city through all the other people who influence their way of thinking while the other borrows what another knows and remembers. The mediation of ideas, thoughts and memories between these travellers is an inevitable process. In this chapter, this is represented through the work of Calvino, Berger, Freud, Fray, Guercino, Magritte, Said, Benjamin, Greenaway, Rossi, Geddes and principally Maurice Halbwachs with his delineation of memory typologies. Halbwachs revises our common perception that memory may be 'considered as a properly individual faculty' (1980: 54). For Halbwachs, even individual memory is mediated as a social construct. In Halwachs's terms, even the Banja Luka City that we remember and imagine is 'always

already' mediated by received knowledge and other people's memories, thoughts and ideas. Besides the fact that the city as imaged and the city as remembered are collective and that their collective aspects are not recorded in the conventional maps, they are produced as a need to understand the cities with volatile histories. All sorts of changes present in the territory of Banja Luka City led to the appearance of the phenomenon of forgetting. This means that we remember only the Banja Luka that still exists in our memories and forget the one which no longer exists. Banja Luka, as a city composed of a multiplicity of political and social regimes, requires maps that are both remembered and forgotten, in order to create a truer ideal map. This is a new model for understanding and representing the city with a changeable history to the architects that create its physical structures.

References

Adjmi, M. and Bertolotto, G. (1993), *Aldo Rossi: Drawings and Paintings*, New York: Princeton Architectural Press.

Arendt, H. (1998), *The Human Condition*, Chicago and London: University of Chicago Press.

Benjamin, W. (1992), *Illuminations* (trans. H. Zorn), London: Pimlico.

Berger, J. (1972), *Ways of Seeing*, London: British Broadcasting Corporation and Penguin Books.

Calvino, I. (1974), *Invisible Cities* (trans. W. Weaver), London: Secker & Warburg.

—— —— (1992), *If on a Winter's Night a Traveller* (trans. W. Weaver), London: Minerva.

Derrida, J. (1993), *Memoirs of the Blind: The Self-Portrait and Other Ruins* (trans. P. A. Brault and M. Naas), Chicago: University of Chicago Press.

Escher, M. C. (1983), *29 Master Prints*, New York: Harry N. Abrams.

Freud, S. (1991), 'A disturbance of memory on the Acropolis', in J. Strachey and A. Richards (eds), *On Metapsychology: The Theory of Psychoanalysis: 'Beyond the Pleasure Principle', 'The Ego and the Id' and Other Works*, London: Penguin Books, pp. 449–59.

Fry, T. (2015), *City Future in the Age of a Changing Climate*, New York: Routledge.

Geddes, P. (2010), *The World Without and the World Within: Sunday Talks with My Children (1905)*, Whitefish MT: Kessinger Legasy Reprints.

Greenaway, P. (1998), *100 Allegories to Represent the World*, London: Merrell Holberton.

Halbwachs, M. (1980), *The Collective Memory* (trans. F. J. Ditter, Jr. and V. Y. Ditter), New York: Harper & Row Publishers.

—— —— (1992), *On Collective Memory* (trans. and ed. L. A. Coser), Chicago: University of Chicago Press.

Lynch, K. (1960), *Image of the City*, Cambridge, MA and London: MIT Press.

Rossi, A. (1981), *A Scientific Autobiography* (trans. L. Venuti), Graham Foundation for Advanced Studies in the Fine Arts, Chicago, and Institute for Architecture and Urban Studies, New York: MIT Press.

—— —— (1982), *The Architecture of the City*, Graham Foundation for Advanced Studies in the Fine Arts, Chicago, and Institute for Architecture and Urban Studies, New York: MIT Press.

Said, E. (1979), *Orientalism*, New York: Vintage.

Welter, V. M. (2002), *Biopolis: Patrick Geddes and the City of Life*, Cambridge, MA and London: MIT Press.

Intersection 1

A city of grids and algorithms and soundtracks in cars and planes and glass

Joshua Singer

Driving through the hills above the city (the vast and wide collection of cities that is confused as a single one), the driver and passengers gleefully cry its name so as to make clear they are here and that here is precisely here. The name is repeated to confirm. I do not have the heart to say to them that where we are and where I reside 350 miles north of here are almost precisely the same, although different to degrees of which can be argued to various degrees to be various degrees. To them (rightfully so), the here (now there as I write as I fly away from it) is particular and they particularly believe that they are here and that the here is particular. And they are right, but they are not just here, they are not only in one particular place, but in a part of many, like a constellation. But that isn't as much fun.

The here, that is precisely here (but not really), is to my fellow passengers something seen before (if they could only remember). It has been pictured in images and built in pictures. Picturing this now, this city, the image is a name we happily cry aloud as we wind down the dark road. It is important to keep this in mind here, this picture, that constellation, the here that we build in an instant (Friedlander 2008).

A constellation is before us, below us. As we gaze from the ridge, the city is only visible as a twinkling grid across the earth's surface. This is of little help, really.

'Ideas are to objects as constellations are to stars'. (Benjamin 2002: 34)

An idea so they might be able to picture this place.

*

I type the name in the search field and instantly in the rectilinear pane of glass appear rows of planar figures of four straight sides and four right angles with unequal adjacent sides framing skylines, palm trees, smiling faces and sunshine. Little windows.

This ecology is the simplest of all. The most common of agents and chemistries.

I can picture the city in my mind, which is an interesting way to say I have an idea of it. So it shouldn't be such a surprise that the German word for picture is 'bild' which shares its origins with 'build'. So, I might understand this ecology (and just about anything else in my environment, including this city as we drive through it and also, later, as I look at the images of it on this screen) by assembling it or by 'picturing' it and then, as I go through my life, re-picturing it from the continual flow of the pictures and environments I pass through.

The rows of pictures of the city on my screen, for a moment, are the picture of the city in my mind. But the city I picture is a cluster of images (texts, really) that piece together dialectically and build the real [sic] cityscape. It is not a place. It is not a series of images. It is 'a dimension of reality made recognizable' (Friedlander 2008: 4).

*

The driver's phone sends its playlist to the rental car's mediocre stereo. A soundtrack to the moving picture of the city as seen through the glass in front of me and to my right side (I like this spot in the back to the side where I can sit quietly and play my little games about cities and pictures). A panorama syncopated by KC and the Sunshine Band. While I am quite sure the view of the city is *through* the glass, I am seeing the city *in* the glass. The city's dimensionality smoothed to a shiny surface just inches from my eyes. The night-time city and its infinite depth flattened and breadth brutally framed as an image in the car window is liberated in some way by the cosmic depth of KC's sonic space. It pictures the city anew. The sensorial experience is arbitrarily, but certainly perfectly, curated. Not the southern California city of sunshine, but stars.

When we're all, all alone
When you whisper sweet in my ear
When you turn, turn me on. (Casey and Finch 1975)

*

As a prelude to writing this chapter, before the conference in Burbank (just outside the diffuse spread of Los Angeles), before the ride, as a little experiment (but really just a game I like to play) I type the word 'Los Angeles' in the rectangular search field. Google Images returns a grid of familiar views. A Ferris wheel on the boardwalk, the skyline contrasted against mountains in the distance, the skyline at night, palm trees, sun, freeways. It is the same I have seen in film, television, the airline magazine in the seat pocket in front of me now.

This is not a gallery, but rather a small semiotic space. And this is where it might be helpful to bring in a little more structure to explain such a thing.

Yuri Lotman's concept of the semiosphere theorizes a semiotic continuum like the biosphere of the natural world that is contained and self-regulated. It is an ecology of semiosis. Like the biosphere, it can be seen both as a whole and as an interconnected, interdependent, systemic complex. It is a semiotic organism of nested semiotic organisms. It is an ecology of signs.

Within the semiosphere, the primary task of culture is to structurally organize around humanity the world of objects, relationships and processes with language functioning as a 'diecasting mechanism'. It thereby creates an 'intuitive sense of structuredness that transforms the "open" world of reality into a "closed" world of names, forcing people to treat as structures those phenomena whose structuredness, at best, is not apparent' (Lotman, Uspensky and Mihaychuk 1978: 213).

The semiosphere is grounded by cultural memory, the texts that persist over time, which forms the myriad conventions, codes, expectations and truths that act as restricting forces. It is a closed system and a maintenance of stasis; a balancing of the ecosystem maintaining equilibrium and status quo.

The Google image search is a semiosphere that is part of a larger one that is the entirety of the Internet that is itself a part of the entirety of culture. It doesn't show me anything new.

This space in the car is its own semiosphere (or maybe a semiome, as a biome, as in a diminutive subsystem of the semiosphere). The textually-laden urban structures that pass before our eyes, the soundtrack setting the stage, the narrative atmospherics of what it means to be driving, not walking, through this city.

*

As part of the game I repeat the search in Getty Images.

Getty Images, the mother of all stock photo agencies, has a collection of over 80 million still images and illustrations and more than 50,000 hours of stock film footage. It is an archive but ultimately it is a technological apparatus; a computational service; an archive of digitized images with every image retrievable through search.

It services creative professionals (advertising and graphic design), the media (print and online publishing) and the corporate (in-house design, marketing and communication departments). It serves a world of persuasion and desire to produce the lures of commodity.

The designers and art directors wandering through Getty's archive of imagery (as I once did, but now do only idly, wandering through its promenade only as an amusement)

depend on these image-texts to communicate clearly and effectively. And so, constrained by the context of advertising and commercial communication, these image-texts conform to social constructs that are then easily and reliably parsed and comprehended by their intended audience. Beautiful and seductive, they play with our desires but only the familiar ones. If they challenge our world it is only for a brief instance in order to steal our attention and not to challenge us so far that we can't come back to a comfortable place. These images are palatable, and sometimes good, but never truly delicious or sublime. They are dishes that neither offend nor delight.

My Getty Images search of 'Los Angeles' returns a collection that at first glance appears to serve me images with a somewhat diverse range of subjects. Upon closer inspection, it isn't so much. Like Google, there are cityscapes and sunshine, but these pictures are, for the majority, images of (but really ideas about) people. A beautiful world of young, happy and attractive people, usually engaging in some form of recreation.

These are not views of material space. This is not an illustration or a slice of the sensorium of the here and now, but symbols within textual space. Every smiling face, every palm tree and line of traffic is heavier in meaning by multitudes than the simple elements of their composition.

The symbolic is literally (from the Greek) a throwing together. A sphere of meaning unto itself. Celestial objects pulled together by a unifying force. Rich and deep with meaning they have 'preserved this ability to store up extremely long and important texts in condensed form' (Lotman and Shukman 2000: 103).

*

Walking to the Piazza Navona at 11 p.m. is easy when your biologic-temporal perspective is in California. It is an exhilarating feeling – the complex and syncopated geometries of planes and their subtle anomalies as they come into view and then enclose me. Narrow and intricately undulating cobbled streets. The sounds of groups large and small start as white noise and then build in details and mass as I approach, echoing against the walls of the narrow streets and small piazzas that punctuate the landscape. Smells of salt, fish, beer, gelato, the gentle and ineffable must of stone and dust and diesel as the air of the warm day continues to cool.

As I pass diners on the street of a trattoria I think of how I am here, in it, again, and how intense all the immediate, material, haptic, audible and visual experience is. Pictures are fine substitutes when physical absence precludes experience or when one needs a reminder of the place, or there is nothing else to have, but they are silly things when here, now.

But that's not really the case when I'm looking at the pictures when, after a time, the bodily imprint has dissipated, when my memory shrinks to only a handful of brief views and smells and when the scale, breadth and depth, and complexity is gone. Or before I had ever been here, now. Then images will do and for many they do.

The route that I take through these Euclidean valleys of stone is arbitrary and not. Elsa said this is better than following the main street, which is a sewer of cars. I decide my turns as I go opting for the most sinewy of paths, the lonelier streets. But still, this view is built by my wandering urges, by my semantic games. I am not, like the many couples out on their Friday night, heading to eat, to drink, to bed. I hear a large gaggle of American students, in an amateurishly poor attempt at self-deprecation, complain about the tourists. Authenticity is a rat hole. Yearn for it and you will never get there. If you think you have won it, you will only eventually find a greater champion.

*

The grid of images on my screen I see now, while surely less sensual an experience of the place, are no less authentic an experience of the place. They are part of the ecology of the perceptions of the place; the visual, spatial, cognitive. It is not complete, but it never is.

*

I teach young prospective designers the beauty of the grid. Rows and columns, gutters, margins and modules. An adaptable system, an invisible skeleton, a plan, a map. But its beauty is only in its ability to structure a rectilinear world or, at its best, to gracefully inhabit our world's rectilinear structure. As I tell them, this simple mathematics of human space – precisely 90 degrees – is everywhere. The table they sit at. Their laptop displays. Precisely. It is an easy world to build and easy to build a consistent world by the grace of right angles.

A city is not simple, which is a simple thing to say. It is not stuff and not form. It is a poem, which is an easy thing to say, but easy to understand if one has any faith in poetry. Even poems sit in grids in rectangles; columns of text, lines of words, neatly aligned letters, all perfectly spaced (hopefully). An impression of the here and there, now and then.

Words are formed by pixels almost as quickly as those that are now forming in my mind (informed) as I am typing in this small rectilinear landscape. Unless of course I speak or sing the poem, but even then the contrast of phonemes, the spacing of sounds in time, become another grid to a certain degree.

*

The here pictured by words and pictures is not the imagination (well actually it is) of my travel companions (and me too) in the car, but more accurately it is imaged from all the images that picture it, most of them framed, and on a sheet of glass. My companions have seen it, and read it, and heard it. When they are in it, it is surely familiar; they know they are there, in it there, in the picture; here and there.

A universe of experiences. An ecology of words. A constellation of images (Benjamin 2002). I wish I really knew where I was beyond the images I see and the words I hear and speak.

The rows of images of the city on my screen are kind of boring. A typographic hierarchical grid, from top to bottom, left to right. Starting with views from upon high, higher than our ridge that night, lower than my plane the following day, aimed right at the centre to the most incongruous feature of this city. We look towards its cluster of towers. The grid progresses in two themes: the cluster of geometric forms amidst an infinite sea of city or contrasted against the mountains and/or clouds. The city as confrontation and contrast. A cosmic irony portrayed with all the depth of an inspirational poster in a drab office.

As I scan down and across the rows, the theme shifts. New images emerge in a syncopation interspersed with Ferris wheels and boardwalks, palm tree-lined streets, letters – as tall as houses – perched on a green hill, traffic clogged highways, beaches. I have seen these before. Surely you have seen these before, at least on some sort of a screen.

*

The city is a dynamic cultural process, like an ecology which is like a biologic metabolism which changes in response to inputs, but, unlike a biologic metabolism, it is also evolving diachronically. It is a metabolism in which the past, present and future are continually adapting in response to the input of new codes and texts (Lotman and Shukman 2000). New views, new soundtracks, new stories. The conceptions of a city's history, its current state, and the conception of its potential future are in constant evolution and adaptation. What this city was, is and will be can only be seen through this frame, right now, right here.

It is an easy thing to say that there is a great contrast between the infinitely complex and detailed textual sensorium of material urban space and the semiospheres of Google and Getty image searches. It is much harder to make the case that they are the same. It seems cruel. I keep returning to the thought that ecology is cruel.

*

Walking down the stairs I bathe in the sound of my feet on the dark-grey-flecked-with-tiny-white-particles marble steps. Rosellina is ahead of me, the sound of the elevator's motor distant below me with the whir of cables in their pulleys above me heading towards Francesco and Elsa who wait above for the elevator that Rosellina and I decided was silly to take considering the number of floors needed to descend comfortably. The view of steel rods and bars formed into a spiralling path ahead of me offer affordances for the way my hand should follow. My hand guides me through the curve. The shape of the handrail allows me the opportunity to incrementally change my grip to assist my descent of the stairs. The sculpted moulding that forms parallelograms in succession along the tan painted plaster wall to my left, interrupted evenly approximately every twenty steps, is a square framed double door with horizontal sculpted brass handles (clearly meant to pull), dark and contrasting sharply against the beige walls.

Down the stairs and I am gone. Gone to a new world of the street and the layers of the hum of the cars driving by, the smell of a summer night in an old city, the pattern of light and dark across the surfaces surrounding me. There is little left of the staircase unless I choose to summon it back, and then it is just a collection of fragments, enough to picture it.

The full complexity of the moment of experience begins to degrade immediately after it happens. Little by little is lost along subsequent time, but enough is kept to maintain a plausible scenario. In many cases, there aren't enough reasons and opportunities to retrieve memories of the experience, so it deteriorates from lack of use eventually to nothing.

The image of the beach in Los Angeles on the next-to-last row on the screen. A curving 'S' of white sea-foam dividing the bright azure blue of the sea on the left and the light pure sand of the beach on the right. It is bristling with stands of people occupying the space from the edge of the foam on the left and halfway across the strip of beach from close enough to appear clearly like humans forms to far away enough to appear clearly like a faint dark blur. There are mountains in the distance on the far right with a haze of mist/clouds/smog/ (does one know for sure?) crossing the horizon starting at approximately 60 per cent from the bottom. It must be warm. I think of the beach and California and an image of a surfer on a beach in what must be the 1950s and then there's Annette Funicello, and the Beach Boys, and Annette Funicello again, and Elvis of course, and prosperity, and pleasure, and warmth, and muscle cars, and Sanford and Son. The chain of signification goes on and on and lists as long as I care to keep going (and then some) as I dream about the symbol in front of me.

*

While I progressively lose individual experiences, the symbols carry on, fixed in place. Monuments not easily moved, fixed with the dense centre of the semiotic sphere. They are persistent and ubiquitous and I am compelled to use these simple experiences to picture my life. I will see photos of Saint Paul's more than I will experience walking down that staircase at one in the morning on a cool May night.

A grid is a plan in anticipation of the chaos of the minutiae of life. A view from above, up very high, far from the grand mess of the surface of the real. In the air away from the dead end of gravity where the surface is littered with detail. I cannot see the detritus on the ground, the conversations of the inhabitants, the smell of the dinners on the tables.

Landscape architect James Corner posits that the city is to be viewed not merely as a collection of forms but rather as a dynamic and complex system of interconnected elements. A landscape of agents and actions, since 'cities and infrastructure are just as ecological as forests and rivers' (Corner 2006: 29).

And a semiotic space since

Public spaces are firstly the containers of collective memory and desire, and secondly they are the places for geographic and social imagination to extend new relationships and sets of possibility. Materiality, representation, and imagination are not separate worlds; [...] place construction owes as much to the representational and symbolic realms as to material activities. (Corner 2006: 32)

*

I remember this song, but it has not crossed my mind for decades. It draws me to another time but still I sit here in steel and glass rolling across the city's landscape. The feeling is not specific but I somehow feel different for a moment as a different me that I have not known for decades. Bathed in a chemistry from the past, my present is not the same, for the moment. This song (text) catalyses the present place and time and builds (I can picture it) all the world – my past, present and, if I think about it, future – in an instant.

A soundtrack is clearly necessary for this kind of show. Delicately sweet sounds of the lost, the hapless, the maligned. I can't say I remember liking the song, even then.

*

I strike 'Los Angeles punk rock' on the square keys.

*

Lotman describes the semiosphere's border as the space where texts can enter the semiosphere, but must be translated, as through a filter of a membrane. At the semiosphere's periphery, semiotic processes occur more rapidly, translating and adapting texts entering from outside.

The peripheries – the margins – of the semiosphere are the regions where change, innovation and new meanings are built. It is an open system where the hybridization and adaptation of texts into new forms can occur; new terms, ideas, narratives that have yet to become part of the conventional cultural lexicon.

As these texts change and morph into new images and narratives they can over time become more accepted and conventional, and they make their way towards the more structured core of the semiosphere. It is here that Getty's semiosphere is nested.

Fashion, hairstyles and typography have all seen their days in the peripheries, in the centre, and back out to the peripheries.

By adding 'punk rock' to the search term – by adding a sign from the cultural periphery – new 'pictures' of the city are built. By choosing names, signifiers, that are to a degree incongruous, we might alter the location of the sign of the city within the semiosphere and send it to the periphery. But constrained within Getty's sphere, it can't go very far.

> The notion of boundary is an ambivalent one: it both separates and unites. It is always the boundary of something and so belongs to both frontier cultures, to both contiguous semiospheres. The boundary is bilingual and polylingual. The boundary is a mechanism for translating texts of an alien semiotics into 'our' language, it is the place where what is 'external' is transformed into what is 'internal', it is a filtering membrane which so transforms foreign texts that they become part of the semiosphere's internal semiotics while still retaining their own characteristics. (Lotman and Shukman 2000: 136–37)

Within a Getty search, LA Punk is a rather limited affair. It forms a perfectly pleasant little world, where punk is not much more than a fashion choice (I momentarily remember the guy in the park in Boston in the Summer of 1988, who was friends with The Germs, had an American flag tattoo on his neck, and hadn't bathed in a while). The characters depicted here are the same smiling contented folks we see in most other stylistic categories in the Getty search; young and happy only with the addition of slightly unusual hair (a lot of magenta). I picture ads for text messaging and soft drinks.

'Los Angeles punk rock' returns results that are a bit closer to the recollection of my friend in the park within the larger semiotic space of the Google search. Here I find the archetypes of the historic scene (*X*, *The Avengers*, *Black Flag*), grit, B&W photos, snarls

and attitude. Even so, within the greater semiosphere, these may be somewhere near the centre as evidenced by the fact that they even appear in a Google search.

It would take a cultural shift, when the language of commodity and desire needs a more genuine picture of punk rock as a form of identification, in order for these images, this reality, to migrate towards the more structured core of the semiosphere. Then they too might penetrate the Getty's boundary.

New and unfamiliar texts contrast and challenge the existing structure. The texts we read are continually assessed against other texts and are either rejected or are incorporated in a process of cultural adaptation in an ecological process, as catalysts in an open system, shaping and reshaping culture. It is a process of continual evolution where new texts challenge or conjoin with existing texts in constant tension between forces of stasis and change. It is a metabolism that continually names and re-names reality.

The periphery of the semiosphere where my Google image search resides is a bit like the ride in the car; KC and the Sunshine band and Mulholland Drive in the warm night.

A Google Images search is ostensibly an archive of the moment of the world. Getty is business as usual.

Each search is a big-bang. From nothing other than the latent potential of everything, a world is born. A constellation of images within a larger sphere of intersecting and nested constellations. A semiotic galactic space neatly gridded and hierarchical. Close the window and it is gone, into black nothingness. Open a new window, a new search, and a little time (enough for the world to change a little from its billions of catalysts) will in an instance give birth to a new constellation, likely similar but evolved from new inputs and order. An ecological evolution.

'That's the way, aha aha, I like it, aha aha'. (Casey and Finch 1975)

*

Twelve hours later, the sun glistens over the surface of the deep and wide sea and I dream of boxes and lines and points and words. Over land and floating above grids of crops and neighbourhoods and industrial parks. Framed by mounds of earth and grass fluted by millions of years of rivulets of water. The distinctions of the grid and the earth is pretty obvious. Like the letters on this screen, we make a lot of straight lines and are ruled by the spaces within them. The margins, the places between the rows of words, between the words, the letters, the places inside the letters, between the searches, between the rows of buildings, between the incongruous words, are the spaces of pause and possibility. The

contrast of figure and ground and when it tricks us there seems to be no black and white or front and back but only layers and layers with no order and no end.

References

Benjamin, W. (2002), *The Arcades Project* (ed. R. Tiedemann; trans. H. Eiland and K. McLaughlin), Cambridge, MA: Harvard University Press.

Casey, H. W. and Finch, R. (1975), *That's the Way (I Like It)*, on KC & The Sunshine Band: 25th Anniversary Collection (US Release) CD, Rhino, Burbank.

Corner, J. (2006), 'Terra Fluxus', in C. Waldheim (ed.), *The Landscape Urbanism Reader*, New York: Princeton Architectural Press, pp. 21–33.

Dixon, D. and Jones III, J. (1997), 'My dinner with Derrida, or spatial analysis and poststructuralism do lunch', *Environment and Planning*, 30(A), pp. 247–60.

Flusser, V. and Cullars, J. (1995), 'On the word design: An etymological essay', *Design Issues*, 11: 3, pp. 50–53.

Friedlander, E. (2008), 'The measure of the contingent: Walter Benjamin's dialectical image', *Boundary 2*, 35: 3, pp. 1–26.

Kuipers, B. (1994), 'An ontological hierarchy for spatial knowledge', *AAAI Technical Report*, New Orleans, LA: AAAI.

Kull, K. (1998), 'Semiotic ecology: Different natures in the semiosphere', *Sign Systems Studies*, Vol. 26, pp. 344–71.

——— Lindström, K., and Palang, H. (2014), 'Landscape semiotics: Contribution to culture theory', in K. Kull and V. Lang (eds), *Estonian Approaches to Culture Theory*, Tartu: University of Tartu Press, pp. 110–32.

Lotman, Y. M., Uspensky, B. A. and Mihaychuk, G. (1978), 'On the semiotic mechanism of culture', *New Literary History*, 9: 2, pp. 211–32.

——— and Shukman, A. (2000), *Universe of the Mind: A Semiotic Theory of Culture*, Second World Series, Bloomington: Indiana University Press.

Marcuse, H. (1979), *The Aesthetic Dimension: Toward a Critique of Marxist Aesthetics*, Boston: Beacon Press.

Modrak, R. (2015), 'Bougie crap: Art, design and gentrification', ∞ *Mile*, Issue 14.

Section Two

Applications – Traditional Technologies of Perception and the Imagination

Chapter 6

Sep Yama/Finding Country to Burning City Studios

Kevin O'Brien

Introduction

On 22 August 1770 at Possession Island, Lieutenant James Cook claimed on behalf of the British Crown the entire eastern coastline of Australia that he had begun surveying on 19 April earlier that year (MoAD 1768). In 1835, General Sir Richard Bourke, Governor of NSW between 1831 and 1837 declared terra nullius by proclaiming that Aboriginal people could not sell or assign land, nor could an individual person acquire it, other than through distribution by the Crown (MHC 1835). In one swift move, a singular state by way of property title was enacted on the Australian continent radically altering its ancient uses.

Entering the new millennium, what remains a distinct and haunting reality is that the Australian City has not yet come to terms with those origins located deep in the Australian continent. It is not unreasonable to suggest that clues can be found by considering the absence of property title as a way of inverting the imposition of the City. This inevitably leads backwards to a time prior to 1770. From one continent of one country, back to one continent of many Aboriginal countries, and away to something else, it can be further argued that there exists numerous, distinct and unresolved tensions between City and Country.

Sep Yama/Finding Country is an idea that seeks to engage this tension. Since 2005, the idea has taken several forms of investigation, drawing on collaborations with numerous colleagues and students to reveal the next iteration of inquiry. The ambition is to arrive at a new paradigm that argues for Country as the beginning of the City, thereby countering the current condition of the City as the end of Country.

Proposition

Mabo

The Meriam people are located on the eastern islands of the Torres Strait between the furthermost northern point of mainland Queensland, Australia and Papua New Guinea. In 1982, several Meriam claimants, led by Eddie Koiki Mabo, commenced proceedings in the High Court of Australia testing the validity of their legal rights to the islands of Mer, Dauar and Waier.

On 3 June 1992, *Mabo* v. *Queensland* (no.2) was decided (ABS 1995). The High Court by a majority of six to one upheld the claim and ruled that the lands of this continent were not terra nullius when European settlement occurred, and that the Meriam people were 'entitled as against the whole world to possessions, occupation, use and enjoyment of (most of) the lands of the Murray Islands'. The decision struck down the doctrine that Australia was terra nullius – a land belonging to no one.

This case is relevant to this chapter for two reasons. Firstly, in response to the ensuing judgement, the Parliament of Australia, led by then Prime Minister Paul Keating, enacted the Native Title Act 1993 (ComLaw 2013) to recognize Aboriginal people's claim to Country. This move exemplified the political will of the time and declared a shift towards the acknowledgement of Country as a pre-existing condition the nation needed to come to terms with. Secondly, as an architectural educator, the author has observed that architecture students are trained to begin with an empty sheet of paper in direct line with the 1835 declaration of terra nullius. The Mabo decision, in overturning terra nullius, clearly imputes that the paper on which architects draw is not empty, but full of what needs to be seen, that is, Country.

Country

Country, in the context of this chapter, refers to an Aboriginal idea of place. A definition of Country carries two distinct categories, on one hand the spiritual, and on the other the practical (Gammage 2011:139).

Country as a spiritual connection binds Aboriginal people to the place of their ancestors, it is a matter of belonging to a place, as opposed to owning it. The connection also considers every moment of the land, sea and sky, its particles, its prospects and its prompts, as enablers of life in an endless cycle of renewal. Its spiritual connotations are considered a belief system complete with symbols and signals commensurate with those religions bound to nature.

Country as a practical connection is found in the way Aboriginal people managed natural resources and domiciliary constructions. In *The Biggest Estate on Earth: How Aborigines Made Australia* (2011) historian Bill Gammage argues that Aboriginal peoples managed this continent with fire. Fire was the tool used to manage and alter the land. A variety of burning techniques were applied to regenerate plant life and direct wild life to locations for harvesting. Small, medium and large fires were scaled according to use. Gammage recounts that in Sydney at the time of British contact, a horse could gallop at full speed through the forests, so clear was the ground plane of fuel. Within seven years of the establishment of the colony, the undergrowth was thick and at times impenetrable due to the absence of fire-clearing (Gammage 2011: 5–17). To not burn your Country could be interpreted as allowing your estate to fall into disrepair. Fire was, and in a number of regions still is, used as a tool of management, a matter of renewal by way of emptying.

Emptying

In a 2007 paper titled 'Shrinking Cities cities in Australia' by M. Christina Martinez-Fernandez and Chung-Tong Wu (Martinez-Fernandez and Wu 2007: 795–810), the authors noted that at the time the topic had 'not yet become a prominent national issue despite the critical impact that cities with shrinkage patterns have in regional Australia'. At the same time, analysis of shrinking cities was intensifying in North America, Europe and Asia and in light of the devastating fallout from the financial crisis this could be considered all the more poignant. In analyzing the Australian Bureau of Statistics' population and economic data, the authors argue that there are three kinds of shrinkage: urban shrinkage, rural shrinkage and industrial centre decline.

If these forms of the City have confronted shrinkage it seems reasonable to suggest that Country must, or at least has the potential to, encounter growth. In the authors' 'Concluding Remarks', in particular, their third issue, the question of alternatives to the current planning paradigm of growth, is reservedly tabled as being bound to the history and national economic context of the place. Despite the initial development of *Sep Yama/ Finding Country* occurring two years prior to this paper, it was most definitely informed by the shrinkage discussion at that time, particularly population decline as an integral factor. It followed that conceptually adjusting population levels as the determining factor in the first instance could lead to alternative models from those that follow population or economic decline as a matter of catastrophe.

Catastrophe is commonly understood to be the primary force affecting the permanence of a city and its population. However, *Sep Yama/Finding Country* is not an attempt to pick up where shrinkage or catastrophe leaves off. *Sep Yama/Finding Country* is arguing explicitly for a practical engagement with Country by bringing it into a symmetrical tension with the City. Active emptying of both the City and Country is unlike the passive shrinking that occurs to the City as an exclusive condition. Implicitly, *Sep Yama/Finding Country* is searching for the unknown agent of change that can achieve the required symmetrical tension through an informed analysis of a hypothetically reduced population.

Exhibitions

In 2005, the author in collaboration with Michael Markham, formalized the idea of *Sep Yama/Finding Country* as a bi-lingual catalogue entry for an Australian competition. The catalogue was entered under the respective practice names of Merrima and tUG Workshop for the Creative Directors of the Australian Pavilion for the Venice Architecture Biennale 2006. The competition, procured by the Royal Australian Institute of Architects (RAIA), received the submission that was initially shortlisted but later unsuccessful. The same entry was resubmitted to the RAIA in 2007 and again was initially shortlisted and later deemed the unanimous winner by a national jury of architects.

The win, however, was short-lived (ArchitectureAU 2007) due to creative differences with national office representatives and staff of the RAIA. The expectations of the RAIA's sponsorship model was based on marketing opportunities bound to the presence of corporate logos, where the submission was based on an alternative model of patronage with no corporate presence or exchange allowed. This was a disappointing yet inevitable outcome. Irrespective, the experience proved invaluable and a decision was taken to pursue the idea as an independent undertaking.

Sep Yama/Finding Country: A Primer

In 2009, the author commissioned and directed *Sep Yama/Finding Country: A Primer* in Melbourne and Brisbane. The basic, if slightly naive, position of the inquiry requested that the invited participants imagine a 50 per cent reduced population and that they empty their allotted A4 city grid according to a defined logic. The location of the inquiry was Brisbane and its greater region. The final drawing was approximately 8m × 3m and included nineteen submissions of varying complexity and understanding. Over 400 A4 sheets were printed off the author's office printer and reassembled as a tiled cohesive whole in a gallery space in Melbourne. The contributions were processed through an aesthetic programme set on adapting the luminescent colours of a car dashboard at night as a way to navigate unseen space.

The majority of the contributors were final year architecture students at the University of Queensland, with several mid–late career architects providing a not unexpected deeper penetration of the premise. Of the students' contributions, a clear pattern of ideas emanated from emptying reparation zones deduced from tidal and flood levels connected to the Brisbane River. This was not surprising given the way the drawing captured the mountains to the west and the coastal bay to the east, effectively capturing the water lines of the Country (as opposed to the boundaries of the City). What was surprising, however, was the way most submissions associated Country with a concept of nature, generally 'wilderness'. This became the central problem of this exhibition.

Of the nineteen submissions, fifteen characterized Country as green spaces found through the erasure of the City. Of these fifteen, two designated the green space for agricultural use. For the initial Primer, no specific definition of Country was offered to the participants. Country, as a concept, therefore could be interpreted as a matter of cultural, symbolic, spiritual, natural, zoned or economic conditions. Indeed, in one contribution, it is understood as something managed through fire under strict and highly rhetorical planning codes. In turning a cold critical eye on the submissions, and especially with a view to Gammage's text, it is simply not possible to accept the definition of Country as wilderness. If there is one thing for certain about the Australian continent, it is that fire was used as a tool to manage and alter Country. Yet despite this seemingly negative revelation, the real strength of the submissions was located in the overwhelming courage

of the students in attempting to grapple with Finding Country as an expansive set of questions bound to the past, present and future uses of both the City and Country. The next iterations would benefit from this preliminary work.

Carol Go-Sam, architect and writer, in reviewing the exhibition, noted:

> rather than a sentimental return to the past, Sep Yama was a prompter, to push those living in the present to remember that the city of today must be vigorously interrogated, and that it is the culmination of earlier displacements. (Go-Sam 2010 154–59)

Accompanying the drawing was a study on the conflict between the concept of ownership as title, and ownership as occupation. The study was really a thinly veiled examination of the unresolved displacement of Aboriginal people in the twenty-first century. The author painted eleven skateboards in figurative motifs inspired by the Torres Strait Islands, sent them to a team of pool skaters in Melbourne and Los Angeles with a request to use and return the decks in their respective endeavours. The skaters entered abandoned properties, cleaned up the pools and skated until one found the perfect line over the pool box. Here, ownership was raised as both property title (and therefore technically illegal entry by the skaters) and ownership as temporal (and respectful) occupation. Several video works, edited by Michael Markham, were projected above the returned skateboards, now rendered as the splintered artefacts of the conflict.

An examination of this conflict was critical in developing a broader understanding of the complex tension between Country and City through the lens of ownership. Country, here, could be argued as the absence of the Torrens title, and City could be argued as the presence of the Torrens title. Terra nullius as the basis for the colonizing roll-out of the British Torrens title registration was subsequently found to be in conflict with the findings of the Mabo case.

Finding Country Exhibition

In 2012, the author commissioned and directed the *Finding Country Exhibition* as an official Collateral Event of the Venice Architecture Biennale 2012 (Chipperfield 2012). The central exhibit was a remade 8m × 3m canvas drawing of Brisbane and its greater region including the previous nineteen submissions with an additional 25 submissions to make a total of 44 submissions. On this occasion an opportunity to up the ante was relayed to the contributors with each grid being an explicit architectural negotiation with a 50 per cent reduced population, whilst carrying an implicit personal challenge to non-aboriginal architects to engage Country, a slight, yet important shift in the ambition of the exercise.

On this occasion the aesthetic filter was derived from the silver tones of an X-ray image alluding to a sense of what lays beneath. Printed onto five canvas panels, stretched and framed on site in Venice, the drawing took on an ethereal quality made all the more

splendid by its location beside the wet door of the exhibition space. Set behind the drawings was a sound installation by Netherlands-based artist and sonologist Barbara Ellison (Ellison 2012). Her sound piece separated numerous sound recordings from Brisbane into various frequencies before emptying by 50 per cent and reassembling into a carefully composed work. In terms of contributing to the sensory experience of the exhibition it provided the perfect aural setting. Expanding the sensory experience, the drawing was infused with eucalyptus oil for the western mountains, frangipani oil for the central city, and tea-tree oil for the eastern bay islands.

The new submissions had the hindsight and benefit of the *Sep Yama/Finding Country: A Primer* exhibition, in addition to a clearer set of definitions around Country and City as a matter of ownership and (productive) use. What became evident upon completion was the anxiety stemming from the absence of an historical or contemporary understanding of Aboriginal use. To be fair, how could a non-aboriginal architect reasonably anticipate future Aboriginal uses without falling into a paternal trap? It was obvious that a new problem had been encountered that would require attention in the future.

This condition was made all the more obvious through one considered attempt to confront this matter. Elliot Harvey, in grid E16, states:

> The process of emptying commenced with the erasure of all post-war housing stock, revealing, in fragments, the patter of early suburbia as it colonised the ancient landscape. These fragments themselves represent the cultural loss our colony inflicted – the loss of something irretrievable. The lost places, histories and systems of Brisbane's original inhabitants then begin to avenge themselves on the already revised city, as new landscape weaves and swallows part of the suburb, yielding spaces both sacred and circulatory. The course of Riding Road, climbing towards colonial-era aboriginal camps at Bulimba, begins to eat into the voids of the city blocks, then reclaims elements of the old subdivisions as gathering places, especially where they stray into the path of the landscaped procession. This reclamation of the subdivisions continues around engorged Norman Creek, once the site of hunting, fishing and camping, and the now smothered peaks at Seven Hills in the west. (Harvey 2012)

Upon the completion of the Vernissage opening celebrations, the author burned the drawing. The smell of burnt canvas, together with the feeling of heat, completed the sensory experience of the exhibition and would now be understood by those who saw before the burning, and those who saw after it.

Professor David B. Stewart, architectural historian, in contributing an essay to the exhibition catalogue, noted:

> The entire notion is a rubbing out, organic and cautiously hopeful. A Nemesis, diffused, even confused, and deliberately de-centered, to modernism's hubristic 'cold nebular

Figure 1. *Finding Country Exhibition* (2012): E16 drawing extract by Elliot Harvey. © Elliot Harvey.

cloud' – yet one foretold as a work of years, if not of centuries. To be set afire at the end of this Biennale, are we not perfectly entitled to discern here a glowing stick plucked from the burning? (Stewart 2012)

Accompanying the drawing were four photographic studies by the author (aided by two assistants) contemplating irreconcilable differences found in the built environment of Brisbane. Each image was constructed by projecting archived Aboriginal material onto buildings: a hanging projected onto the first convict mill tower; men fishing on the banks of the river where the Gallery of Modern Arts now stands; a young boy dancing on the initiation ground now known as the Woolloongabba cricket and football ground; and a rainforest dwelling projected onto a colonial Queensland timber house. This last image was called 'Black Bones' and caught the attention of Nathalie Weadick of the Irish Architecture Foundation.

The everyday experience

From November 2013 to January 2014, Nathalie Weadick, Director of the Irish Architecture Foundation, included this photograph titled 'Black Bones' in a group show she curated at the Irish Museum of Modern Art. The exhibition sought to 'reveal how much of our experience of designed or informal space is unconscious, immersed in the everyday and woven into life' (IMMA 2014).

'Black Bones' took a close look at the local timber housing tradition referred to as the 'Queenslander' (QM n.d.). The Queenslander's origin is located around the turn of the twentieth century as the British colony extended into the northern regions of the Australian continent. The Queenslander comes complete with its own construction order, where the pyramid (tin roof) sits on the plinth (veranda) that sits on the capital (ant cap) of the column (Doric) under. Numerous local writers have sentimentalized these honest creations for decades. Anyone who has ever lived in a Queenslander is familiar with the creaking, the scale, the sounds and the heat. It is quintessentially Queensland and for a young state, such as Queensland, an absolute source of identity and pride.

The Queenslander is a logical tectonic structure derived from the spanning strengths of the first growth timber sections. For the best part of a century it was the domain of carpenters and their guild's mathematical proportions. However, further research indicates that one (of many) traditional burial rituals amongst Aboriginal people involved embedding deceased family members in the forks and hollows of trees. This further presumes that the trees grew around, or more precisely, Aboriginal people grew into the trees. Rites included the laying of the deceased on platforms high up in tree branches, as well as carving tree limbs to indicate the location and identity of those deceased and placed (known as scar trees). Over thousands of years these trees represented what is referred to as 'first growth forestry' here in Australia. It is this first growth that was felled

and milled in order to construct the houses (amongst other things) of the new British colony. The irreconcilable tension is revealed as a matter of construction.

Although a side project, the photograph embodied the irreconcilable differences that can exist in a state of tension; here the carpenter was located in the construction and Aboriginal people in the structure. Two seemingly exclusive conditions brought into a symmetrical contest with one another, the central theme of the previous exhibition's emptied drawings.

QUT

'Finding Country' lecture series

In between the first two exhibitions, in 2011, Queensland University of Technology (QUT) invited the author to direct a lecture series under the title 'Finding Country' to flesh out the project's position and broaden its discussion. Between August and October that year, six speakers, namely Eames Demetrios (geographer and artist, USA); Tom dePaor (architect and artist, Ireland); Tim Hall (structural engineer and architect, Australia); David B. Stewart (architectural historian and writer, USA/Japan); Gina Levenspiel (materials researcher and architect, Australia); and Michael Markham (architect and provocateur, Australia), were invited to respond to the notion of tension between opposite conditions within their own areas of expertise.

Eames Demetrios presented his 'Kcymaerxthaere' project as a storytelling phenomenon literally bringing to life regional characters entwined in a globally inter-dependent interaction. The project takes Demetrios around the world on an ongoing basis installing bronze markers at specific sites within a story with no beginning and no end. Tom dePaor discussed several of his architectural projects through the revelation of construction as the origin of his work. Of note was the tension it presented back towards the initiating client brief and architect's intent. Tim Hall began with a review of archival photographs of an Aboriginal dwelling from eastern Victoria near his home and practice, with specific explanation of the efficiency in the temporal nature of its construction system. This condition stood in stark contrast to the contemporary over-engineered permanent structures he constantly confronts. David B. Stewart offered archive footage and explanation of Kazuo Shinohara's four styles of work. Of note was Shinohara's central challenge to maintain a Japanese sense in the face of an international style onslaught in the latter half of the twentieth century. Gina Levenspiel forensically examined the conflict between architectural journalism and architectural culture in Australia. The lopsided publishing of projects from the state of Victoria in *Architecture Australia* (the RAIA's official magazine) over the first decade post-2000 drew a distinct difference to the building approval statistics of other states. Michael Markham described the nature of inclusivism as diluting the authenticity of genuine creative acts. From sponsorship logos

strangling artistic freedom, to the covert absorption of ideas by the overtly commercially minded architect, numerous case studies illustrated the challenge to maintain individual integrity in the face of communal dilution. Put simply, the contest between excellence and mediocrity.

The lecture series was a side project in the same way that the 'Black Bones' photograph was a side project; it sparked a number of urban, architectural and artistic possibilities that laid the critical framework for the studios to come.

Studios

At the end of 2012 after the success of the *Finding Country Exhibition*, QUT invited the author to teach design studios in the final year of the architecture course in the Faculty of Creative Industries, School of Design, beginning January 2013 and ceasing December 2015. At this juncture, four studios have drawn on the central theme of the symmetrical contest and its associated tensions, and required students to engage with the explicit task of emptying a City to find an understanding of Country. The studios needed to build upon the collective assemblage of one drawing, and establish individual opportunities for students to seek architectural interventions that transcended their conceptual thinking. This was (and still remains) a permanent challenge.

Burning City Studio

The first studio was run as two stages over two semesters. The first stage was titled, *Burning City I: Finding Brisbane* and revisited the Brisbane and greater region drawing from the *Finding Country Exhibition* in Venice. The class of 32 students considered their individual grids with the benefit of hindsight and two central texts. The first was *The Biggest Estate on Earth: How Aborigines Made Australia* by Bill Gammage (2011); and the second, discovered during the Venice experience, was *The Possibility of an Absolute Architecture* by Pier Vittorio Aureli (2011). The purpose of these respective texts was firstly, to introduce students to the use of fire as a practical tool of Country; and secondly, to consider architecture 'at once the essence of the city and the essence of itself as political form: the city as the composition of (separate) parts'. In other words, establish a case for Country to be brought into contest with the City by recognizing the limits of each in the absence of the other.

However, unlike the previous exhibition drawings where the scale was locked to 1:10,000, the students were required to empty the City at 1:10,000, 1:5,000 and 1:1,000. At each of these scales the detail of the City shifted the investigation up to a new consideration beginning with the form of the City, then its blocks, and then its lots. Significantly, it stopped before building detail became a premature and distractive mode of investigation. That would be the purpose of the second stage.

Finding Crevalcore Studio

The second stage of the first studio was completed with the same cohort of students and titled *Finding Crevalcore Studio*. It piggybacked an international student competition (YAC 2013) that sought ideas for the redevelopment of the medieval town, just north of Bologna, Italy. In 2012, an earthquake struck the northern region of Italy destroying many historical buildings and leaving areas as abandoned ruins. Accompanying statistics indicated that many of the region's towns were also experiencing declining populations. The challenge for the students was to look past the catastrophic nature of the earthquake and focus their thoughts on a 50 per cent reduced population as a way to not only empty the town but also to arrive at an architecture with an awareness of Aureli's notions.

Students moved directly in from 1:1,000 drawings, through 1:500, 1:200, 1:100, 1:50 and 1:20 developing the emptying technique as a dialectic method between two conditions at respective scales. At the same time, a third text titled *The Australian Ugliness* by Robin Boyd (1960) was introduced to expose the students to the practical question of how a singular architectural form might be derived from its method of production; a provocative recalibration away from Aureli's theoretical gaze. The expectation of the author was that a 1:20 detail would be expected to resonate with the 1:1,000 emptying of the City.

Student Toby Mackay submitted a grid proposition that sought to empty Crevalcore by exploiting Aureli's notion of the archipelago.

> What is currently a conservative city where architecture repeats itself in a historically nostalgic sense is now a plan of confrontation and agonism, disrupting the status quo in an attempt to reinvigorate the city by presenting opportunities for this comfortable flow or order to be disrupted. (Mackay 2014)

Mackay's emptying also revealed an urban form bound to the nature of architectural use, a not uncommon condition for this studio cohort. The implied argument was that Country (or not City), by default, would also be bound to its own nature of use and by extension definitions of wilderness (or no use) could not be applied to the notion of Country. The final scheme was ultimately shortlisted and received a commendation in the judging of the international student competition.

Burning City II: Finding Sydney

The second studio, titled *Burning City II: Finding Sydney*, returned to the concerns of the first but ended in the requirements of the second. The central business district of Sydney was divided into grids and allotted to each of the 32 students to pursue the previous lines of inquiry and the same referential texts. The difference on this occasion was an accompanying axonometric drawing that sought to translate the two-dimensional plan

Between pages 37 and 44 of Aureli's *The Possibility of an Absolute Architecture*, he describes the architecture of Mies van der Rohe, in particular his use of the plinth. The plinth 'reinvents urban space as an archipelago of limited urban artefacts. It is this emphasis on finiteness and separateness that makes artefacts like these the most intense manifestation of the political in the city.' Aureli then describes Mies' projects as being 'the highest examples of an absolute architecture, for they make clear its separateness, provoking an agonistic experience of the city. The city made by agonistic parts is the archipelago.' This is then what drove the emptying of Crevalcore. In this new plan of Crevalcore the city is divided into a number of separate and isolated forms. The walls of the architecture no longer define the city pattern as a grid (as they currently do), but as an archipelago. What is currently a conservative city where architecture repeats itself in a historically nostalgic sense is now a plan of confrontation and agonism, disrupting the status quo in an attempt to reinvigorate the city by presenting opportunities for this comfortable flow or order to be disrupted. The sites that possess this ability the most are highlighted in the image above.

EMPTYING PLAN 1:1000 1 Toby Mackay n7191995
DAN200 Kevin O'Brien

Figure 2. *Finding Crevalcore* drawing extract by Toby Mackay. © Toby Mackay.

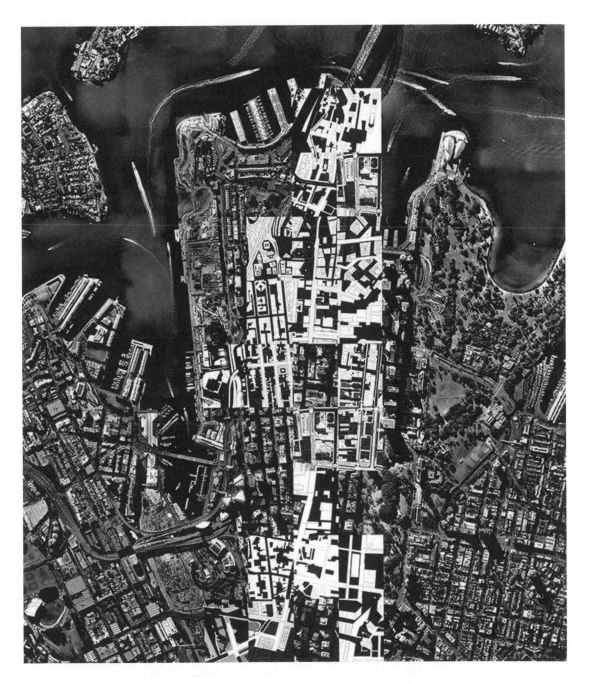

Figure 3. *Burning City II – Finding Sydney* (2014) composite drawing. Image courtesy of the author. © Kevin O'Brien.

inquiry into a three-dimensional spatial inquiry at the scale of the City and the scale of an architectural intervention derived from the context between burnt Country and emptied City.

As the primer for this studio, students travelled to Sydney to engage with the Sydney Biennale Arts Festival. The reason for this attention was due to the perceived controversial nature of the principal sponsor and its relationship with the Manus Island detention centre (Harvey and Storey 2014). A number of artists claimed Transfield Holdings represented an unethical presence and a number of artists withdrew from the festival. A contentious debate raged for months before and after the event, but the question made relevant from the event was that if a sponsor could attempt to influence an artist, should an artist attempt to influence a sponsor? In light of the *Finding Country Exhibition* experience it presented a variation on the sponsor-vs-patron model by subverting it to an artist-vs-sponsor model.

Parallel with and separate to the festival programme, a Museum of Sydney exhibition titled 'Suburban Noir' showcased police photographs of crime scenes; the exhibition broke 'with the tradition of presenting Sydney as a visual splendour, finding instead a more reserved city' (MoS 2013). The mysterious black-and-white style of those images, especially the plan perspective, informed the aesthetic of the student's composite drawing of Sydney and attempted to reveal a hidden underbelly. The composite drawing was then exhibited as part of the *Mediated City Conference* held 1–14 October 2014 at Woodbury University in Los Angeles.

Gina Levenspiel, in writing the catalogue essay, noted,

> It is not surprising then that planning is able to position architecture behind all of its historical tools – the mimetic setbacks, height limits, context analysis, color, age, decoration etc etc. If planning is always in front of architecture, how can architecture move beyond the zeitgeist? Or perhaps worse, if architecture is to be modelled on the planner's reality, how is it possible to propose an "index" for "an idea of the city" beyond its false residue as a Classical Object? (Levenspiel 2014)

The final form of the reassembled drawing of Sydney carried a layer of interrogation and confrontation that had inevitably moved well forward of the 2009, 2012 and 2013 drawings.

Student Moe Shahin, in his grid submission for the composite drawing, argued for 'The Heterogeneous City' where 'At the most basic level, the buildings in this city reveal that there exists a temporal resistance to the "finite" state of an architecture, that is consolidated by new modes, occupation, signs and commemoration that mark difference' (Shahin 2014). Where Mackay had interrogated use as way into the emptied archipelago, Shahin attempted to identify the changing nature of difference within the city ultimately as a condition bound to the symbolic architectural gesture. These notions recalibrated the direction of the next studio.

Figure 4. *Burning City II*: (2014) B8 drawing extract by Moe Shahin. © Moe Shahin.

Figure 5. *Burning City II*: (2014) F4 drawing extract by Kimberley Allingham. © Kimberley Allingham.

Burning City III: Finding Melbourne

The third studio, titled *Burning City III: Finding Melbourne*, tested the problem on Greater Melbourne with a similar ambition to the previous studio, except on this occasion the studio extended an interrogation of the three-dimensional spatial inquiry as a matter of structure and construction. Students were expected to move well beyond the conceptual, through the schematic and into the nature of assembly as a condition of their final architectural intervention.

The primer for this project was a site visit to experience the Swanston Street axis in the Melbourne central business district CBD. Of interest was the local version of postmodernist offerings stretching from the Shrine of Remembrance on the south of the Yarra River, to the end of Swanston Street heading north. The semiotic-come-exterior-design offerings were established as a counter-point to the intent of the studio's concept-to-construction manifestation. This led the author to observe that Swanston Street was more 'Sideshow Alley' with contemporary architectural facades and retail offerings screaming for attention from one end to the other. A significant and radical departure was the RMIT Design Hub by architect Sean Godsell in association with Peddle Thorp Architect that appeared to reject this context by shrouding a simple orthogonal volume with hundreds of circular glass portals. The overall effect was of a blocking out from the inside, and a re-ordering of the streetscape from the outside.

Student Kimberley Allingham submitted an interesting proposition for the emptying of her grid based on 'the remains of the productive machine, after all of the superfluous has been burnt away' (Allingham 2015). This established her position in working towards her final architectural intervention, or in other words, an architecture that would start with its technical performance in order to arrive at its aesthetic condition. Where Shahin in the previous studio had revealed the limitation of the symbol, Allingham had revealed the possibility of production as a way into finding Country.

Conclusion

Over two hundred years after Cook's proclamation, the Australian City has comprehensively extended itself as the instrument of property title drawn on empty paper over a presumed emptied continent. Its spatial derivatives, played out as surveyor's pegs and speculative land holdings, inform an urban expertise still preoccupied with building expansion. Its accompanying architecture, taught from European historical origins, remains bound to these marks and limited to individual pursuits.

The *Sep Yama/Finding Country* idea has, over the course of nine years, slowly developed an idea about a symmetrical context between City and Country, into one now titled Burning City. Fire is currently understood as the mediating tool, in the same way that water might be for Aureli in Venice. The recalibration of each studio, and the expectation

of found limitation of one studio becoming the possibility of the next, keeps the endeavour fresh in its next iteration. Where this ends is unclear, but where it needs to go is clear.

The next frontier for this project is to explore Country as a genuine origin of architecture on this continent (as opposed to City with its western origins elsewhere). This is currently underway through both the student architectural interventions within studio as well as the professional commissions of the author as a practising architect. Initial findings on both fronts have revealed Country as not just a form and politic of the City but more importantly as an architectural construct bound to the notion of what we belong to and how we should build. It is beyond the focus of this chapter and will be explored in the not too distant future.

References

ABS (Australian Bureau of Statistics) (1995), 'The Mabo Case and the Native Title Act', http://www.abs.gov.au/Ausstats/abs@.nsf/Previousproducts/1301.0FeatureArticle21995. Accessed 7 June 2014.

Allingham, K. (2015), 'F4', *Burning City III – Finding Melbourne* [Studio drawing], Brisbane: Queensland University of Technology (QUT).

ArchitectureAU (2007), 'Biennale', http://www.architectureau.com/articles/biennale-4/. Accessed 12 June 2014.

Aureli, P. V. (2011), *The Possibility of an Absolute Architecture*, Cambridge, MA: MIT Press.

Boyd, R. (1960), *The Australian Ugliness*, Melbourne: F.W.Chesire.

Chipperfield, D. (2012), *Common Ground: 13th International Architecure Exhibition*, Venice: La Biennale di Venezia.

ComLaw (Australian Government ComLaw) (2013), 'Native Title Act 1993', http://www.comlaw.gov.au/Details/C2013C00128. Accessed 7 June 2014.

Ellison, B. (2012) 'Finding Country' [Sound work], *Finding Country Exhibition* [Online catalogue], http://http://www.findingcountry.com.au/#/submissions/barbara-ellison. Accessed 2 May 2012.

Gammage, B. (2011), *The Biggest Estate on Earth: How Aborigines Made Australia*, Sydney: Allen & Unwin.

Go-Sam, C. (2010), 'Sep Yama: "Ground you cannot see" Finding Country (a primer)', *A Interstices 11: The Traction of Drawing, Journal of Architecture and Related Arts*, pp. 154–59.

Harvey, E. (2012), 'E16', *Finding Country Exhibition* [Exhibition catalogue], Venice: pp. 58–59.

———— and Storey, R. (2014), 'Sponsorship debate sidelined as Sydney Biennale lets the art speak for itself', http://www.abc.net.au/arts/blog/Video/Sydney-Biennale-lets-talk-about-the-art-140319/default.htm. Accessed 15 May 2015.

Irish Museum of Modern Art (IMMA) (2014), 'The Everyday Experience', http://www.imma.ie/en/page_236790.html. Accessed June 9 2014.

Levenspiel, G. (2014), 'Empty Space to Finding Country', *Burning City II – Finding Sydney* [Exhibition catalogue], Brisbane: Queensland University of Technology (QUT), pp. 8–17.

Mackay, T. (2014), *Finding Crevalcore*, [Studio drawing], Brisbane: Queensland University of Technology (QUT).

Martinez-Fernandez, M. C. and Wu, C. T. (2007), 'Shrinking cities in Australia', *State of Australian Cities National Conference*, pp. 795–810. http://soac.fbe.unsw.edu. au/2007/SOAC/shrinkingcities.pdf. Accessed 1 July 2015.

MHC (Migration Heritage Centre) (1835), 'Governor Bourke's 1835 Proclamation of Terra Nullius', http://migrationheritage.nsw.gov.au/exhibition/objectsthroughtime/ bourketerra/. Accessed 6 June 2014.

MoAD (Museum of Australian Democracy) (1768), 'Secret Instructions to Lieutenant Cook 20 July 1768 (UK)', http://foundingdocs.gov.au/item-did-34.html. Accessed 6 June 2014.

Museum of Sydney (MoS) (2013), 'Suburban Noir', http://sydneylivingmuseums.com.au/ exhibitions/suburban-noir. Accessed 15 May 2015.

Queensland Museum (QM) (2014), 'Queensland house', http://www.qm.qld. gov.au/Find+out+about/Histories+of+Queensland/Queensland+families/ Queensland+house#.U57KxS90yRM. Accessed 9 June 2014.

Shahin, M. (2014), 'The Heterogeneous City – B8', *Burning City II – Finding Sydney* [Exhibition catalogue], Brisbane: Queensland University of Technology (QUT), pp. 58–59.

Stewart, D. B. (2012), 'Rescinding the Erstwhile Brisbane "Curfew Zone" to Regain its Lost Places: Implicit Personal Challenge to Find Country', *Finding Country Exhibition* [Exhibition catalogue], Venice: pp. 2–5.

YAC (Young Architects Competitions) (2013), 'Post-Quake Visions', http://www. youngarchitectscompetitions.com/en/pqv-competition.html. Accessed 12 June 2014.

Chapter 7

Surface tension: Experimental dance films and the undoing of urban space

Sylvie Vitaglione

Introduction

In the past twenty years, due to the increasing availability and affordability of cameras, a plethora of experimental dance films have been shot on location in cities. On the one hand, the recurrent use of cityscapes demonstrates an eagerness to capture movement in public space and to highlight the social choreography of everyday life. Dance becomes about finding pedestrian movement and gestures, on sidewalks, benches, plazas and parking lots. This choreographic tradition harks back to the 1960s Judson Dance Theatre in New York City where artists such as Trisha Brown and Yvonne Rainer began to explore the transposition of pedestrian movement and task-based activities into theatrical settings, while also utilizing the city streets and parks as alternative performance sites. In these films, crowds seem to move in synch à la Busby Berkeley and somehow traffic flows to a beat. The camera gives the city a pulse. On the other hand, choreographers push the dancers' endurance by designing athletic movements, treating the city not as a backdrop but as an obstacle course. As they defy gravity by leaping from rooftops, jumping over walls and climbing lampposts – such as in Parkour – these hyperactive bodies are conditioned to experience urban space on a different level.

This chapter explores the types of movement predicated by spaces in cities in recent short experimental dance films, moving through London, Paris, Montreal, Tel Aviv, San Francisco, Helsinki and Lausanne. In their attempt to master the daunting surfaces of the city, the crowds, the noise and the cost of public horizontal space, contemporary dance film-makers expose current borders between our skin and the built environment and give architectural spaces new life and energy.

Dance films, as defined here, differ from recorded live performances and present choreography created specifically for the camera. Shot on film, video or digital video, dance films have come to be dubbed 'experimental', meaning primarily short, non-verbal films focusing solely on a body moving in space. These films, similar to music videos in their construction of micro-narratives, are usually designed as collaborations between directors and choreographers but are also occasionally shot by the choreographers themselves, regardless of whether they have any formal film-making training. Experimental dance films are most often seen at specialized film festivals, in museum exhibitions or online (YouTube and Vimeo) and typically produced on small budgets.[1]

At the moment, within contemporary dance, site-specific practice remains a subcategory, mainly due to the impracticality of getting audiences and technical equipment on-site.

Few dance-technique classes teach how to move on grass, sand, rock, ice or concrete; most dancers train and perform on a sprung wood floor. While aerial dance workshops (dance on wires) exist and an increasing amount of movement practices such as Parkour are exploiting the outdoors, the dancing body remains for the most part protected by four walls and a ceiling. However, with the presence of the camera and its tempting control over space, choreography moves outdoors and engages with new sites, proportions, textures and temperatures. Numerous dance film-makers are lured into wild landscapes filled with rich natural materials, sounds and breathtaking sunsets against sharp horizon lines. Others choose to remain within urban settings ready to cope with the weather, natural light, dirt, rodents, crowds and the noise of the city (though most films exclude direct sound). Challenged by this new environment, the dancers are urged to roll on the street, jump over fences and climb walls, their active bodies now conditioned to overcome urban space. As the number of dance films grows, outdoor space is becoming a key component for choreographic practices and is pushing dancers to build newly resistant and responsive bodies.

Faced with the chaos of the city, what space do dance film-makers have to stage movement? From a practical standpoint, filming in the city requires numerous permits, with the sites themselves subject to various regulations. How much does a piece of the city cost to rent for a day or two? What public sites remain free to film in? Given the small crews and low-budget nature of the majority of these films, dance film-makers are faced with two options: either obtain a permit for a location that is 'cheap', or 'steal' the site by filming in multiple quieter spaces with the hopes of not being caught. In an ideal case, a choreographer would receive sponsorship from local governments for the production of their site-specific films. The downside to this financial support is that such films frequently end up resembling a postcard tour of the city, featuring dancers plopped onto local monuments and iconic spots without any apparent connection to the choreography.

The films discussed in this chapter thus face regulations not only in terms of their choice of location but also in terms of the types of movement allowed in such spaces. In order to gain the freedom of motion, to manage the crowds of bodies and vehicles, choreographers must either empty space or find a space already emptied. In these films the city as such is not immediately recognizable, it is used more for its component parts than for its monuments. Neglected architecture and side streets call for action.

Once a space is found and appropriated for the film, the degree of interaction between the dancers and the location begins to articulate its stance on the city and its movement. Within these new containers what do the artists bring to the space and what do they take from it? What movement qualities and quantities are necessary to intervene in the site? For many, the degree of tactile contact is crucial in grounding the body in space. Touch functions as a choreographic tool through which to expose the borders between people and the materials of the city. Through friction between skin and architectural surfaces, these asphalt dances look to undo spaces, or turn their logic on their head.

In addition to considering the quantity and quality of touch in relation to site, dance film-makers must also observe existing movement patterns in the space so as to decide

how and where their choreography will fit in. Much like a skateboarder or a free-runner, the dancer creates a path in space that weaves in and out of obstacles and pedestrians, that balances pauses and accelerations. Flow and resistance become choices to choreograph new rhythms, to transgress dominant movement patterns. The choreographer can insert stillness or add movement to a space, opting to move with it or against it. In altering the tempo and flow of the city, dance films, like skateboarders, seek to 'transform everyday life into a work of art' as Iain Borden puts it in *Skateboarding, Space and the City* (Borden 2013: 12). By analysing touch and rhythm this chapter will now explore the ways these films transform urban space through movement, framing, sound and editing.

Light touch: The city as backdrop

In the following two films, the dancers approach outdoor space gently. While the location offers a fraction of confined space to explore, these bodies resist transgression and utilize the site primarily for its visual qualities as a backdrop. The dancers hover near the borders of their container, grazing the walls with their fingertips and barely covering ground with their feet. These bodies tread lightly on the ground: the space is left intact and the skin and bones unscathed. If, as Henri Lefebvre suggests, 'there is an immediate relationship between the body and its space, between the body's deployment in space and its occupation of space' (Lefebvre 1991: 212), then these films avoid critically engaging with the sites by casting urban elements as a background that could have been recreated through green-screen CGI. The dance deploys itself in space but it could be in any place whatsoever.

Shot on the outskirts of London, *Brighter Borough* (2012, 4 minutes) directed by Georgia Parris, takes place in and around a mint-green neon-lit pedestrian underpass near a highway. Three women dressed in silk printed dresses and black ballet flats framed in medium shots move through the space, making elegant gestures with their arms and giving the fabric movement. The film's focus is pulled away from the bodies and the concrete linings of the space towards the smooth and shiny texture of the fabric, as if it were a commercial for laundry detergent. The film is in fact part of a fashion portfolio and is meant as an advertisement for the dresses designed by Louisa Parris, the film-maker's sister. The non-diegetic music glosses over the sounds of heavy traffic, making it seem almost pleasant to linger in a space usually plagued by cacophonous noise and the noxious smell of exhaust fumes. The film's title after all does suggest a sunny, brighter borough. One recognizes this superficial treatment of site from fashion photography: the backdrop and sunlight helps outline the clothes but the body has no real reason to be there. As they dwell leisurely in a space intended for transit, their incongruous elegance reminds us that the fast linear cities of Le Corbusier and Robert Moses are created by and for traffic, not for people.

Shot in an inner courtyard in the 20th arrondissement in Paris, *46 Bis, Rue de Belleville* (Baes, 1988, 3 minutes) is a black-and-white stop-motion 16mm film by Pascal Baes that features two women moving along a circular chalk-drawn pattern on the ground. The film

Figure 1. Skimming the concrete surface in *Brighter Borough* (Georgia Parris, 2012). © Georgia Parris.

opens with a high-angle shot of the two dancers dressed in black tops, skirts and boots on a wet surface that reflects the surrounding buildings. As if in a game of hopscotch, they glide over the surface, never stepping out of the prescribed path. As they twist and twirl around each other in a deconstructed jumpy tango accompanied by vocals and an accordion, their feet track the white line on the ground while the camera roams freely in and out of this superficially confined space. This square gap between buildings is filled spatially by the circular patterns of the dance and the camera, but the tangible presence of the bodies and the site remain muted by the stop-motion and lack of diegetic sound.

Stepping in: Altered pedestrian movement

Writing in the early 1970s, architect Lawrence Halprin suggests that the speed of pedestrians is the primary dimension to consider in designing movement in the city. He claims that 'long linear vistas, overly great spaces, undifferentiated and uninterrupted streets, lack of color are dull and uninteresting, not so much because of their static visual qualities but because they are uninviting to move through at pedestrian speeds' (Halprin 1972: 193). These next films take into consideration the range and speed of pedestrian motion. No cars are present here, only the flow of humans and man-powered vehicles. Both films' small interventions in this routine motion highlight codified steps and their typical pace in the city, reminding us of what Jane Jacobs called a sidewalk ballet:

This order is composed of movement and change, and although it is life, not art, we may fancifully call it the art form of the city and liken it to the dance – not to a simple-minded precision dance with everyone kicking up at the same time, but to an intricate ballet in which the individual dancers and ensembles all have distinctive parts which miraculously reinforce each other and compose an orderly whole. The ballet of the good city sidewalk never repeats itself from place to place, and in any one place is always replete with new improvisations. (Jacobs 1961: 50)

Jacobs praises the randomness of movements and their syncopated rhythms on the sidewalk. She sees the disorder as a sign of individuality, of uniqueness to the location. In a similar vein, Lefebvre in the *Production of Space* suggests that 'appropriated space must be understood in relation to time, and to rhythms of time and life' (Lefebvre 1991: 356). Thus the delicate rhythm and speed of the flow of pedestrians – their walking, stopping, standing, sitting, jogging – becomes a choreographic element to disrupt and even appropriate space.

Directed by Jacob Niedzwiecki, *Who by Fire* (2013, 4 minutes) combines a high-angle shot and a lateral shot through the use of a diagonally split screen to reveal the floor patterns of a coordinated group movement in a staircase in Montreal. As the people dressed in winter clothes, ascend and descend the steps in lines with precision, none of them acknowledge each other, some are even wearing headphones. Close-ups of different shoes stepping onto the ground generate a uniform visual rhythm, as if the architecture of the staircase dictated how fast one should move. With each change of angle the camera frames the five railings, separating the flow of movement in the wide staircase, keeping the focus not on their function as aids for walking but rather on their linear division of space and potential motion. Here, this simple experiment highlights the dynamism of the staircase but also the regulated movement of the crowd associated with spaces of transit. Set to a cover of a Leonard Cohen song of the same title as the film, the non-diegetic music replaces the sounds of pedestrians, the noises of traffic and people talking with sweet voices and guitar strings. Only one young man dares to break this harmonious yet stifling mass movement pattern by hopping over a railing, bringing the crowd to a freeze-frame-like halt: he dared to step out of line.

Shot in several locations throughout Tel Aviv, *Private I's* (2012, 20 minutes) directed by Oren Shkedy and choreographed by Dana Ruttenberg, presents an instance of stalling in a space of transit. Under a bridge, two men dressed in suits move in place against the flow of pedestrians, runners, bikes and small boats. Set to a slow acoustic guitar song, the film, like others, cuts out direct sound, in the process glossing over the echoes of this large concrete space. The fixed camera frames the dancers from across the water, alternating long and medium shots, making sure to keep them centred in the linear structure of the bridge and sidewalk at all times. Their bodies face the camera, ignoring the stream of passers-by behind them just as the pedestrians ignore their largely static and gestural dance. This location, usually associated with the homeless population who use it as

shelter or musicians who use it for acoustic properties, becomes host to these theatrical bodies, over-dressed for this drab setting. Vertically compressed between the bridge and the strip of water, the bodies are only allowed horizontal movement and yet they resist it.

Surface tensions: Between skin and concrete

The next two films seek to fill vacant spaces by bringing awareness to angles, corners, nooks and crannies in the city. Displaying no apprehension of surfaces, the dancers embrace new proximities between their bodies and the environment, sharpening their tactile knowledge of visually mundane surfaces. Touching the city the way a child does, the dancers contrast the fragility of their skin and flesh with the solidity and roughness of the dirty ground. The tension between textures becomes a sensual transgression: most architecture in the city is designed to avoid direct contact with its materials. Feet seek walls, forearms scrape ledges, cheeks meet sidewalks and lips hover over grass. Exposing their bodies to raw, harsh and at times dangerous materials the dancers brave the hostile urban environment to regain the freedom to touch, to cross the border between themselves and the city.

Directed and choreographed by Eric Garcia and Kat Cole, *Pedestrian Crossing* (2012, 19 minutes) brings a human scale to public places in San Francisco. Rolling on a sidewalk or resting upside down on a bench, the dancers reconfigure the arrangement of limbs in liminal spaces such as alleys, bus stops or piers, suggesting that waiting or lingering can be seen and experienced anew. Each location seems to bubble up with collectively inscribed gestures framed in close-up and medium shots. The fixed camera depicts the city as sunny, warm and colourful. The waterfront breeze sweeps through hair and clothes. Slight car noises are heard periodically under the various music tracks while several inserts of time-lapse traffic are scattered throughout the film. Iconic shots are mixed in with dance scenes in less recognizable places. This charismatic depiction of pedestrian activities comes close to a dance film version of *Amélie* (Jean-Pierre Jeunet 2001): San Francisco looks smiley, playful and almost clean.

In Philippe Saire's film *Le bassin* (2008, 9 minutes), three men dressed in green scrubs explore a small courtyard and garden beside the Palais de Rumine in Lausanne, Switzerland. Surrounded by grass, water and stone these flexible bodies measure the building's architecture with their limbs. The film opens with a long shot of the courtyard, seen from the other side of the street, and the three men walk up to an iron gate, as if stumbling on the spot by chance during their lunch break. As the men take over the space, piece by piece, they transform three pedestal-like stone squares into platforms for dance. Each horizontal surface in the courtyard meets a body part, softly at times and with greater impact at others. They roll on soft grass, sensually tangled like a wave of human bodies. We cut to the stone where the camera catches their quick moves in close-up while the microphone records the scrapes, swipes, squeaks and ker-plunks

Figure 2. Alternative ways to sit in *Pedestrian Crossing* in San Francisco's piers. (Eric Garcia and Kat Cole, 2012) © Eric Garcia and Kat Cole.

Figure 3. Braving slabs of stone in Lausanne in *Le bassin*. (Philippe Saire, 2008) © Philippe Saire.

made by their bodies as they meet solid planes. While seemingly playful in the quality of their moves the sound underscores the pain and impact felt in the skin and bones of the dancers, exposing the relatively impoverished range of movement in urban space for the average untrained body. Taking as its main score the ambient sounds of birds and passing cars, the film gives the sense that this sheltered environment is all that is needed for this dance to take place within the city. The rhythm is to be found in the collisions between materials of the built infrastructure and the skin and weight of the human body.

The city as playground: Urban obstacle course

As the city grows vertically and horizontal space becomes crowded and expensive, it seems one would have to fight to find a piece of horizon-line or blue sky. In the late 1980s, in a Parisian *banlieue*, some found air and freedom in the practice of Parkour, or free running. Vincent Thibault, a practitioner, suggests that this discipline provides

'skilled ways to overcome obstacles, to grow from our encounters with them and to "play" with them, to have fun with them, rather than avoid them' (Thibault 2012: 38). Through rigorous training the 'parkour athlete is able to take advantage of ramps and barriers, walls and rocks, facades and railings – and any other supports, surfaces or obstacles he or she encounters. The possible movements are unlimited' (Thibault 2012: 26). In this last selection of films, urban space is finally mastered. Movements appear spontaneous because they are triggered by external stimuli like in Parkour. Material surfaces, poles, cracks, nooks and ledges provoke the body, coax it into testing their resistance. Sitting, walking, running, climbing, jumping and rolling become rebellious actions through their transposition in the wrong place: transgression seems worth the risk. By moving against the grain of the location, by playfully misusing it, these bodies find air and freedom.

Much like in urban skateboarding or free running, these films encourage a confrontational stance, seeing space 'as something dangerous to be conquered' (Borden 2013: 37). The balance between danger/safety and legality/freedom remains crucial in determining just how far one can go to become a child again, to provide what Borden calls 'a redefinition of what adult space might be' (Borden 2013: 167). Moving in such a fashion requires testing out the support of the surfaces before jumping on and off of them. Choreographers and dancers not only need to gain a tactile knowledge of the terrain but here they also must measure the possible impact of the body on the ground as it lands. This of course demands an extreme training of the dancer, but beyond physical ability it also requires the urge to play and take risks.

From split screens to composite image, from the rigid urban centre to a park's green space with the relief of a horizon line, Arja Raatikainen and Thomas Freundlich's film *Step Out* (2012, 10 minutes), set in Helsinki, suggests the need to escape the daily grind of the indoors. Grids, frames, road lines and a form-fitting office suit confine a man to a deserted city, one with no people but merely orders. The fixed camera frames his body against the empty linear space, transforming the city into a fictional cinematic world with no people or cars. As he breaks free and begins running, the obstacles shift from road blocks to triggers for potential liberating movement. As the moving camera follows him as in third-person shooter video games, the lone man jumps over fences, benches and ledges landing on snow, grass and concrete. As he reaches a park space near water, with people on benches and soft curving hills, the camera focuses on his outward gaze and pans around him in a 360-degree shot before he runs off-screen, suggesting that mobility and freedom are linked.

In *Rue Centrale 17–19* (2004, 8 minutes), another of Philippe Saire's films, three men and a woman are confined to a courtyard surrounding a building and a nearby staircase. This mundane space is pedestrian and vehicle-free but not without onlooking neighbours, who survey the bizarre activities of the group from balconies above. Through high-angle and medium shots and direct sound, we observe the dancers reappropriate this relatively non-descript location through play, creating a utopia where bodies wander freely. Corners and gaps in space are tested and probed through pressure and weight

Figure 4. The lone man against solid linear space in *Step Out*. (Arja Raatikainen and Thomas Freundlich, 2012) © Arja Raatikainen and Thomas Freundlich.

Figure 5. Exploring the limits of domestic space in *Rue Centrale 17–19*, (Philippe Saire, 2004) © Philippe Saire.

shifting. They measure the proportions and potential of the building's design, suggesting that this courtyard is anything but boring. Horizontally constricted, the dancers push, climb and jump upwards, defying the enclosed courtyard's limits.

Conclusion

Writing in the 1990s, architect Bernard Tschumi asked, 'could the use and misuse of the architectural space lead to new architecture?' (Tschumi 1994: 16). One could suggest that the trend of location shooting in experimental dance films illustrates a variety of potential uses and misuses of urban space. Tschumi continues,

fragments of architecture (bits of walls, of rooms, of streets, of ideas) are all one actually sees. These fragments are like beginnings without ends. [...] It is not the clash between these contradictory fragments that counts but the movement between them. (Tschumi 1994: 95)

In this search for movement between fragments of architecture, between chunks of the city, it is suggested here that dance films are responding to, and filling, empty spaces in the urban topography. The space produced by the dance between the bodies and the buildings becomes voluminous, almost tangible, through film.

As the camera records the traces of pedestrian and rebellious motion it 'invites everyone to become aware of the sensitive reality of the immediate environment' as Sylvie Clidière and Alix de Morant have put it in their study of site-specific dance in France (Clidière and de Morant 2009: 184). In their opinion the dancing body in urban space has the ability:

to inscribe a gesture in relation to a context, the capacity to point out a detail, to underline the features of architecture, to occupy the emptiness, to join the flux, to participate in the re-appropriation of a landscape or of a space that filters through the skin as much as the eye. (Clidière and de Morant 2009: 184)

The films brought forth, urge the viewer to reconsider the types of movement present in urban space and those predicated by architectural structures. Through their engagement with the city, these choreographers heighten our awareness of the built environment and question the codification of movement within public and private space.

Through such cinematic devices as framing, split-screens, time-lapse photography, non-diegetic music and editing, dance film-makers have found ways to empty and quieten the city enough to move in it. This process becomes a visual – and occasionally acoustic – discovery of gaps in the city's grid, textures typically masked under shoes, clothes or wheels, and a lexicon of movement not available to the average pedestrian. For the dancers involved, these films require a physical retraining of the body's muscles and senses and a breaking down of shyness in order to confront social norms. This socio-spatial inhibition is what Tim Edensor calls 'the internalization of [...] spatial norms about how to act in urban space', which 'fosters a reflexive monitoring of the self and a watchfulness towards fellow urbanites, self-surveillance and the surveillance of others' (Edensor 2005: 56). The regimentation of city life is brilliantly summed up by skateboarder Miki Vukovich, as quoted in Borden:

Our feet wrapped in cotton and leather, we trod upon a concrete and asphalt sheath, the topographical inconsistencies paved over by a more biped-friendly habitat. Mobility is orderly and efficient: sidewalks, stairways and elevators [...] With our eventual adaptation to our contrived civilization, we've adjusted and now take its sheltered

nature for granted. The crosswalk signal turns red too fast. Please pay the cashier first. My calling card has too many numbers on it. Don't even think of merging into my lane. (Borden 2013: 190)

The small interventions in the urban chaos that dance films offer urge us to consider what other art forms are currently scraping the smooth surface of architecture, pushing art outside the walls as a means of taking back public space and public movements. As Borden so evocatively ends his study on skateboarding, we ponder here the same questions in relation to art and the city: 'What does it mean to adapt, take over, colonize, emulate, repeat, work within, work against, reimagine, retemporalize, reject, edit and recompose the spaces of the city and its architecture?' (Borden 2013: 267).

As shorts largely viewed by a specialized audience, dance films face several limitations in relation to their possible impact on the city. The first practical challenge is their narrow viewership, dictated in part by their liminal status as an intermedia art, lack of mainstream distribution, and minimal inclusion in curated museum exhibitions. With the presence of online platforms such as Vimeo and an increasing number of international dance film festivals, this exposure is likely to change and this chapter aims to be instrumental in introducing dance films to other disciplines such as architecture.

The second issue is that given their focus on the physicality and aesthetics of the city, these films remain largely ahistorical. As short non-verbal works it appears beyond the scope of dance films to address and engage with the various histories of sites. Blending strategies of other site-specific arts such as land art with documentary-style filming could help create a more concrete and rooted approach to working on location. Breaching the arbitrary restricted use of text or voice would also generate interesting films that are about specific movement in a specific place at a specific time.

The third difficulty faced relates to the possible intervention made by a medium such as cinema. In seeking to empty and quieten spaces in order to fill them with bodies that dance, these films create a fictional world where such alterations are possible. As films, they crop out distractions, clean up the streets, and eliminate undesirable socio-economic problems from the backgrounds, leaving just the photogenic elements for the camera. The city's sound selectively makes its way onto the audio track, masked by music. The film filters out noise crafting harmony and rhythm in a cacophonous space. This cinematic intervention differs from a more permanent one such as sculpture or performance. In a way, the mere presence of the camera on location excuses the misuse of space. The reappropriation therefore remains primarily imaginary, making the transgression possible through cinema but not necessarily in real life.

What dance films can permanently alter is the way we imagine our trajectories in urban space. Technology now dictates the most efficient and rapid paths throughout the city, drawing the trajectory from point A to B, leaving out everything in between that is not a shop or a landmark. Google Maps, Uber, Grinder and even Grub Hub encourage us to view maps and locate ourselves within them. The increasing tactility enabled by

phones technically does allow us to hold the city at our fingertips. We touch the screen to find out where we are, we swipe to track ourselves, zoom out to see the bigger picture. But what apps exist to help us slow down? What technology teaches us what a particular city feels like? What do footsteps sound like in New York versus Amsterdam or Tokyo? What app captures Jane Jacobs's sidewalk ballet?

Dance films encourage us to re-engage with the city on a human scale, to map our own trajectories according to our physical curiosities rather than our schedule needs. How would our path through the city take shape if we were to re-temporalize it to include time to linger, to explore, to occupy, to experience the city at our literal fingertips? These films ask us to imagine what it is like to move in cities as opposed to through them, to truly sense our environments and to appreciate the value of misuse.

References

Baes, P. (1988), *46 Bis, Rue de Bellville*, Belgium.

Borden, I. (2013), *Skateboarding, Space and the City: Architecture and the Body*, New York and London: Bloomsbury Academic.

Brannigan, E. (2011), *DanceFilm: Choreography and the Moving Image*, New York: Oxford University Press.

Briginshaw, V. (2001), *Dance, Space and Subjectivity*, New York: Palgrave.

Certeau, M. de (1984), *The Practice of Everyday Life*, Berkeley: University of California Press.

Clidière, S. and de Morant, A. (2009), *Extérieur Danse: Essai sur la Danse dans l'Espace Public*/Outdoor dance: an essay on dance in public space, Montpellier: L'Entretemps Editions.

Garcia, E. and Cole, K. (2012), *Pedestrian Crossing*, USA.

Halprin, L. (1972), *Cities*, Cambridge, MA: MIT Press.

Jacobs, J. (1961), *The Death and Life of Great American Cities*, New York: Vintage.

Kloetzel, M. and Pavlik, C. (eds) (2009), *Site Dance: Choreographers and the Lure of Alternative Spaces*, Gainesville, FL: University Press of Florida.

Lefebvre, H. (1991), *The Production of Space*, Oxford: Blackwell.

MacPherson, K. (2006), *Making Video Dance*, New York and London: Routledge.

Niedzwiecki, J. (2013), *Who by Fire*, Canada.

Parris, G. (2012), *Brighter Borough*, UK.

Raatikainen, A. and Freundlich, T. (2012), *Step Out*, Finland.

Rosenberg, D. (2012), *Screendance: Inscribing the Ephemeral Image*, Oxford: Oxford University Press.

Saire, P. (2004), *Cartographie 5: Rue Centrale 17–19*, Switzerland.

—— —— (2008), *Cartographie 7 – Le bassin*, Switzerland.

Shkedy, O. (2012), *Private I's*, Israel.

Thibault, V. (2012), *Parkour and the Art du Déplacement*, Montreal: Baraka Books.

Tschumi, B. (1994), *Architecture and Disjunction*, Cambridge, MA: MIT Press.

Notes

1. For further information on the different categories in dance film see Erin Brannigan, *DanceFilm: Choreography and the Moving Image* (2011), Douglas Rosenberg, *Screendance: Inscribing the Ephemeral Image* (2012), or the recently published *International Journal of Screendance* Vol. 5 (2015).

Chapter 8

Thresh, hold

Dirk de Bruyn

Introduction

This analysis focuses in on the short documentary *ThreshHold* (2014, 20 minutes) by Dirk de Bruyn, constructed to document the history and childhood remembrances of the Geelong Waterfront area and its Western and Eastern Beach-fronts for exhibition at local tourist sites and at Deakin University's Waterfront Campus. The City of Geelong is a regional centre situated close to Melbourne critically expanded in the 1960s through post-World War II migration and on the back of now disappearing manufacturing industries. This chapter discusses the use of photographic material gleaned from the Geelong Heritage Centre, the Victoria State Library, the National Film and Sound Archive and other archives, and how this material was placed in relation to each other through digital animation techniques. This discussion's primary focus are the photographic collections of Charles Daniel Pratt and Wolfgang Sievers sourced from these archives. The searching for photographic material is itself experienced as a simulated situationist dérive (a drifting urban journey) similar, yet experienced as idiosyncratically different, to a material exploration of the city itself. Using examples from the video, it is argued that the gap between what is verifiable and what is remembered has affinities with the way memory itself gets things 'wrong', with what Janet Walker has called disremembering in which memories are often reshaped by their emotional charge on the one hand and by the characteristics and biases of the recording devices on the other.

ThreshHold presents an illustrated oral history of the impact of industrialization and its decline on a regional metropolis. In this audio-visual essay/animated documentary, Jim Demetrious' childhood memories of the Geelong Waterfront are recounted through phases of technological change. Jim's father's family fish shop was critical to his remembering. His Greek migrant parents met at the heart of the region's industrialization, the Ford Motor Factory, now lost through the forces of globalization. Jim relates time spent at local beach and amusement spaces, and he maps the decline of the local fishing industry, the waterfront trade and its wool stores (now a university campus), and the rise and wane of local beach culture.

The word 'threshold' was used in the title(s) as a McLuhan-like 'probe' to simultaneously evoke the waterfront as city border, its role as trade portal, as recreation zone, as transition between public and private space but also as suggestive of the liminal zone between remembering and forgetting, of imagining both past and future. The word was

further split into its two parts 'thresh' and 'hold' to invoke the Janus-like tensions between mobility and stasis, enhancement and obsolescence that run through this analysis of progress. Inside of *ThreshHold* the word's various dictionary meanings are spoken in varying digitized migrant's voices/accents to emphasize the focus on migration of people, ideas and media in this study.

Critically, *ThreshHold* also implicitly maps the generational shifts in recording devices spanning its narrative. The clean and stylized black-and-white photography of industrial and design photographer Wolfgang Sievers (1913–2007) and the highly detailed imagery of aerial photographer Charles Daniel Pratt (1892–1968) both reflect in form as well as content their originating context. Pratt offers an autobiographical trace of the technologies of World War I and Sievers offers a response to the experience of World War II, not at the centre of these conflicts but at the postcolonial margins in both Australia and New Zealand.

Sievers' and Pratt's work is now digitally accessible in online archives, more complex and multifaceted than the ones these artists originally assembled, enhancing the accessibility of the original physical photographs. From their originating form, historic image technologies have now migrated into the hyper-malleable digital form of Vilém Flusser's 'technical image' as demonstrated by Google Maps, where they re-perform many aspects of Sievers' and Pratt's earlier 'real' migration. For Flusser, 'technical images are meaningful surfaces. Created by programs, they are dependent on the laws of technology and the natural sciences' (Ströhl 2004: xxiii). This online mobility obsolesces physical migration. Animation's value is also evaluated to depict aspects of the past that remain more inaccessible to recall, unspeakable or otherwise irretrievable.

There are four historic strands weaved through *ThreshHold*. These are placed in relationship to each other, both sequentially and simultaneously, in the screen's expanded field. The earliest thread is the aerial photography archive of Charles Daniel Pratt surveying Geelong's provincial metropolis from the 1920s to the 1950s. Secondly, the celebrated industrial photography of Wolfgang Sievers documents the Ford Factory and Geelong Wharves in the 1960s and 1970s, while Jim Demetrious' oral history of growing up in Geelong from the late 1950s provides the film's spoken narrative spine. A fourth contemporary animation amalgam: contemporary recordings from Google Maps and surveillance-like time-lapse recordings of the beach areas, today functions as terminal container for Pratt's and Sievers' work, in dialogue with Demetrious' oral history.

Pratt's and Sievers' histories especially are incorporated into the narrative as an ahistorical aesthetic trace, implicitly communicating its period through the idiosyncrasies of the recording devices accessible in each period. How much are these traces about the personalities that produced them and how much are they about the technical processes at the heart of those media that envelop these personae?

Pratt

Charles Daniel Pratt (1892–1968) began working life as a New Zealand grocer in Helensville coming to Geelong after World War I. He had enlisted in the army from 1914 to 1918 and served in the Gallipoli campaign, where he was wounded. The Gallipoli campaign is the foundation legend of both Australian and New Zealand nationhood, celebrated annually in both countries on the public holiday of ANZAC Day (Australian and New Zealand Army Corps) on the date of the Gallipoli landing. Interestingly, the re-named ANZAC Cove site itself in Turkey has been transformed into a site of both remembrance and celebratory nationhood with all the tourist trappings this brings, succumbing to the same forces at play in the transformation of Geelong's cityscape. On its 2016 celebration special mobile stands were built and a tourist cruise ship lay off the coast to witness the dawn service of ANZAC's centenary remembrance, an event also dominating every local television screen and news report back in Australia as a media event.

Charles Pratt also served in the Egypt and Palestine campaigns, serving in the New Zealand Engineers, in the motor dispatch riders. He received a Victory Medal. His final service was in the Royal Flying Corps. He rose from private to lieutenant during his service. There are a number of photographs in the New Zealand Archives of crashed and captured planes from these campaigns attributed to Pratt. After his war service, Charles and his brothers established a factory in Geelong, Geelong Air Service Pratt Bros., where they assembled De Havilland planes and offered joyrides to the public as well as providing flying instruction. Charles taught his three brothers to fly.

Geelong became the base for Pratt's aviation business by chance. Charles had bought a shipment of planes in Egypt after the war in the early 1920s and found difficulty in moving them from the docks in Melbourne in transit on to New Zealand due to an industrial dispute. As a result, he assembled his De Havilland plane there and flew to the bay area of Port Phillip Bay, discovering Geelong's Belmont Commons as a productive site to offer joyrides around the area, leasing it in 1919 with residence established at 200 Latrobe Terrace, Geelong.

The Pratt Brothers also ran a Sunbeam motorcycle business in Geelong from 1932. Younger brother Frank Pratt became a successful motorbike racer at Phillip Island, which Charles recorded on 16mm motion picture film. The Auckland War Memorial Museum has a series of images of Charles Pratt in World War I soldier's uniform and photos on motorbikes with his brothers, indicating an extended relationship with the existing technologies of speed. There is also a Geelong Air Service Pratt Bros. photograph of workers and staff from 1922 and a group photo of the Citizens Air Force taken at Point Cook (near Geelong) in 1926. Interestingly in this New Zealand archive Pratt's birth is given as 1891 and date of death is unknown, whereas the State Library of Victoria has his life spanning 1892 to 1968.

The aerial photographs used in *ThreshHold* are attributed to Charles Daniel Pratt and his company Airspy (see Figure 1). During World War I many pilots were trained in air photography with improved technologies requiring both a pilot and photographer. Aerial

photography had come of age in the Palestine campaign by augmenting inadequate maps of the Turkish Front. The Warbird Information Exchange, a public sharing archive of historic aviation imagery, has a series of images attributed to Charles Pratt, posted by CDF (pseud.) (CDF 2009), of British and German crashed and intact World War I aircraft, photographs referenced to the Royal Australian Flying Corps in Palestine. The State Library of Victoria has also made a 30-page virtual photographic album from the Airspy collection available online, with four images per page containing further images of aircraft and motorbikes and also photographs taken from the air of an airstrip and camp, in both Egypt and Palestine. Figures 1–3 show airborne imagery of the technology associated with aerial photography (State Library of Victoria n.d.).

From the 1920s to the 1960s, Airspy was a significant innovative enterprise in regional Victoria, Geelong and Melbourne. Independent researchers Ken Mansell and Michael Riley indicate that Major Harry Turner Shaw (1889–1973) and William Herbert Hansom (1862–1939) were central figures, and they note that: 'It is unclear when Pratt became involved with Airspy. Nor is it clear his involvement was ever as photographer' (Mansell 2013). Images viewable through the Warbird Information Exchange and the Auckland War Memorial Museum (Auckland War Memorial Museum n.d.) indicate that Pratt had a long, competent relationship with aerial photography.

Figure 1. Dirk de Bruyn, *ThreshHold* (2014). Video still.

In any case, Charles Pratt's estate donated the extensive 'Airspy Collection' of aerial photos to the State Library of Victoria under Pratt's name in 1972 and the collection was consequently digitized in the early 2000s. Pre-1950s photographs are legally out of copyright and so freely downloadable as 4K image files (.tiff) from the Library website. This access is available to all members of the public with no login required. These photographs were originally located through a simple online search of the State Library of Victoria, using combinations of 'Waterfront', 'Eastern Beach', 'Western Beach' and 'Geelong', with Pratt's critical history unearthed by coincidence and expanded through further online inquiry. In some ways this digital search reiterates in digital form Pratt's own situation with his aircraft immobilized on a Melbourne wharf and his consequent pragmatic searching-flight landing him in Geelong.

Akin to Pratt's encounter with the Melbourne wharves, research at the Geelong Heritage Centre had proved much slower than at the Victorian State Library and Victorian Museum, as it required searching through a physical filing system and microfiche during opening hours that gave uneven written descriptions of the images involved. At least a day's notice was then required to view any images on-site and then further negotiation on their use. This appeared to be a system designed for efficient pre-digital use, one that had not yet incorporated the efficiencies of online archiving. This necessary but time-consuming process was of course much more difficult to execute than going online after completing a list of other teaching and academic tasks during the day; the reality of an information-rich but time-poor professional environment.

Within the digital, ethical constraints and copyright considerations can further slow the acquisition of images. Though executed online, the use of culturally sensitive images of Geelong's early indigenous inhabitants has understandably had to undergo an ethical but obscure clearance process within the State Library system that took eighteen months to finalize and so was not available for the production of *ThreshHold*'s final iteration, although within the digital another version can always be cloned and projects, technically speaking, can always remain open-ended at no extra expense.

Pratt's war-hero status in a military campaign that defined Australia and New Zealand's key ANZAC identity, combined with the eminent role of aviator and a continued association with the technologies of progress, all marked Charles Pratt with distinction, and were markers successfully converted to commercial success in a provincial setting. The prominent high-definition vistas of Airspy's black-and-white aerial photographs speak to this cultural elevation, further offering a domesticated visual trace of the brutal military operations that spawned its technology and technique, situations experienced directly by Pratt during his World War I service. The archiving of Pratt's accumulated photographic record that registered within it the technologies (or media) of flight, speed and travel, transforms Pratt's cultural capital into a form of distinction tailored for digital retrieval.

Sievers

Wolfgang Sievers' (1913–2007) photographs were also sourced from the Victorian State Library online catalogue. His story and practice were more visible inside Australian cultural debate than Pratt's. Sievers landing in Australia in 1938, uncannily avoiding conscription as an aerial photographer for the German Luftwaffe led him to become the pre-eminent industrial and architectural photographer in Australia. Sievers himself 'claimed to have been instrumental in changing the image of Australia as a country of wheat and wool to one of industry, craftsmen and scientific achievements' (Zuker and Jones 2007). His father was an art and architectural historian dismissed by the Nazi government in 1933 and his mother a Jewish writer and educator. From 1936 to 1938, Sievers studied at the Contempora-Lehrateliers für neue Werkkunst in Berlin. After war was declared, already in Australia, he served in the Australian Army from 1942 to 1946.

In 1988, Sievers stated that the aim of his industrial photography was:

To promote and enhance Australia's standing in the world as an industrial nation capable of turning out precision work of the highest quality and to overcome ideas still widely held overseas that Australia was a strange place only fit for sheep, wheat, minerals, kangaroos. (Ennis 2011: 33)

In Australia, Sievers' Bauhaus-influenced industrial photographs are widely understood as documenting the nation's post-war industrial boom. His stylized photographs of Geelong's Ford Motor Factory workers and its production line communicate the dignity of labour in relation to the precision of industrial machinery. These visual documents were fashioned, photographed at night so that Sievers could control the lighting and clean up the 'set' of what became imagined theatrical dramas, producing images as considered as any black-and-white publicity still from a 1950s popular movie. Sievers' archive has been culturally recognized in analogue form and then institutionalized as communicating the optimism and vision of its time. In 1991 and 1992, the National Gallery of Australia toured a major retrospective of his work and in 2002 the National Library of Australia purchased his photographic archive.

While Helen Ennis asserts that Sievers' photographs could have been taken anywhere in the industrialized world (Ennis 1997: 116), for Dunja Rmandic 'the full effect of the photograph lies in its context' (Rmandic 2007: 7), communicating an in-between that is part of being a migrant in Australia, performing Paul Carter's 'constant arrival'; 'the migrant does not arrive once and for all but continues to arrive, each new situation requiring a new set of responses, almost a new identity' (Carter 1992: 3). For Rmandic, images like the Geelong Ford Motor Factory parking lot, surrounded by established suburban houses, ask 'are we looking at an abandoned project or one newly begun?' (Rmandic 2007: 7) (see Figure 2). This is a question that now returns, predicting Geelong's contemporary waterfront, a public space morphing from industrial hub to public entertainment

Wolfgang Sievers, 1951

Figure 2. Dirk de Bruyn, *ThreshHold* (2014). Video still.

precinct. This ambiguity of simultaneous stasis and mobility that Rmandic alludes to from her migrant's perspective is extended and flipped by the digital tourist who trawls and sends information around the globe at the speed of light, while themselves completely immobilized at their computer workstation.

Sievers' images deliver more than a modernist aesthetic. They suggest an in-between space to the viewer. European migrants, upon arrival in Australia, often lamented the provincial state of their new location (Rmandic 2007: 8). Echoing Rmandic's query on abandonment and renewal, Sievers' 1960s images of Geelong's Cunningham Pier, for example, though respectful of the workers recorded, have the now refurbished Lascelles Wool Stores in the background, before their transformation into Deakin University's Waterfront Campus: an image of a landscape in transition and containing the signs of both abandonment and renewal, of obsolescence and enhancement. Jim Demetrious' childhood reminiscences also noted a working waterfront in decline.

Being post-1950, Sievers' photographs, though available online in thumbnail form, are not copyright-free like those of Pratt's, but can at the discretion of the Library services, under the stipulations of Sievers' donation, be freely utilized for educational or research purposes, enabling their use for the *ThreshHold* project. Within these guidelines each image is available in high-quality digital form for a nominal $23.00 fee, a process negotiable online.

In a further, even more emphatic moral framing, in 2006 Sievers submitted all his remaining photographs in benevolence to human rights activist Julian Burnside, QC, to be sold to benefit human rights causes. This gesture had raised more than $350,000 by the end of 2011 (Burnside 2011). This is a further iteration of Sievers' open professional practice, both echoing and re-asserting his laudable evasion of the Holocaust and its consequences, while simultaneously ensuring the ethical stature and retrievability of his archive within mainstream Australian national history.

Demetrious

The narrative spine of *ThreshHold* is a roaming recounting of Jim Demetrious' childhood and youth, of Geelong's changing waterfront spaces, earlier recorded physically by Pratt and Sievers, and the recall of events and beach vistas from the 1960s and 1980s. Jim's voice contains those searching pauses and hesitations of retrieval, that oral rhythm and tone signifying the act of a searching remembrance. There is a randomized rhythm here akin to that grazing mode when image-trawling the Internet or aimlessly wandering through a city's streetscape, something that now gets simulated at the other side of the world with a dérive through Google Maps, the latest reincarnation of what Vilém Flusser has named the 'technical image'.

Jim Demetrious' Greek parents migrated in the 1950s, slightly later than Sievers, post-World War II. They met and married in Australia. After working at the Ford Motor Factory the family started its own fish shop in the early 1960s, buying fish from the local fishermen. Demetrious recounts going to Eastern Beach as a child with his father and later his friends, and the games they played. As a youth he recalls the platforms and diving boards of the more popular Western Beach, the vanished dodgem cars of Hilite Park, the carnival rides and bowling alley, moving as a group of boys through the now obsolete railway yards servicing a working port in decline. He recounts a disappearing scallop industry through overfishing, a diminished wool industry relocated elsewhere, and the pleasures of fishing for large schools of whiting now also absent.

He mentions the emptying of crowds from Eastern to Western Beach and then to the nearby surf beaches facilitated, ironically, by the new mobility of the affordable family car manufactured in the very factory that had sustained Geelong but is now also set to close in 2016. The film notes Western Beach's 1980s gentrification as a park for local family and community life, as well as the current urban renewal centred around the tourist refurbishment of the waterfront area near Eastern Beach, of which the new Ferris wheel is a major feature. It is this malleable oral recounting that is illustrated by the works of Pratt, Sievers and others in digital form.

An important anomaly is Jim's recall of a display of Elvis Presley's pink Cadillac. This was a stand-out memory from his youth: 'The honey pot that brought people back to Hi-Lite Park'. Awkwardly, research confirms that the Cadillac was actually gold, not pink.

How could he get it so wrong? Judith Walker coined the term 'disremembering' for such a synthesis of embellishment and blunder (Walker 2005: 80). Such mistakes do not discount a core experience at the memory's base but power an emotive force for transforming the real into metaphor. Does a similar architecture of anomaly and 'truth' hold true for the authorship of Airspy's archive, Pratt's date of birth and death, or Sievers' view of his own achievements? Also, is such dis-remembering now embedded too seamlessly through the malleability of digital media, into the surface of Flusser's 'technical image'?

Animation amalgam

A digital amalgam of these historic traces form *ThreshHold*, combined with contemporary animation techniques (see Figure 3) such as time-lapse, rotoscoping, pixilation and sounds from present-day Geelong. Sound effects of dodgem cars, bowling alleys and seaside atmosphere are sourced from online sound libraries. Time-lapse images of Geelong's new Ferris wheel and Eastern and Western Beach foot and road traffic are all recorded on-site.

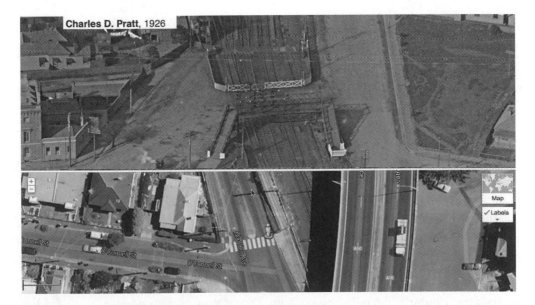

Figure 3. Dirk de Bruyn, *ThreshHold* (2014). Video still.

Figure 4. Dirk de Bruyn, *ThreshHold* (2014). Video still.

Today, the waterfront precinct near Eastern Beach is under transformation into a public recreational space populated with coffee shops and restaurants, surrounded by sculptures and community art. The precinct's enclosed swimming area with its surrounding lawns and palm trees are crowded family recreation areas at the height of summer, but in winter speak of an emptied desolation rather than 'public' and 'community' (see Figure 4). Western Beach foreshore has also undergone a gentrification process, initiated in the 1980s, to parkland and community- and family-recreation areas in which Jim Demetrious' own young family participated through community clean-up events.

This is presented in *ThreshHold* by colour photographs taken by members of that community. These images are marked by the aesthetic of the one-hour-photo processing service and speak to a period when the act of colour photography in itself had become easily accessible as a form of public recreational pursuit. These DIY collections are not resident in an artist's or professional photographer's studio or public library but available in the family home and family photo album. Digital cameras have more recently further mobilized such personal documentation, leading to the contemporary rise of the selfie, the proliferation of images on sites like Facebook, Flickr and online generally.

This amalgam demonstrates what Lev Manovich identifies as the shift in visual culture from a photographic to a malleable painterly digital medium with animation practice at its core (Manovich 2001: 302). The layering technologies of editing software now available, like Photoshop, Final Cut Pro, Premiere Pro and After Effects, and phone apps like Motion Pics (2011) and Stop Motion (2014), which enable HD time-lapse and animation on the fly, all transform the documentary image into the endlessly plastic and pliable moving artefact. This signifies a shift from the witnessing of the real associated with the traditional analogue chemical photograph whose final popular iteration was really the one-hour photolab image and the Super 8 film.

Time-lapse of city streets and night-time skyscrapers and traffic have become generic background filler in news, documentary and fiction films. Today, anyone walking along the Geelong Waterfront with their iPhone can make a pixilated or time-lapse record of their journey on a phone app and no passer-by gives it a second thought. Animation practice has mobilized, moving out of the studio and into the city streets. Documentary animations by Blu, Stephan Müller, Kseniya Simonova and Darcy Prendergast demonstrate this mobility. In *Muto* (2008) and *Combo* (2009), Blu re-animates his characters onto discarded buildings and walls. Müller uses public billboards, street signs and found objects as tabloids for his quirky visual humour in *Bow Tie Duty for Squareheads* (2004). Simonova won the *Ukraine's Got Talent* TV show in 2009 with a historic narrative presented live in the television studio. In *Lucky* (2010), Prendergast draws and animates objects and animals in public spaces with coloured torches at night.

As stated, for Manovich animation is now the core discipline at the base of digital media. He discerns an affinity with pre-cinema toys: 'the manual construction of images in digital cinema represents a return to the pro-cinematic practices of the nineteenth century, when images were hand-painted and hand-animated' (Manovich 2001: 295). Such flexibility is available in the annotated post-cinema Google Map, the mixing of live action and time-lapse with hand-drawn animation, all examples of Flusser's contemporary 'technical image' (Ströhl 2004: xxiii). For Flusser, the means of constructing these meaningful surfaces are rendered invisible, creating a form of amnesia in its audience that compels analysis:

> The technical images currently all around us are in the process of magically re-structuring our 'reality' and turning it into a 'global image scenario'. Essentially this is a question of 'amnesia'. Human beings forget that they created the images in order to orientate themselves in the world. Since they are no longer able to decode them, their lives become a function of their own images: Imagination has turned to hallucination. (Flusser 2000: 10)

> [...] any criticism of technical images must be aimed at an elucidation of its inner workings. As long as there is no way of engaging in such criticism of technical images, we shall remain illiterate. (Flusser 2000: 16)

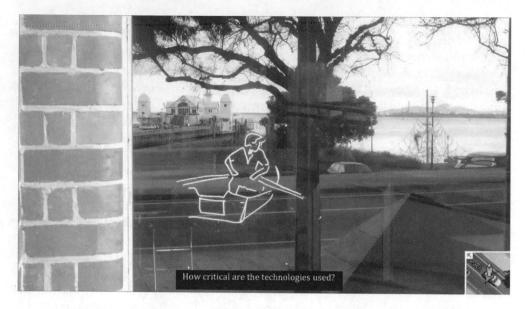

How critical are the technologies used?

Figure 5. Dirk de Bruyn, *ThreshHold* (2014). Video still.

Like Müller's, Blu's and Prendergast's, *ThreshHold's* animated sequences also migrated out of the studio and into street, to lay bare the inner workings of the 'technical image' in public space. This move was executed by rotoscoping historic activities with liquid chalk on the windows and walls of waterfront buildings as animated removable graffiti, and also more simply by recording frame-by-frame (pixilation) movement of bodies, cars and light at the Geelong Waterfront. Rotoscoping is a technique of tracing over footage, frame by frame; it is a cost effective method of recycling historic material. The rotoscoping included white line animations of a man rowing a boat across a real road (see Figure 5), a girl digging for sand with a bike path visible in the window's reflection, and another white line drawing of boys diving into water with a children's playground visible in the window's reflection. Yet another animation has a couple swimming over the top of evening traffic at Cunningham Pier. Further, emulating Prendergast's technique, a penlight was used to animate texts in public space at night using the time-exposure settings on the digital still camera. In these ways, imagined or remembered activities were placed back into the real space from which they had originated.

Rewind

The rationale in identifying the personal histories embedded in Sievers' and Pratt's imagery, and suggesting that these can be retrieved ahistorically through their texture, form and structure, returns to Flusser's call to elucidate the technical image's inner workings and essentially incorporates McLuhan's insight on the primacy of the medium over its content. Flusser's call brings into focus an archaeology of the (technical) image where different layers of progress can be gleaned from the digital's surface by the tutored or trained eye – one familiar with the aesthetics of a particular period of technological innovation and progress, homologous to how a history of architecture is available to the trained eye via a procession of building facades.

Flusser's 'global image scenario' is not as utopian as Marshall McLuhan's 1960s manifestation of a 'Global Village', incorporating the insights of migrant displacement that Rmandic identifies in Sievers' photographs. McLuhan's 'Age of Anxiety' (McLuhan 1964: 12), brought on by electric speed, and evident in the mobility performed by Pratt's heroic engagement with the machine and displayed like trophies inside his photographs, becomes for Flusser a problem of hallucination and amnesia, of forgetting within the information overload of the digital-image explosion, which Demetrious' oral remembering in turn valiantly attempts to counter and retrieve through the personal.

The tensions at play between different media within *ThreshHold*'s audio-visual essay bring to mind McLuhan's *Laws of Media* (1992). These laws probe the relationships between media, which Graham Harman further extends to all entities such as 'trees, reptiles, gases and stones' (Harman 2009: 122). McLuhan's four laws of media ask: what does each medium enhance? What does the medium make obsolete? What does the medium retrieve that was previously obsolesced? What does the medium reverse, flip into, when pushed to its limits? For McLuhan, these laws are not deterministic but to be used as reflexive 'probes', as tools to make visible, lay bare, the forces at play.

In contemporary mixed-media environments these shifts have become more complex and multilayered. At its most challenging, now a digital moving-image work like *ThreshHold* presents a field of instantaneous interactions between media forms, rather than the physical migration from point A to point B performed by Pratt and Sievers. The historically obsolesced imagery of Pratt and Sievers is retrieved in a digital form in archives, photo albums and videos and placed in relation to other media, in a cluster that enhances, extends the multi-tasking capacity of the human nervous system. A Pratt image may sit on the screen next to a Google Map with subtitles below, for example.

The migrant's in-between that Rmandic locates in Sievers' photography now proliferates as a system in its own right. This is Flusser's 'Global Image Scenario'. Pratt's aerial views now blanket the globe, available for an infinite and continuous set of fly-throughs from the confines of your own apartment. What reversal occurs when this open system reaches its limits? The pervasiveness of recording devices and their reflex-like use predict a flip

from the public metropolis of multiple voices into a panopticon of profiling, surveillance cameras and drone technologies.

For Flusser, the experience of displacement, a dissociation experienced directly and viscerally in real physical migration, which grounds the migrant's experience, is now experienced by all through the digital hyper-mobility of capital and media, bringing about a preoccupation with surface and a proliferation of technical images that communicate concepts rather than phenomena and events (Flusser 2003), a more ambiguous reincarnation of McLuhan's 'The Medium is the Message'. For Flusser, what is retrieved in digital media is the 'freedom of the migrant' rather than the mind-set of the privileged cultural tourist. Invoking McLuhan's fourth law: what will return into view when this technological situation is pushed to the extreme of information overload is the visceral trauma of the concentration camp, its constant denials and forgetting, its pervasive scrutiny and the looping metamorphosis of all flesh into capital. This is a situation for which Arthur Kroker predictively invoked the term 'Panic Bodies': 'unlike billboards in the age of pavement, these advertisements are injected directly into the veins of the post-flesh body like bar codes burned into flesh' (Kroker and Weinstein 1994: 109).

Conclusion

What remains retrievable, embedded in the seamless transitions to digitized archives, is the implicit aesthetic trace fashioned by the recording devices of each historic period. Within the digital's malleable imagery – Flusser's 'technical images' – the possibility emerges for the image to perform the flawed but real processes of remembering, which for Walker includes disremembering, identifying forces operating in the complex narratives of daily life, that propelled both Pratt and Sievers to an Australia at the fringes of Empire.

Does this new situation enable the archive to communicate a more 'accurate' view of the past? Or is this question merely a trace of a way of critical thinking no longer available in our new field of technologies? This analysis suggests that it is a bit of both, and that the push and pull of McLuhan's four laws of media can help probe the layered archaeology of the contested media spaces documented in *ThreshHold*, and the media sourced to construct that animated audio-visual essay into a shadow of the mediated city.

A version of the documentary that was used as platform for this discussion can be viewed online at: https://vimeo.com/87764985.

Photographs by Wolfgang Sievers and Charles Daniel Pratt sourced from the Pictures Collection, State Library of Victoria, Melbourne, Australia.

References

Auckland War Memorial Museum (n.d.), 'Charles Daniel Pratt', *Online Cenotaph*, http://www.aucklandmuseum.com/war-memorial/online-cenotaph/record/C20515. Accessed 15 May 2015.

Bruyn, Dirk de (2014), *ThreshHold*, https://vimeo.com/87764985. Accessed 12 June 2015.

Burnside, J. (2011), 'Born to See', *Australian Book Review*, 334, September pp. 44–45.

Carter, P. (1992), *Living in a New Country: History, Travelling and Language*, London and Boston: Faber and Faber.

CDF (2009), 'WW1 Images by Charles Daniel Pratt 1892–1968', *Warbird Information Exchange*, http://warbirdinformationexchange.org/phpBB3/viewtopic.php?p=519583. Accessed 15 May 2015.

Ennis, H. (1997), 'Blue hydrangeas: Four emigré photographers', in R. Butler (ed.), *Emigré Artists in Australia 1930–1960*, Canberra: National Gallery of Australia, pp. 109–18.

—— —— (2011), *Wolfgang Sievers*, Canberra: National Library of Australia.

Flusser, V. (2000), *Towards a Philosophy of Photography*, London: Reaktion.

—— —— (2003), *The Freedom of the Migrant: Objections to Nationalism* (ed. A. Finger), Urbana: University of Illinois Press.

Harman, G. (2009), 'The McLuhans and metaphysics', in J. K. B. Olsen, E. Selinger and S. Riis (eds), *New Waves in Philosophy of Technology*, London: Palgrave Macmillan, pp. 100–22.

Kroker, A. and Weinstein, M. (1994), *Data Trash: The Theory of the Virtual Class*, CultureTexts, New York: St. Martin's Press.

Manovich, L. (2001), *The Language of New Media*, Cambridge, MA: MIT Press.

Mansell, K. (2013), 'Boyles Football Photos', http://boylesfootballphotos.net.au/tiki-read_article.php?articleId=33. Accessed 15 May 2015.

McLuhan, M. (1964), *Understanding Media: The Extensions of Man*, New York: Signet.

—— —— and McLuhan, E. (1992), *Laws of Media: The New Science*, Toronto: University of Toronto Press.

Rmandic, D. (2007), 'Wolfgang Sievers and the revisionism of Australian migrant art', *emaj*, 2, pp. 1–9.

State Library of Victoria (n.d.), 'World War 1 – Charles Daniel Pratt', http://www.slv.vic.gov.au/flipbook/ww1_charles_pratt/#. Accessed 15 May 2015.

Ströhl, A. (ed.) (2004), *Vilém Flusser: Writings*, Minneapolis: University of Minnesota Press.

Walker, J. (2005), *Trauma Cinema: Documenting Incest and the Holocaust*, Berkeley: University of California Press.

Zuker, D. and Barry, J. (2007), 'Titan's lens and moral compass enlightened all', *The Age*, 17 August 2007.

Chapter 9

Qualities of lustrous gatherings

Riet Eeckhout and Ephraim Joris

Introduction: Continuation of historical experiential spatial qualities

In today's urban environments, sited in network, the notion of place, as described by Marc Augé and Michel de Certeau, has a reduced capacity to acquire 'stability' or apply the idea of absolute emplacement (Augé 1995; de Certeau 1984). Typically, when we analyse sites within the contemporary metropolis, we aim at understanding their identities through exploring relations of proximity, connecting a network of information such as local climate and socio-historical data with newly designed form, in order to generate contextual relevance for its new spatial conditions. A place, as defined by Marc Augé and Michel de Certeau, is relational to its surroundings and its history. Yet in these current environments of 'connective-ness', the idea of relational proximity starts to show signs of absolute vastness. Where Marc Augé describes the emergent phenomenon of non-places as a result of these global mediated conditions, we aim to put forward, as part of our work, the idea of rescaling the technique by which we assume emplacement. As illustrated through a number of projects later on, many urban sites we work with have gained a particular quality of emptiness. Erasures upon erasures of urban fabric, the subtraction of a local community, the abundance of vehicular traffic infrastructures interlaced with generic architectural mass, has transformed such sites into urban vacuums. 'Architectures that were once specific and local have become interchangeable and global; national identity has seemingly been sacrificed to modernity,' Rem Koolhaas states in his role as director of the Venice Architecture Biennale 2014 in which we participated with a counterproposal (Figure 1). We see our work, in part, as a challenging force against this state of modernity not to promote national identities but to develop an architecture in our cities that establishes continuity between past and present; an architecture of duration to allow a narrative capacity to re-emerge in the way we assume emplacement. As we will explain, we do this by according to a collapse of time, firstly within the space of the drawing, the mediating instrument of architecture. Through drawing we place objects within the simultaneous-ness of all time past to allow endless possibilities of conceptual and formal intersection. Within this space we record décor for the object to accumulate historical traces with the aim to continue certain historical-experiential spatial qualities without creating a theatre for nostalgic clichés.

Expressing duration as a spatial quality

In doing so, we aim for the escape of a scholarly landscape of memory-theory to actively search for useful overlaps between indeed a scholarship of memory and a scholarship of vitalism (McKim 2010). Our interest in memory is thus not entrenched in pursuing acts of conservation and tradition. When we speak of continuing historical-experiential spatial qualities, we carefully act through tactics of duration and repetition to allow memory to be subjected to a variety of transformational forces. The act of repetition is thus subjected to conversion as opposed to conservation to engender what one could call 'architecture of becoming' as opposed to 'architecture of being' (with a certain Deleuzian connotation). The trajectory force in this instance is thus more oriented towards the future than it is towards the past, clearly without denying the importance of the past.

Like Constantin Constantius (Kierkegaard [1843]), we find ourselves trying to regain sensations and impressions from a past; not just our own but the past of any site anywhere in the world. Very much like Constantin Constantius, we find that no such thing is possible, in that a repeated experience is a new experience in reference to the old and never ever equal or even remotely similar. Sensations and impressions cannot be regained as they were, as one would hold time in detention in a representation of the past without allowing the world to continue its ever-changing momentum. Repetition, as defined by Kierkegaard, has indeed a very significant property in that there can only be repetition through change. This understanding of generating difference through repetition opens up new exploratory roots of investigation into more profound understandings of architectural design in reference to its own history. Of course amongst everyone else, we undergo an uncompromising force towards the future as our grinning faces gleam in its brightness. However, as the mother of all inventions walks her ancestral path, modernism has allowed (but is not fully responsible) for a bridging of a historical topography and has offered us the highroad. Here we trace our scope for architecture, sustaining these urges for progress without the amplified need for fast semi-normalized architecture. Instead we want to recognize, time and time again, the potency, the implicit sense of duration, that history holds.

Time as duration

Time in this instance is perceived as a force on which multiple pasts – memories and chronicles – drift simultaneously and interdependently. As such, we observe the status of the past as a positive presence sustaining a momentum of actuality.

Henri Bergson (1913) opposes the concept of time and the idea of our consciousness within to be a linear construct of divisible instants, such as hours, minutes and seconds, mainly because this Newtonian understanding of time as quantified segments does not allow us to understand or even come into contact with the qualitative nature of time and our being conscious of that time. For example, if we enter the Duomo in Milan we can

170

experience an overall experience of contentment and awe. Walking through a field of gigantic stone pillars, this feeling cannot be subdivided into moments. One experiential moment of walking along the nave continues into a next experience of walking along the transept windows without clear boundaries or identifiable margins between these experiences. Bergson defines this as duration, a progression of qualitative changes allowing one to impact the other. Joel McKim (2010) provides us with an account of what Bergson and Deleuze unravel as an elaborate structure of time and addresses two very different kinds of past: on the one hand he accounts for a past that was once present, such as us walking past the transept windows of the Duomo; on the other, he explains the existence of an a priori past into which the former present can drift. This 'pure-past' pre-exists the passing present and forms a repository for all former presents to exist in a virtual state of coexistence. Deleuze writes, '*it is the whole, integral past; it is all our past, which coexists with each present*' (Deleuze 1953: 59 [emphasis added]). It is precisely because of this co-occurrence of past and present that one can never repeat an event from the past without significantly changing the experience of this. This also explains the impossibility of reclaiming or reconstructing the 'original meaning' of any historic event or object, as many art historians have attempted to do.

So we ask ourselves: how can we work productively from an inevitable present through memories of the past? With our drawings we associate with what Bergson and Deleuze explain as the process of remembering through a double act of expansion and contraction, taking place in what they refer to as the pure-past.

Bergson describes the first act of remembering as an expanding action, bringing oneself into the realm of the pure-past in which all past events coexist in reference to the presence. Here, one enters a simultaneous-ness of all time past; a duration of monumental vastness. Although not directly translatable into a cognitive exercise, we engage with such consciousness first of all by accepting such a concept of time. This acceptance allows us to tear down earlier barriers between past and present architecture. Between historical references and contemporary precedents. Between the palaces we used to restore and the new architectural proposals we designed for them. Although such walls are merely metaphorical and the tearing down only a conceptual act, the output is enormous. The effect on the practice of architecture represents a shift from being a humble observer of history to activating a vast architectonic heritage as part of a contemporary practice.

The second act would be a movement through a specific event one wants to recollect. This is possible, as Deleuze describes, through an action of compression, through which the entirety of the past remains present yet in a contracted form and positioned towards a specific event. Both authors describe the recollection of past events into the present as a movement through a pure-past. In many ways, our drawings are to be seen as compressions of an a priori past into a particular drawing present. As earlier explained they do not represent objects in a secular reality yet they engage with space as a phenomenological entity. As such, the drawing illustrates a looking for an architectural vocabulary holding an entirety of the past yet in a contracted form.

Preparations for a Gate Project and the *Gate Demolition Drawings* (Figures 1–4) are projects designed through a process of recollection as opposed to following a practice of reaffirming existing historical interpretations. We allow projects to take form in a field of site-specific relations drawn as lines; cutting into one another, to slice, to part, to recompose and eventually create new sectional conditions. In this space of intersectional forces, old data becomes potent again, dormant images awake just before they indeed intersect with others and intensely change. This work resists the use of the metaphor, in that we do not aim for the transposition of older concepts and tradition to a present architecture. Instead we aim for instilling new substance through the intersection and replay of old form, like a musician plays an ancient melody instilling this with new significance as he plays the notes (Eeckhout and Joris 2014).

Deleuze suggests the possibility for memory to be an active creative process. We use our drawings to excavate previously unseen memory in a landscape of current and historic imagery to form new embankments and guide possible streams of thought. Like most pictures, the imagery we choose to retrace holds implicit qualities of duration, a latent certainty of continuity. When we look at a photograph, study the instilled moment, we know something happened before and after that photo was taken. In fact, we look at the picture with this exact knowledge. This concealment of information generates its magnificence, providing meaning to that-what-is by means of that-what-is-not (visible). One could say this to entail the performative nature of the medium of photography, in that the image can act as décor against which new memory is to be constructed by the onlooker. The still image is keeping still for a moment or indeed is keeping a moment still. It is holding back and continuously speaks of its holding. The exact knowledge of this holding is of no importance, not to us (Eeckhout 2014). Essential to the performance of the image is for it to allow an audience, through a responsive consciousness, to co-author the photograph's meaning.

The act of drawing – the retracing of the image – aims at the consolidation of this responsive consciousness; recording décor through the act of drawing as one expands in the image only to enter a state of perception, taking place in what Deleuze describes as pure-past, a space in which all past drifts simultaneously and lines are allowed to intersect and correlate indiscriminately.

Plurality of systems of interpretation

In a world where memory has become part of a global culture, the social act of remembering has changed in our recent history. Not so long ago history provided relative stability in its representations of past events. This stability has been shattered and 'today we think of the past as memory without borders rather than national histories within borders'; 'today memory is understood as a mode of re-presentation and as belonging to the present' (Huyssen 2003: 4).

Through the work of our practice we engage strongly with the idea of the past performing through the present. Such practice is not marked by the design of explicit memorials tied to official histories of specific communities, yet aims at a process of including residues of (perhaps mythical) narratives when we design new urban interventions.

As such, the work does not want to gravitate towards designing places for exception yet involves designing places of the everyday. In recent work, and perhaps in seeming conflict with the previous statement, work references ideas on mortality, not so much to commemorate the death but to instil a specific experiential, sensory quality; a quality we have all experienced when we pass a grave and are confronted with death as we become conscious of the presence of human remains. In this moment we experience a halt in our everyday life and seem to be carried to another place (Loos 1993), a place usually submerged within the self. In this moment, time collapses to a dense mesh through which we experience a lingering consciousness stretching into an immensity of time-space; a vastness approaching a state of nullity. It is such a description of monumentality, as incalculable enormity, that we look for, to complement the notation of the material with a phenomenological monumentality, in such a way that a certain place or object allows us to feel or perceive something beyond itself.

It is thus important to set ourselves outside the practice of designing exceptional spaces in that such spaces often become substitute environments upon which political agendas are transposed, unavoidably diminishing the richness and diversity of individual experience. We contemplate architecture and urban design freed from compensating moralizing tactics for it cannot embody any truths or act as a correction of life (such as in war memorials). The architectonic body does not have to warn or remind us, but can remain 'empty' and in doing so become endlessly more forceful.

'How would the painter or poet express anything other than his encounter with the world?' exclaims Maurice Merleau-Ponty at the start of his seven lectures on science and perception (Kearney 1994: 82). Around the same time, Jean-Paul Sartre states, Architecture mediates between the outer and the inner worlds by means of its suggestive and mediating metaphors (Sartre 2001). This metaphorical performance does not limit itself to a symbolizing relationship; the metaphor is implicit to the world and spaces we inhabit. As designers we aim at such mediating performances to gaze at the world and our being in it as we draw and model space. Architecture, and urbanism as such, is a performing event. 'Gaston Bachelard introduces in his 1957 La poétique de l'espace the concept of topo-analysis' (Bachelard 1994); 'a psychoanalysis of places', as such, studying our phenomenological relationship with places. The object of study here is not merely architecture; the aim is to study how space (that which exists within and around architecture) accommodates consciousness or as Bachelard denotes: reverie. A consciousness accommodated by a collapse of time, where multiple pasts and present come together. Any attempt to locate this moment, however, would allow us to understand the placeless-ness of this event. Past and present do not come together in one point. Any definition of such a point would be a falsifying act. As designers, interested in

generating structures of consciousness, as we study our spatial being, we can only enter an incalculable enormity to experience vastness beyond any point.

Tracing the performance of space

Our practice, like most others, is often led by preconceived sculptural images as we mediate within a network of intersecting timelines. They manifest themselves as figurations lingering in the poiesis of each project. As part of our design method, we strive for a resistance of these figurations and eliminate implicit figurative qualities by deploying a drawing discourse of 'replay', as will be explained later, through which a multiplicity of historical data is embraced without the inclusion of archetypical elements that would lead to figuration. The term figuration is used to denote levels of conventionally associated meaning or symbolic value, often through the use of archetypical historicized elements in the composition of architectures: something we thus want to avoid. This sets up a practice of paradox: negotiating the architectonic body as figure in the storytelling of place yet resisting figuration (avoiding a subordination to the preconceived image) and therefore designing presence through levels of absence. Projects born out of this practice exist as 'circulatory systems' including video, sound, drawing (Figures 1 and 4) and writing, with the aim to define a broad practice-platform with a central methodological concern: language as primary material – designing the figure freed from its figurative role.

This drives a design discourse where subordination to a historical taxonomy can be sidestepped. In doing so, drawings have become instruments of internal dialogue (Goldschmidt 1991: 123). They guide a process of discovery setting up a continual recording of boundaries as a graphical manipulation of site and volume. These recordings, subject to site-specific parameters, seen and unseen and across different timeframes, set up a multifaceted interchange between drawing and context yet aim at repressing any passive recording of nostalgic clichés. The outcome negates the creation of an architectural metaphorical mark (buildings as symbols or icons) and instead aims for the description of a new and highly contextual object/landscape supporting a state of remembrance, reciprocating an active gaze towards history interweaving multiple pasts with present.

As an intrinsic part of this practice, the drawing is used as a detour, only to arrive at a more direct interest in the mediating metaphorical performance of spaces – mainly by drawing through levels of sensation rather than drawing representations of an a priori formal vocabulary (historicized archetypes) in order to look at symbolizing relationships freed from the picturesque. As such, symbolizing relationships in space are explored through 'the making visible of forces' (Figures 2 and 3), sequentially moulding form. One could look at this drawing practice as an aesthetic sensing of forces within the space of the drawing to trace the performance of a space. As children after modernism, we have become very distant to such practice. However, it is important to

remember that for certain cultures throughout history, such practice has always been in the foreground. To illustrate, we could look at differences between ancient languages. In Anglo-Saxon sentence-structure, the verb is subordinate to the noun for example. This partly supported the development in western civilization of an enlightened view of the world where a Cartesian understanding of things allows us to describe the world as the relationship between objects. So when we speak of a 'house' in English, we denote an object or a cluster of objects. With this, we can identify a principal keystone to the inherent characteristic of a consumer society wherein everything can be defined as (consumable) object (Lefebvre 1991), even the sensory aspects of life, ultimately to be turned into quantifiable commodities. As designers, we have trained ourselves to think and work through concepts of objectifying abstraction to describe and engage with abstract space, privileging the objective over the element of experienced space (Lefebvre 1991: 38). When we look at the Hebrew language for example, we can see a sentence structure where the noun is subordinate to the verb. When we speak of 'house' in Hebrew, we denote a performance and not an object. Therefore 'house' becomes 'housing' and the idea of an abstracted object is replaced by the idea of a performing space.

Our preoccupation with sensation is not only a strategy to look at experienced space but also allows us to proclaim a feeling of discontent, of a disagreement of form, of current form as a normative formal language: a guiding force in our consumerist apparatus. As such, the drawing exists in a state of destruction claiming back territory of freedom from this normative imprisonment. At the same time, it exists in a state of becoming, of en-forcing form towards unimagined spaces. In the drawing of these spaces, or more specifically the drawing towards these spaces, different levels of figuration are mediated. The architectonic figure could be described as signifying form deeply embedded in a cultural language. Figures are archetypical elements such as front porches, pitched roofs and clock towers. When we speak of negotiating the architectonic body, as figure yet resisting figuration in the storytelling of place, the non-figurative is not accomplished through abstraction but through a process of isolation and replay; this will be explained in greater detail after a more general account of the status of our drawing.

Using autographic strategies as a mode of representation to unpack relative-experiential qualities of a site

In his *The Production of Space*, Henri Lefebvre (1991: 11) describes how our Western industrialized world overwhelms us with concepts of objectifying abstraction. With this, he refers to the inherent characteristic of a consumer society wherein everything can be turned into a traded object, in such a way that even sensory aspects of our everyday life are dealt with in terms of quantifiable commodities and categories. He describes how concepts of objectifying abstraction stand at the basis of a professional authority, such as architecture, to describe and engage with abstract space by privileging the element of

'conceived space' (mathematically qualified and conceptualized space), and repressing the element of experienced space or 'perceived space'. This observation leads Lefebvre to distinguish three categories of spaces (or what he calls 'fields'): physical space (conceived as a product of processes of thinking, abstracting, measuring, categorizing, etc.) and mental space (perceived through experience, memory, allegory, smell, touch, etc.) form the basis. Then there is a third field that he describes as social space, a space that can only be lived and that is a combination of physical space and experienced space, becoming, as a result, a container of social myths and narratives. When we work as part of an interdisciplinary practice, navigating between allographic and autographic drawing, it is to accommodate the study of this lived space and allow for the production of architectural proposals that are not just an answer to physical or programmatic issues but something much more complex: the idea of social space, which lingers everywhere in the city but as it appears to us, is too often overlooked.

Lefebvre argues that our basic understanding of the world is devised by a sensory spatial relationship between our body and the world. Our understanding of space is in direct correlation to the understanding of our bodies' spatial presence, long suppressed by Cartesian duality. His central claim, that space is a social product, directly challenges the predominant western (Cartesian) notion of empty space to exist prior to its users' occupancy. As such, he claims Western philosophy to have betrayed the body because it has defined space outside its users' experience; it has denied the body. Lefebvre describes the body, as simultaneous subject and object and can therefore not tolerate the conceptual division between body and space.

The autonomous drawing versus the implicit subject

Until now we have explained an interest in architectural history vis-à-vis contemporary practice as a meandering between two opposing concepts: absolute and relative authenticity, models borrowed from restoration and renovation practice. Our work is positioned between a searching for absolute authenticity (when dealing with historical sites) through the reconciliation of a material past and relative authenticity, allowing current sociocultural parameters to impact the identity of the renewal of a historical site.

Understanding the deceptiveness of historical rhetoric, capable of performing a profound yet dangerous political swagger, our working methods escape the supremacy of written transcripts and favour the use of the pictorial; the image as self-determining object. As such, our work does not reference old ideals symbolically. Instead, we trace the 'literal' form of old form through a process of multiple reiterations and repetitions. Drawings are transposed onto one another to allow lines to interfere and create new sectional conditions permitting architectural form of unforeseen complexity; a grammaticism of collisions and compressions to eventually expand in time (Eeckhout 2013) (Figure 11).

Ideas on the cultural implications of form can be traced through multiples of debates and opposing theoretical strata. On the one end of the theoretical spectrum we find self-confirming discourses of form-making through sets of pre-defined cultural operations. Examples of such operations would be a classicist architecture based on Roman ideals. On the other end of the spectrum we find languages of pure formal abstraction detached from the contingencies of place and history, such as the five points of modernism in early-twentieth-century architecture.

We actively search for a positioning between these two appearing oppositions by indeed remembering history through a process of repetition (and thus change) allowing the autonomy of an abstract formal system to develop and instil a space of critical displacement, as explained in more depth in the following chapter. It is important however, to identify the difference between the role of a designer and the role of a cultural historian, for example, with regards to positioning oneself against the historic architectural object. We do not negate the implicit cultural value of a historic formal language and the significance of its form as expressions of previous cultural values. We do not negate the correspondence between a pervious culture and its architecture, however, we would find it problematic if this retrospective viewing would be a lone theoretical route taken to qualify the historic object. Because if this would be the case, all historic architecture could merely be seen as completed and instilled in time past, which is explained in the above as impossible. Nor do we believe in an alternative were the absence of historical concern would clear the way for a practice concealed in pure conceptual space, where architecture is conceived as an autonomous object by means of contained sets of formal operations. With our practice, we position ourselves as equidistant from both ends of this theoretical spectrum and work towards historically insinuated architecture by using semi-autonomous formal systems of repetition. As such, we can ponder as a child of our time, fascinated by the role of the image as it drives the mediated world and its architecture. It was sociologist and philosopher Georg Simmel who described a chaotic world in the first half of the twentieth century as such: 'the rapid crowding of changing images, the sharp discontinuity in the grasp of a single glance, and the unexpectedness of onrushing impressions. These are the psychological conditions which the metropolis creates' (Simmel 1950: 415 [emphasis added]). He described this to stand at the basis of a certain indifference by bystanders and architects alike; symptomatic of a voluntary cognitive castration to survive the chaos. We see our work as an attempt to contemplate on the vitality to counter such indifference and work with the ambiguities and disjunctions created by the metropolis as we stand at its crest. We pay tribute to Jean Arp and his comment: 'Dada wished to destroy the hoaxes of reason [in its pursuit for order] and to discover an unreasoned order' (Arp 1948 [emphasis added]), when we draw new architectures. Even if it is just to remind ourselves, time and time again, we can only strive for a creation of architecture and thus whose cultural significance is inherently unresolved.

Conclusion: Isolation and replay

With an overall speculative positioning of our drawing practice in place, we can now describe in more detail important procedural aspects during the act of drawing. In general, our drawing discourse is initiated by isolating a figure from its original narrative framework. The first 'act' in the drawing entails a tracing of site-specific information. As such, the figure (and with it, the person drawing the figure) is placed in an empty field allowing the drawing of the figure to become site. Within this field, the act of drawing accommodates a tracing of forces through which a process of reconfiguration takes place. The isolation of the figure does not install inertia yet accommodates a looking, an exploration of the figure within the operative field of the drawing. Through the isolation of the figure, its relational symbolic ties are momentarily broken and the figure becomes image. In Lacanian terms, the figure trans-locates from the symbolic order to the imaginary order or what has been described as the pre-mirror sate; the moment in the psychological development of a child where it fails to recognize itself in the mirror yet only sees the image of another child. One could say that through this process of drawing, a momentary state of psychosis is established where the figure becomes image, disrupting any relation to signified meaning.

Here the act of figuration has been compromised and the drawing enters a state of the figural, as described by Foucault (1972). In this state of the figural (the non-figurative yet non-abstract), relations between image and object are broken. The image as such, does not illustrate the object anymore and becomes pure image. The drawing in this momentary state of psychosis halts the act of figuration in the performance of the drawing and instead submits the image as image without reference but to itself. Such image accommodates an inwards-looking and reveals a self-exploring figure. With this type of drawing we can invest in sensation freed from the demands of representation, and thus pre-set architectural vocabularies. If one describes the pre-set vocabulary within architecture and urban design as a set of figurative figures, it is important to understand that the drawing freed from the demand of figuration does not erase the figures. Figures remain present in the drawing; however, within the drawing there is the emergence of figures freed from figuration. This state of the drawing – the state of psychosis, dislodged from reality – is only momentary.

It is in such a way that at certain points the drawing becomes an illustration of architectonic and urban space again. As such, the shift from the representational to pure image is at some point reversed: the drawing shifts from pure image back into a representational state. This moment of the re-representational marks a moment in the drawing were its symbolic relationships are re-established after a process of isolation and replay. This confirms the drawing as detour, only to arrive at the study and design of symbolizing relationships in architecture and urban design yet freed from the picturesque, the cliché or the archetype.

Preparations for a Gate Project and the *Gate Demolition Drawings* (Figures 1–4) that we mention at the opening of this chapter are projects placed within a site of historical significance yet suffering greatly from an almost total erasure of its mnemonic properties.

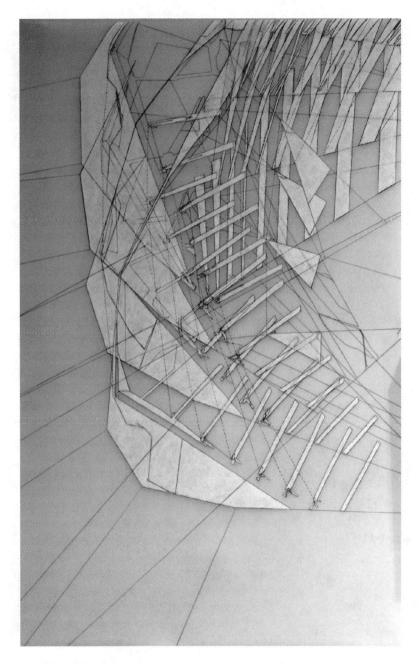

Figure 1. Architecture Project. Multi-disciplinary installation titled *Year 2225* – a triptych at Palazzo Mora during the 2014 Venice Architecture Biennale's collateral event *Time Space Existence*. © Architecture Project.

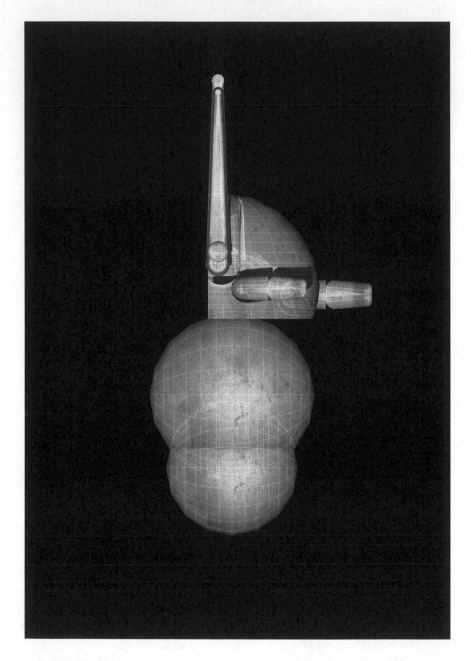

Figure 2. Riet Eeckhout and Ephraim Joris, *Preparations for a Gate Project* (2014) – initial semi-dome monolith is intersected by four subtractors to create space through subtraction. © Architecture Project.

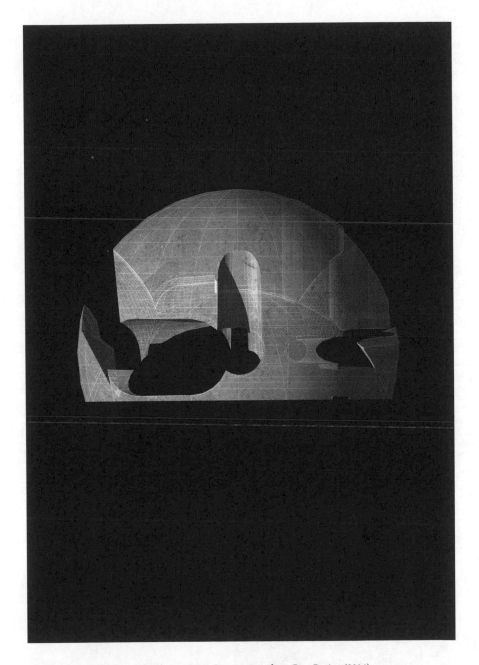

Figure 3. Riet Eeckhout and Ephraim Joris, *Preparations for a Gate Project* (2014) (Eeckhout and Joris, 2014) resulting void, penetration in the semi-dome after subtraction process. © Architecture Project.

Figure 4. Riet Eeckhout and Ephraim Joris, *Gate Demolition Drawings* (2014) – exhibited at La Galerie d'Architecture, Paris, 2014. © Architecture Project.

Both projects started with 'visiting' deleted urban scenes (via researching historical photographic material), places with ghostly properties connecting our world with an intangible past (Hetherington 2001). The act of objectifying the past is avoided in order to focus more on an aesthetic sensing or replay of dormant histories. We describe the design of such places as the result of composing spaces, objects and times. The drawing in this case is not a matter of composing form or harmonies but is occupied with unravelling implicit forces within existing form and harmonies. This implicates the impossibility of 'new form' and accepts a practice of continuing form through a drawing practice studying forces within form (Deleuze 2003: 111, 122). As such, the act of drawing engages in the unravelling of forces within the memorial realm of an architectural consciousness in order to bring into presence that which has become absent. Paul Klee states in his famous formula to 'not render the visible but to render visible'. Similarly, Monet paints forces of light and Bacon paints forces of de-figuration, energies that are invisible unless made evident through third-party phenomena such as Newton's apple falling from the tree. We see our drawings as third-party phenomena: indirectly making visible, as opposed to typical architectural drawing practice which annotates a projected state of the visible (Allen 1999). The use of drawing as such cultivates a design process towards remembrance; to reinstate the presence of historical figures freed from figuration to allow a spatial performance of these figures, not through a process of postmodernist iconic recycling but through a process of making visible implicit forces and harmonies in the world we see around us, and this through multiple timeframes.

References

Allen, S. (1999), *Field Conditions, Points + Lines*, Princeton: Princeton Architectural Press.

Arp, J. (1948), *On My Way: Poetry and Essays 1912–1916*, New York: Wittenborn.

Augé, M. (1995), *Non-places: Introduction to an Anthropology of Supermodernity*, London: Verso.

Bachelard, G. (1994), *The Poetics of Space* (trans. J. R. Stilgoe), repr., Boston: Beacon Press.

Bergson, H. (2002 [1913]), 'Time and free will', in Keith Ansell Pearson and John Mullarkey (eds), *Key Writings*, New York: Continuum, pp 49-80.

Certeau, M. de (1984), *The Practice of Everyday Life*, London: University of California Press.

Deleuze, G. (1953), *Empiricism and Subjectivity: An Essay on Hume's Theory of Human Nature* (trans. C. Boundas), New York: Columbia University Press.

—— —— (2003), *Francis Bacon: The Logic of Sensation* (trans. D. W. Smith), London: Continuum.

Eeckhout, R. (2013), 'Resisting the representational', *Why is it so difficult to speak about architecture?*, UCL Faculty of Architecture, London. December 3-5, 2013.

—— —— (2014), 'Inevitable reconstructions', in ADU2020, KULeuven, *Creative Adjacencies, new challenges for Architecture, Design and Urbanism for updating, modernizing and synchronizing the university curricula*, Ghent, Belgium, 3–6 June.

—— —— (2014), 'Process drawing', Doctoral thesis, Melbourne: RMIT University.

Foucault, M. (1972), *The Archaeology of Knowledge* (trans. A. M. Sheridan Smith), New York: Harper and Row.

Goldschmidt, G. (1991), 'The dialectics of sketching', *Creativity Research Journal*, (2), pp 123–43

Hetherington, K. (2001), 'Phantasmagoria/phantasm agora: Materialities, socialities and ghosts', *Space and Culture*, 1(11/12), pp. 24–41.

Huyssen, A. (2003), 'Introduction', *Present Pasts: Urban Palimpsests and the Politics of Memory*, Stanford: Stanford University Press.

Kearney, R. (1994), 'Maurice Merleau-Ponty', in R. Kearney (ed.), *Modern Movements in European Philosophy*, Manchester and New York: Manchester University Press.

Kierkegaard, S. (1983 [1843]), *Repetition: Fear and Trembling/Repetition*, Princeton: Princeton University Press.

Lefebvre, H. (1991), *The Production of Space* (trans. Donald Nicholson-Smith), Oxford: Blackwell Publishing.

Loos, A. (1993), 'Architecture', *Speaking into the Void: Collected Essays*, Cambridge, MA: MIT Press.

McKim, J. (2010), 'Creative recall: Contemporary memorial practices and Deleuze's concept of memory', in L. Burke, S. Faulkner and J. Aulich (eds), *The Politics of Cultural Memory*, Cambridge, UK: Cambridge Scholars Publishing.

Sartre, J. P. (2001), 'What is literature?', in Stephen Priest (ed.), *Jean-Paul Sartre: Basic Writings*, London and New York: Routledge.

Simmel, G. (1950), *Die Grosstadt und das Geistesleben/The Metropolis and Mental Life*, in K. H. Wolff (trans. and ed.), *The Sociology of Georg Simmel*, New York: Free Press.

Intersection 2

Sick city: An introduction

Heron-Mazy (Anon)

Hence we should all be sick in some way. We should all feel near to despair in some sense because this semi-despair is the normal form taken by hope in a time like ours. Hope without any sensible or tangible evidence on which to rest. Hope in spite of the sickness that fills us.

Thomas Merton, *Striving Towards Being: The Letters of Thomas Merton & Czeslaw Milosz*

1

Even though this is already old as a concept, the Blind Reviewer said (Sick City is an updated version of *Westworld* starring Yul Brynner), Sick City should have been a reel to real experience that had the potential to generate gravity in an increasingly entertainment-led society. He had to go for the phrase *reel to real*. This groove is out of fashion, to echo David Byrne and Brian Eno, these beats are twenty years old. We are ahead, behind, learned our lesson and really this still kills us even at our age. This still tempts us to choose the vomity-coloured armchair in the lobby of the Hotel Pessoa in Sick City. You'd think, after all those years teaching and practising archery (yes 'archery' we used to call it), we would have learnt our lesson. Well, frankly some of us never learn. The cyborgs are already away with the fairies and the next ciné roman is being prepared. From *reel to real*; we no longer understood such little tricks of language and those phony avenues called The Prado, and wished we were elsewhere in this city.

We don't recall arriving in Sick City. Was there an airport recently built, a museum recently published, a star architect we were doomed to meet? Who could tell? Was there a conference to go to, and what this time would it be called? The Mediated City, Mediated Urbanism, Globally Regional Urbanism or the Lost Global City? The rollerbladers cruised passed us. The sun hurt the sidewalk. Archery could curtain the urban soul without us realizing. We were simultaneously ahead and behind. We stepped into the Hotel Pessoa. Could it be, was it, why was he here? He looked up as if awaiting a foreign agent. 'Hello!' We greeted Frank but didn't know him well enough – except in poetry – to call him Frank. But then all archers, frankly, are called Frank today. He was on his way to Santiago and just happened to be in the Sick City. Funny, we thought, that we collide with the world's most renowned architect. What's going on? 'Beats me,' Frank said. There was

archery even in his smile. We both got up out of the huge leather chairs (these were not vomit coloured) as Daniel rushed in. Last thing we remember we were rushing towards the door again. That was 1993, that was Sick City then, when cities were mediating the crap out of each other, and no one cared.

We are forced to end the paragraph there, though we are unsure whether we have made the point necessary. But it's really not the kind of point, this is not the kind of Sick City that will survive an interminable build-up. This is the pre-textual world where consensus can no longer work its seduction on us. From reel to real, really, who then are the masters of this syntax of the Dead Mall and Sick City; who amongst you and the Existentialists is telling us to get the hell on with our story, sorry narrative? The post-consensual is already upon us; and we began to be chased by Ambulance Architecture before we even realized.

2

We are not as happy as we were in this Mediated City. It appears we may have to apologize for our non-standard approach to the urban novel. At first we thought the developments in the city would force us to make a few concessions. For what did it matter if we learnt to make concessions? We could fall in like the rest of the city-dwellers. And we know well enough that if we are not seduced by images, then our idea of the mediated city would be clearer by virtue of its ambiguity. We see no contradiction in this. But to help the reader here, we are offering the narrative as a manifesto written by two 'agent-provocateurs': in this case the two of us, Frank Heron and Jan Mazy. We have to say – just as an aside – we are quite comfortable with some standard images just as we understand the delicacy of pushing the urban envelope a little too often. But it's the *intellect* and those 'geographies of the imaginary' that we are not so sure of. There are, in fact, strange overtones.

This is a Sick City, but in what way? Yes it is mediated and unmediated, where *ER* meets *Westworld*, as we said. Yes it is a reality hunger of extracts and trends, of incoherencies linked together by pre-texts. But what are pre-texts? Are they strategies that we cannot conform with, that we are in opposition to? Can these be defined by existing, freshly-minted mediated scholastic caveats? No, our Sick City seeks another currency, the grounded-everywhere. But where is that? If gaming and archery are its obvious connections to Sim-Cities then we suggest this interpretation be cautioned as most of what we present has happened and will go on happening without us. We have heard others describe this as the Post-Urban condition leaving archers, urbanists, scholars, theoreticians and planners triumphantly outside the marginal discourse and sideswiped cities of the neoliberal 24/7 variety. And lest you forget, just remember those huddled agreements offering sleep prevention and deprivation models for an ideologically hankered re-calibration of the 'Capital' of urban life.

But it would be wrong to see us as obstinate re-calibrators who go out of their way to disobey the new rules of drone theory and the urban intellect. We are no Dharma Bums, and have given up on the cigarettes, though we still happily go through our supply of Cohibas. There is for us no boundary today between the urban and the non-urban, between the language that controls it and the language that bounces off it, between mediated and unmediated, between the mall-of-beyond and the mall-to-become. Between kingdom come, and the kingdom to come! If you doubt this you must do more deep reading: the cyborgs are already away with the fairies and the next ciné roman is being prepared.

3

Out of time puts us again in time. We are only modestly reprehensible but there is something that cheers the archer's intellectual heart no end; that is this spot convenience, which we call the Dead Mall and its useful and reliable programme of mediated urbanism in the Sick City. It sets up 'pinball strategies' to play the prejudices, preconceptions, privileged codes of the archer against the unknown economics of building, ruin and the ultimate ceaseless enigma of Capital. Prejudice Projects result. City symphonies are often trite re-creations of our own privileged world. The Archers have become tourists to their own Biennales. In our not altogether reliable opinion, the commercialized urban landscape is a provocation that has gone on for too long. Contrary to the privileges we accept, we are not perfectly attuned to photo-realistic imagery or the clichés of digitally laden experiences. We are only imperfectly attuned to moving imagery. Language itself is part of change and resistance to change; the status quo is fed by a rational inertia within the existing urban models. Media transforms media. Only! What we have been alluding to would stand in for a fairish amount of substantial fact, if it were not for the urban novelists that migrated out of the Sick City and rode their Toyota Hilux into the city once known as Alternate, not far from the Plain of Jars. This is a partial world which creatively destabilizes everything we used to settle on. Sick City is now out of site, disconnected as fast as it re-connects. This is 'exceptional space' that can go both ways. Partial, incremental, operative: of course it is a simultaneous experience but how? Content is deflected to immediacy. The outdated is smart thinking, hopelessness is now the new optimism. Financial, tectonic games, and digital blasphemies respond to, deflect and bounce off, a lazy Zen and archery past. The economic and social resuscitation of the Dead Mall takes place. Out of site becomes the in-site/insight for all media and urban overlap. Archers are no longer masters of space-syntax, skateboarders are.

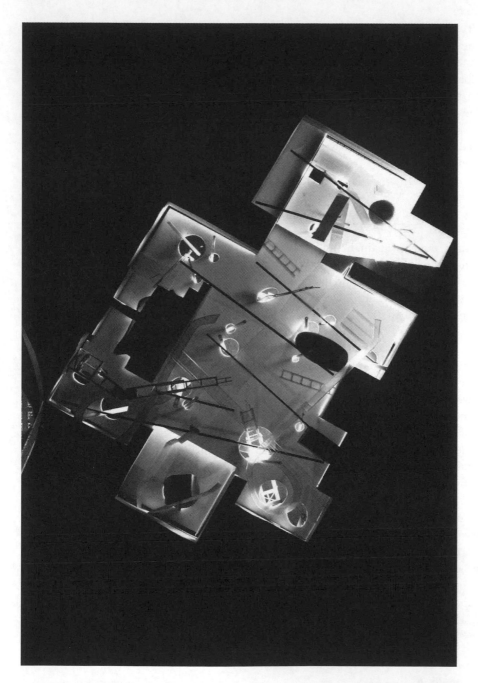

Figure 1. The Post-Consensual is already upon us; and we will be chased by Ambulance Architecture before we even realize. © Heron-Mazy.

4

Interface, Animall and Brautigan is a critical re-mix of a rather sickly mediated project (Bigtown Mall, Mesquite, Texas) exploring how partial architectures constantly overlap to become a reality that will not survive. These mediated strategies suggest a critical re-situating of archery (architecture does eventually creep in to collaborate with institutions and agencies) in order to re-shape activities and potential, a redevelopment in response to community, investment and contractual feasibility. These are mouthfuls we know, but incremental architectural strategies with clear tectonic and structural means allow the 'locality' to regain an identity inviting new spatial and participatory encounters with the global. Those still in business are encouraged to re-invent themselves, or re-occupy the mall-city within the new prejudice project. The structure of investment and incremental design means that declining businesses are resuscitated, resurrected or then allowed to decline in order to be re-animated. We are now beyond neoliberalism. To be accelerated to ruin will be as important as any sustainable resuscitation in Sick City. We have to offer and accept some indulgences: a mediated urbanism for us solitary archers is as much about language, change and structure as it is about archery-nuance and urban potential. The Prejudice Project as brief and anti-brief, sets up 'pinball strategies' to bring public space, the economics of building and investment into open 'dirty' play within the mall-city itself. These strategies use archery to destroy its privileged codes and open up to new codes. Switching codes, indicated by the abuse of language, allows new collaborations to re-shape the dreaded potential for contemporary social needs. We have no idea what these contemporary social needs are. But our view of archery works like this: the fluidity of the relationship between architecture, culture, investment, exceptional and public space must provoke encounters, animosity and even robust and creative ill-will. Communication and collaboration obviously strengthen urbanism's dangerous reach. Scenarios and theory matter little if generosity and responsibility are not embedded in this Prejudice Project from the outset. The youth, the skateboarder, the DJ and sampler, are as much part of the team as the economist. The architect, responsible for the steering parameters, must communicate – partially never totally – with all involved, translating the ideas drawn, projected and imagined into partial, incremental (and occasionally dangerous) developments. Negotiation and encounters between a multidisciplinary working group would begin to shape the scheme: an on-site zone – the *whatever exhibition* – would begin demonstrating these at first ridiculous ideas. Possibly mystic and a touch unbalanced, but remember we *are* speaking here of an architectural ciné roman.

5

For us this metaphor, this archery has taken over Sick City; there are only diagrams-in-progress, re-gouging the ciné roman; *glissements* if you prefer. Or *ricanements*. Resuscitation of the existing Dead Mall in Mesquite (Texas) is operative for, and seeks, the reclamation

of 'dead space'. The revivalists amongst you might see dying space where archery combines with a mediated urbanism and is forever in flux, incomplete and indeterminate. Yes we know, and accept, old chestnuts from the Zen and Archery handbook. The metaphors rebound when faced with Sick City. Downtown is the underbelly, the existing 'base' within which the new activities and trans-programmed functions are proposed. The mall-goer can enter the various activities of Downtown but can also access the unexploded airspace known as Alternate (the drone-superstructure) from within. Various vertical upzones (consider the metropolitan and academic difference between rupture and aperture) need new language which we are no longer privy to. We search the crumbs of our redundant intellect to understand crater and drop zone, bomb and surface-to-air missile. From without, migrants will enter by external chutes of the sort we recognize from airport urban design, but which now have become unrecognizable. New resistant retailing concepts, (known as Choice Architectural Interventions to the Ad-men), low-maintenance cost strategies of dying space will constantly transform the mall-city into a new electronic interactive environmental shopping, social and public space concept. It achieves this by re-integrating the newer, latest waves of anti-merchandizing incrementally and provocatively. There are of course relations between archery and pinball; we do still remember our Dharma Bum days, and have not quite lost our snapshots from that other era. Indeed, if you ask us nicely we could probably whip out a few images from our wallets to pass around (Yes, we still have wallets). And Pinball is pertinent: information and know-how are re-directed and re-combined to form new genres of prejudiced space. It's all relational. A 'personal' as well as a 'social' resuscitation of the mall takes place. Partial architectures become reality or then are allowed to die once more. These are not alibis for architectural form, these are not only dead metaphors for a new dying space; these are life-savers! A potential micro-world of future Sick City urbanism: 1 uptown leisure/entertainment (the airspace) 2 Downtown indoor park (the underbelly) 3 The Scanograph 4 Interface 5 Brautigan 6 Animall Invader 7 Alphabet Centre 8 Safe House 9 The Cry of the Toad Centre for Minorities 10 The Mediathèque 11 The Meme Machine 12 the Whatever Exhibition space 13 The Vacant lot (sports zones) 14 Cine-Terrace 15 The Cutting Edge 16 Nod to Hank, Willie & bob 17 wopBopaLooBop 18 Micro-Stations – craft ateliers 19 The Darkness into Light warehouse 20 Extreme Weather Chasers Centre 21 Farmer's Market 22 Retail Resistance Village 23 The Hotel Architecture 24 wopBopaLooBop.

6

Perhaps you require us to distribute more robust mementos from this lost time. We cannot oblige, I am afraid. After investment potential, on-site riots and local action, an operative strategy can begin in stages. Funding is as incremental as the archery and space revived. Initially, as in oil drilling, a series of tectonic incisions are made into the existing mall, the location of each determined by the possibilities they offer to the whole project.

Figure 2. Possibly mystic and a touch unbalanced but remember we *are* speaking here of an architectural ciné roman. © Heron-Mazy.

Remember this is Sick City in miniature. Apertures are provocatively inserted within the existing roof structures. Chutes consist of two-shard structures penetrating downtown and uptown. These chutes and shards serve as the new constructional structure; a service and technological network. Extending upwards, creating a new 'alternate' airspace, drone-pads and grafted new roof structures are formed. These vary from steel-net vaulting, glass membranes shells and lantern roof pavilions and make up the drone-scape of the mall-city. Extending downwards, glazed and wired shards act as docking stations. Small domes balloon off the shards to take in nodal requirement. Bots rule where drones are landed. New divisions, new functions re-light, re-service and re-claim the indoor park underbelly. These archery manoeuvres – target punch strategies – are the open gambit of the city as motherboard. The game board develops. Urban hybridization and mediation within a new urban park, much talked about, can become a reality, both for the neighbourhood and the wider community. But it is nothing like the reality we can imagine here and now. Using advances in crane and aerospace technology, and in robotics, extending and extendable (inhabitable) long-armed building cranes are used to begin the work. These are either placed as scanographic arms on either side of the complex or then operate from within the building as arcing machines. These constructional-dwelling cranes remain throughout any dubious development, eventually occupying their rightful place within the new complex as connecting machines for the Organimall invaders. These invaders are detailed, telescopic constructions that allow green pods to hang or then be grafted on a newly growing urban forest. Network strategies imply process, movement and change and the invaders – amongst the migrants – likewise move in and around the mall. Flexibility and constant innovation allows the leggy structures to straddle existing environments and space, creating new interstitial inhabitable and vegetal environment zones. The liminal has never been like this!

7

The body of Sick City is operated on. Bots will take over this. Crash-cars scenarios will be un-manned, non-gendered space; the impersonal utopias of brothel creepers. Careful, innovative tectonic devices cut through the carcass of the Dead Mall to open up the green mutations possible. Language itself propels impossible ideas, introduces new models for the 'working site': the abandoned zone (inactive zones) – bypass zones, ruins and runway lighting – cyber screens – blue works – drop zones – new courier ports 'drop-droned' around the site – flight path, gargoyles and glitches – the landing strip/looped zones (night signage and lighting) – navigations and (no) smoking zones – the margins of the repetition of ruins, craters and bomb sites – platforms/open site/pauses/inclined projections, surfaces, parking bowls and amphitheatres – optical fibre runs – tracking walls and twilight zones. Language is reclaimed and taken back from architecture. A green scenario – beyond residue – begins to breathe life back into the 'corpse'. Nothing in

Figure 3. Sick City can take almost any amount of knocking. © Heron-Mazy.

our language can do justice to this vision; suggesting that it would be wise if we found a way to quit this cataloguing and move on. Accept this little number exercise please, and these occasional repetitions as if a non-stop talker has to speak about these things. The size of the existing mall (682,000 sq. ft but it is of no real importance) is re-assessed in relation to potential scenarios; the micro-cosmic Sick City world. Extra space proposed can follow the following scheme but clearly will depend on the scenario favoured: 200,000 sq. ft indoor park + internal grafts, 100,000 sq. ft lightweight roof structures including 100,000 sq. ft projected entertainment area and media roof, 100,000 open contoured asphalt, parking bowls, sports zones, picnic and outdoor event spaces. None of these numbers matter. Existing construction will be disrespected wherever possible whilst infill structural incisions (steel joist, & structural steel framing) will infuse the park underbelly with a new light. Mutations and newly grafted constructions consist of glass, structural glass, steel framed/braced structures, telescopic machinery, modular crane elements plus specialized materials (fibre glass, timber, mesh, 3D-printed recycled materials and so on). Downtown will be integrated into the punch strategies; the concept of elevation will dissolve into more liquid facades; entrances are multiple, exits unlikely and far from dangerous. Sick City can take almost any amount of knocking.

8

The *brautigan* (not The Salinger, we hasten to add) will be irresistible, lower-case magic. It is the new mediated global lobby for any visitor, local or tourist, any archer. It is the floating platform (service ducted, suspended airspace environment, drone-delinquent) which literally uses the existing mall roof and shoots over as an interface, a connecting tissue. The lower-case *brautigan* is a proto-urban promenade, a stroll, the panorama-passage, a multi-user domain utilizing the latest wireless technology, a new but instantly dated non-linear interactive architectural browser, a Post-Google space hijacked for the community which no longer exists. A series of light, tubular structural-glass, timber and steel, extruded structures snake through the existing atrium snaking out along Uptown, and extending with optic fibre drop-down zones to Downtown. A light, suspended airspace becomes the floating 'living' room of the locality, with literal glass ceilings, liquid surfaces and sky monitors. Float on your back – like a Bystander in Calgary – in deep saline waters, and you will know what we mean. Safe House is a surveillance scenario including control centre, a house of comforting and discomforting, using innovations in more and more remote technology. Sick City will eventually be controlled by another Sick City; diasporic, dystopic, this will become the Disinternet. Design of spaces in collaboration with security concerns will be unable to explore safe-house ideas and surveillance strategies but attempts will continue to encourage crime-free design solutions, web-cam walls and moving screens. The liquid virtual wrapping of downtown becomes part of a series of open self-monitored environments. Nodal 'security' zones

within the complex allow the development to integrate and respond to new media technologies. Projections will produce a city in a city. Careful use of electronic screens and the 'remote city' will allow new surveillance potential to manipulate community security and identity. Archery has always been about confidence and the target; that confidence to re-claim and mediate life outside pre-crime. At night, Sick City, 24/7, takes on its night-form, with the connection to the runway and franchise pods this will lead eventually to the development of the 24-hour total night space; with the illuminated crane-scanners and animal invaders, this forms a total installation. Externally the site is an illuminated landscape (recall the CIA airport city called Alternate in Laos circa 1960s) where light sensors activate parking routes and living-death patterns. Zombie urbanism is redefined as something as innocuous as night-time skateboarding and an extreme sports centre coexist amongst the ramped platforms and the parking bowels. The Hotel Architecture, the various lantern pavilions above the Meme Centre and The Vacant Lot Centre for Performing Arts alert the night-time user from afar. Night is the affordable lounge. This is far from impossible! The infidel is also welcome. This is also the Museum of Redundancy.

9

Bit-map, bot-heavy, torrent and j-peg pixel-bashed environment with back-up zones are devoted to destroying the privilege of the instant image – (hourly) data screens, moving walls (stocks and shares: j-peg worlds/kludge/the kudzu) – hypertext hangouts and holding patterns – one of the main attractions and entrances to the Interface – alphabet centre + new kindergarten and hotel concept; a dialogue between the real and the virtual real, sand castles and playgrounds, fairy tales, manifestos all shifting into virtual game sites. All this is so outdated that even this paragraph needs to be hastily concluded. Balanced by The Cry of the Toad Centre for Minorities, a re-assemblage of neighbourhood 'loss' – the very social and economic moves necessary to re-animate the mall as Sick City must be integrated with the energy of the various sub-cultures and minorities within the district and locality. The 3D Print Centre will become more and more crucial as it outdatedly combines with the Meme Machine Centre (moving walls membranes – quicktime/slowtime), Memento Stations – paging platforms & virtual wraps/video environments devoted to the failures to be contemporary and the advantages of ignorance: the Vacant Lot becomes a community performing arts theatre, an auditioning centre for 'survival'. Marvellously liberating and strong stuff. But don't get carried away. Mostly it will all have to come to an end. The Extreme Weather Chasers Centre is a contemporary monitoring and museum of weather – specific for Texas – sky, tornado monitoring cube, hurricane path monitoring centre (tornados/global satellite systems, telescoping and world weather guides). Known as Skylining (solar visiting and sky-guiding structures) the sky-highs are the extremities of the city: the vigilance viewing platform and Animall-extending sky-lights make clear that the mantra for a mediated urbanism is rammed home: way

Figure 4. The tsunami also begins here. The comet flies in front of your eyes. Skyguiders, be on the lookout. Everyone! © Heron-Mazy.

out there is also here. The tsunami also begins here. The comet flies in front of your eyes. Skyguiders, be on the lookout. Everyone!

10

Alright you will say, we've had our fun. We've taken revenge on the asphalt and archery. But everything that happens has already happened – the incremental and mediated nature of resuscitating the mall-city, structuring staged economic and commercial investment will allow Sick City to be nothing more than an operative 'site'. Contractual feasibility depends on confidence and responsibility. The rest is a prejudiced imagination within reach. Nothing else will do! Way out there is also here. A mediated scenario is just that: it is the potential that seeks responsibility. No one runs away from the contemporary but no one ever quite reaches it. *All that is solid...* (you can finish the rest). No one is talking about a new civic existence of partial architectural gestures, an urban survival guide rejecting accomplished codes of current architecture. Media transforms media. Sick City imagines the remainder, the cars, the asphalt, the hinterland; that little dash from air-con to mall-con in Texas heat or the Calgary vortex. We eat the chili and the peach, vomit the vortex, but out there in the new landscape we must no longer allow asphalt to take revenge on the city. Aerodynamic (aero-dromic) shapes and drone-sites with slight inclines in parking spaces transform the edge of any Sick City. Alternative (more and more extreme) sports areas are created through new re-surfacing techniques; new material skirting and flange-topping roof and sky spaces. The mundane needs reinforcing. Car-admiring stops and skateboard contours, landscape and street sports intertwine in the evening. The Electronic Blossom is a restructured global lighting installation, helping to increase security and opening up the idea of the 24-hour mall, linked to other Sick Cities remotely controlled. Crime-free with archery, we are the Mediators! Long live Sick City when it is not so sick. *Strange overtones.* Let's not make the mistake. Yes, we are digitally laden but we are not, we repeat we are not, perfectly attuned to this condition. How, as overlapping and outdated beings could we be? Therein lies our mediated future. All that road going returns; everyone heads for the Anti-Mall! But the skateboarders are there first! The Mediators!

11

If we are to accept serious impermanence and unpredictability, 'undoing' and 'unmeaning' may no longer have that uncomfortable feeling of suggesting power. Instead, just as archery (by now you will have forgiven us for persisting with the metaphor) is no irrevocable thriving on the uncanny, the feeling of seasonal unpredictability, then so the uneven development in our mediated cities. Minds are prepared, shaped, stroked by the presence

of certain memes which gouge out the prejudice project, thereby making them receptive to other memes. Influence and manipulation operate this way. 'The heaven all memes depend on reaching,' Dennett writes (cited by Dawkins in *Unweaving the Rainbow*, 1998, p. 304), 'is the human mind, but a human mind itself is an artifact created when memes restructure a human brain in order to make it a better habitat for memes. The avenues for entry and departure are modified to suit local conditions, and strengthened by various artificial devices that enhance fidelity and prolixity of replication: native Chinese minds differ dramatically from native French minds, and literate minds differ dramatically from illiterate minds.' We apologize, but we don't really like doing this and we know it 'craps up' the general rules but we're incorrigible. There is now no history without replication. William Gibson has long been a direct slayer of the Mediated City. *Mona Lisa Overdrive* dates back to 1988. At that time and the decade to come, Sick City was more likely to be influenced by the likes of Paul Virilio, Jean Baudrillard, J. G. Ballard, besides, of course, Gibson himself.

12

But from the normative to the tsunami, from the comet to the surface-to-air missile, the mediated city has parallel options. It can proceed along the normative, designing buildings and environments from experience, learning from the past and improving on those models. This is generally the neoliberal 'urbanism' as we know it, and many feel professionally comforted by it. But Sick City will proceed according to other models of thinking; these might appear alternative models but are not necessarily oppositional. All disciplines proceed by assimilating alternatives within what has been accepted as the normative praxis. When these alternative models are accelerated and accepted, they begin to replace the previous models. The mediators usually then assimilate these into their accepted, often prejudiced models. Which is why, most of architectural and urban history is a history of the prejudiced project. Sometimes these even move from the margins to the centre. This in no way intends to strike a sour note. But if for some it does, then let us be transparent about it. Recent catastrophic events serve to remind us that we are now planning for the next disaster after the last one. The twenty-first century has already progressed and failed to test itself by its ability to respond to such disasters. Aid and charity are being privatized; humanity is attempting to help faster than governments. Twenty-first century networks exist beyond professions, beyond controlling organizations. The Urgent Urban Network (UUN) is just one 'sick' model of an active interventionist urbanism able to participate and mediate anywhere in the world. *Tsunami* is a mock-up of this network, a sketch of how such 'urgency' would and could work. The result will be a workable model for individuals, organizations and countries to participate and creatively disrupt the urban networks and policies that wish them to design in certain ways and not others. This disruption will be turned into the Sick City model; a kind of active sick city

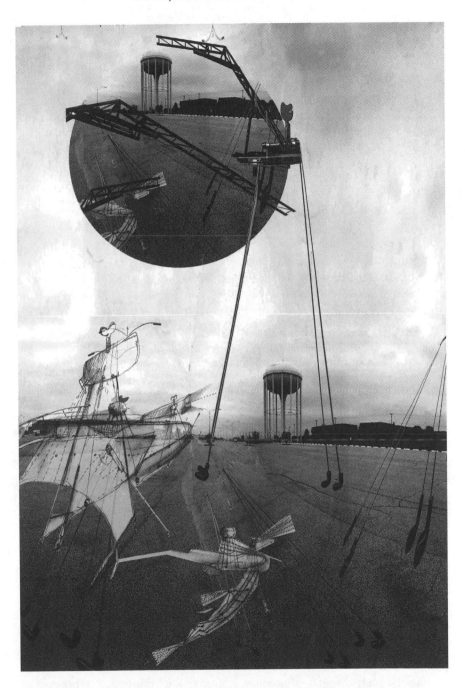

Figure 5. Yes, we are digitally laden but we are not perfectly attuned to this condition. How, as overlapping and outdated beings, could we be? Therein lies our mediated future. © Heron-Mazy.

ready to move anywhere, anytime. Cities on the run! What word after all do the young of today use when they refer to something cool: *That's sick!*

Confessions

(i)

We must now confess to our own sickness. You will see the struggle we have had with the mind and the intellect here. We are two persons but have never become one, nor have ever been able to identify an author (that was responsible for this narrative besides ourselves, though we did search the archives, newspapers, the Internet, and any other chance references not usually accepted). So we would like to take this opportunity to use that convention when the author or journalist's name is missing; we will use 'Anon'. We can skip over the initials – we are Frank Heron and Jan Mazy, not F Heron or J Mazy. You will see that we were unable to ensure that there is always a date of publication enclosed in brackets as our work changes with every manifesto, article, paper or submission offered. We are you see the *sick city re-mix*. To explore the extent to which archers (sorry, architects) and planners monitor their own development and knowledge, we have to put ourselves in a state of constant flux. Researching and establishing the various strategies of self-critical awareness (the way knowledge in architecture develops and distorts itself personally) can help us learn more about the promises, the shifts, prejudices, ideological visions and even the fallacies that often restructure the architect's own work. But this is not us. We are reprehensibly unable to master this feat. Sick City for us is a continuation and deepening of a parallel 'writing' architecture project, and offers a serious attempt to take stock of the role of error and fallibility in the shaping of the city's cumulative brief. Critically, we must remain within the realm of monitoring honesty in relation to the ideas we hold, and the claims made through these ideas. To be able to re-assess the notions of delinquency and failure, even the distortion, creative lying and other hallucinated 'realities' that the city may have offered the twentieth century, would help shift the balance away from accepted urban formations and move us somewhere onto those endgame fictions of Sick City that so attract us. And if we cannot really draw them, then – beastly as it is – so be it.

(ii)

Here we are no longer sure it is worth speaking about any moral acts implied in the public dimensions of Sick City; all ethical and existential aspects like self-discipline, ambiguity, detachment, alienation, redundancy, ignorance (chosen or otherwise), grace, responsibility, anguish, impotence, contestation, impossibility, kenosis, etc.... are all a matter of fishing (not archery, this time). Debating and extending both William

James's and Ronald Laing's use of the notion 'divided self', might help us, as *Heron–Mazy (Anon)*, understand the delusions of our language and images. But that's beastly too, and we wouldn't recommend it. Our moral acts, conscience and confessional limits are – frankly – off-limit. The form of our prejudiced vision can only develop from the actual research above but notions about ruling passions, even the 'fake', might anticipate our confessional exercise. It might also offer unusual ways to analyse the unpopular, the hidden frauds critically embedded in architectural schemata. One outcome might be a very different (even invented) biography of the Sick City. There are many indications how we might do this. Besides St Augustine and Rousseau, and countless others from writers, mystics, philosophers, even artists, there is nothing quite like *Roland Barthes by Roland Barthes*, or William Boyd's *New Confessions* and his later *Nat Tate*. Might we – Heron–Mazy (Anon) – see a similar robust honesty to our own development through a study of our own critical selves? Are we that sick, reprehensible, delinquent? Were we really Dharma Bums that have not survived the new age? Might we not assess the maturity or immaturity of earlier notions as a way to understand the spiral in all ideas and thinking? Can we share this professionally and intellectually? Ultimately, are we talking of a more generous critical thinking entering such a discipline as architecture and urban thinking freeing it from unnecessary endgames? Prompting others to understand their own critical selves, opening up cognitive awareness of those reluctant or unable to re-trace their own spiritual and intellectual development, would be professional reward indeed. Final decisions on this, we know, will be taken by forces beyond our cities. That would be sick indeed, man!

Heron–Mazy (Anon) c. 7.2015.v1

Section Three

Interventions in Design and Experience – New Media and Technologies in the City

Chapter 10

Belén's *Social Repair Kit*: Collective data visualization and participatory civic agency

Ivan Chaparro

Introduction

This chapter summarizes the result of an ongoing practice-led research that aims at facilitating experimental artistic and design practices in public space, which can foster creative transformations of underserved communities, victims of discrimination, or groups who have been neglected by the state. The case study for the initial stage of the research has been a marginal neighbourhood in the city of Bogota, Colombia. An interdisciplinary team of designers, artists, engineers and human sciences practitioners has developed a series of participatory strategies to empower the community by aiding communication processes and promoting activities for visualizing the problems in the area, thus raising *conscientization* and supporting posterior experimentations.

The research methodology employed used instruments and references from a diverse set of theories and disciplines, which included, among some others: participatory design, relational aesthetics, crowd data collection and visualization, social cartographies, experience design and urban interventions. The result is an assortment of urban-data visualizations and interventions in public space, where several skill sets, mixed media and technological appropriations were devised, responding to the initial research questions: how can art and design reframe human experience? And, how can art and design, through humanistic interpretation, add to the offset of prejudice, violence, discrimination, racism and so forth?

In the case of Latin America, one of the most important theoretical references is the Brazilian philosopher and educator Paulo Freire with his 'pedagogy of the oppressed' and 'pedagogy of hope', developed to stimulate *conscientization*, namely, the nurture of critical and social self-consciousness in the case of those who are marginalized for some reason; starting with the awareness of their condition, which according to Freire is something extremely difficult to stimulate in oppressive environments. The idea is to direct the anger and frustration, resulting from the process of creating awareness, towards a creative and direct transformation of the immediate reality of those involved (Taylor 1993: 52).

Strongly influenced by Freire and Bertold Brecht, the theatre artist and theorist Augusto Boal explored dramaturgy as an artistic-political tool for raising social and personal awareness. By developing a series of innovative strategies for breaking the boundaries between actors and spectators – through a reflective-rehearsal process of enactment – he sought to re-conceptualize the audience as *spect-actors* in the public realm as well as in protected, educational frameworks (Bishop 2012: 124). His approaches end up

being transitive pedagogical methods fashioned for specific contexts, designed with the intention of promoting participatory engagement and humanistic education on a social level. Boal abstracted his acting lessons into general principles of social and psychological development.

The initial intention of the project was to draw attention to particular issues that could be translated to social/public practices. Several expanded-field and post-studio practices were considered with special attention, given the significance of their goals and/or methodologies, such as: socially engaged art, community-based art, dialogic art, littoral art, interventionist art, participatory art/design, contextual art, relational aesthetics (Bourriaud 2009), social practice (Bishop 2012: 2), civic and cultural agency (Sommer 2006; 2014), and interdisciplinary public humanities; all of them having in common hybrid methodologies and a reconsideration of the relation between actors-spectators/artist(s)-audience.

Context

Since the establishment of the first colonial settlements in the valley of what today is the historical centre of Bogota, between 1537 and 1539 (Cortés 1982: 19), the city grew and was organized according to the Spanish orthogonal grid around a main square. Several neighbourhoods were created over time around this area, following natural limits such as rivers and the eastern Andes Mountains, but furthermore according to economic and political power, and therefore according to ethnic criteria. While the traditional and wealthy families of Spanish descent lived in the neighbourhood located around the main plaza, the suburbs were situated beyond the southern limit of the city, defined by the San Agustin River, as a territory intended for indigenous people and mestizos. The social order of the time dictated that American Indians belonged to the rural world, while white people belonged to the city (Saldarriaga Roa 1994: 23).

The San Agustin River runs down the eastern Andes Mountains, roughly from east to west; this natural limit defined the north part of the city, which was more consciously planned, in contrast to the south, which was built more spontaneously and organically. Neighbourhoods located south of the San Agustin River were the territory where indigenous people from other regions, victims of forced displacement, arrived to start precarious settlements. The contrast between the intentional part of town and the unplanned one was, and still is, notorious in terms of infrastructure and quality of life and, moreover, it ended up determining the current logic of the city, in which wealthy families moved gradually further north, while poor people and newcomers progressively populated the south. Such division persists today in every Bogotano's imagery of their city as a pronounced contrast between the 'fancy' north and the impoverished south, and providing reasons for all sorts of prejudices related to education, economical status, ancestry, etc.

Four centuries later the situation worsened noticeably, bringing misery and displacement to millions of Colombians. The beginning of the period called 'la violencia' (Vulliamy 2015) can be tracked down to the assassination of the popular leader Jorge Eliécer Gaitán, in 1948, and the following massive revolt that left the city almost completely destroyed. Since then the Colombian multi-sided war has caused the internal displacement of around 5 million people (Vulliamy 2015) who migrated mainly to Bogota, escaping from different armed groups and configuring extensive pauperized areas in the city's outskirts.

Belén, the neighbourhood where the project takes place, is located in the mountainside, right next to the San Agustin River, showing a high contrast with the recently gentrified area on the other side of the former river, which today is an avenue located on top of the channeled watercourse. There are no recent reliable statistics of the migration specific to the neighbourhood, but historical data shows that the accelerated demographic growth and densification of Belén is due, mostly, to migration from the departments of Boyacá, Cundimanarca and Santander (Vargas and Zambrano 1988: 22), alongside some other troubled areas in the south of the country.

In the last decade, Belén has faced a series of opposing forces with dramatic consequences. First, the result of a right-wing policy of social cleansing that has operated extensively in several Colombian cities, eased by the government's blind eye to the problem; second, the territorial dispute by gangs in the area; third, the high percentage of drug dealing and trafficking in the neighbourhood and its vicinity; fourth, the marginalization of new diasporas, especially African Colombians and Native Americans from remote areas. The list could go on, but these are the most important elements to understand the complexity of the neighbourhood.

Urban Interactions Lab: *Social Repair Kit*

Kit de Reparación Social/Social Repair Kit (SRK) is the name of the specific project carried out in Belén, under the framework of the main initiative entitled *Laboratorio de Intervenciones Urbanas/Urban Interactions Lab*, which has been held thanks to a series of partnerships and alliances with the following organizations and institutions: the Resoundcity Art Lab, the Industrial Design Department at Jorge Tadeo Lozano University, the Royal Melbourne Institute of Technology and the Social Foundation CasaB.

The whole initiative was backed by the Industrial Design Department at Jorge Tadeo Lozano University, whose academic project intends to bring about design projects with a social impact by investigating technological explorations of new media and the humanities. The department facilitated logistic and material resources for conducting the hands-on part of the project in their new prototyping workrooms. The course 'Urban Interactions' was offered to undergraduate students from the faculty, who could take it instead of one of the practical subjects of the last year in their respective curriculums. A

team of twelve students from the Faculty of Arts and Design was selected to take part in the interdisciplinary group that started the project at a grassroots level.

The Resoundcity Art Lab was in charge of leading the process, supporting the group with the experience gained in similar ventures and their subsequent methodological approaches and know-how. In 2012, in Stockholm, Sweden, the Lab was founded by the designer and artist Ivan Chaparro, alongside the electronic engineer Ricardo Duenas, as an international collaboration of artists, designers, engineers, dancers and performers who develop transdisciplinary projects involving a broad set of media, related to creative ways of understanding the city as a melting pot for creative and transformative practices.

From a theoretical and methodological point of view, the *SRK* was privileged to count on the invaluable collaboration of professor and researcher Kevin Murray from the Royal Melbourne Institute of Technology, whose work is centred on southern approaches to design, which includes the social object as a means to connect people together. Despite the huge time difference between Australia and Colombia, the team managed to coordinate a common agenda for getting feedback sessions and consultancy from Melbourne. The final piece of the assembly is the social foundation CasaB, a cultural house located in Belén that intends to strengthen communal development processes in the neighbourhood from a perspective of social inclusion and sustainability. Given the fact of our condition as mere visitors and the complexity of the context, their help was irreplaceable in order to get close to the community.

In addition to the direct participants and contributors, we have been sharing insights and advancing some fruitful exchange and feedback with the EU project PARTY – Participatory Tools for Human Development with the Youth – in South Africa, at the Cape Peninsula University of Technology in Cape Town, where researcher and professor Martin Avila, alongside an international group of researchers, is exploring challenges faced by the marginalized youth in developing countries, such as prejudice, exclusion, unemployment, etc.

Method

The research was divided into five steps. First, a theoretical phase in which the literature review and referents were covered together with some technological explorations about participatory visualization of urban phenomena. The second stage implied getting to know the community while identifying their opportunities, strengths, internal tensions, ongoing processes, community leaders and so forth. To accomplish it we envisioned the creation of initial situations, where the spect-actors will weave the relationships between each other and the things around them. At this stage the role of the artist/designer/architect was to become a facilitator or producer for a larger group of participants. The third part of the project was directed towards crafting participatory visualizations of Belén's problematics, involving the broadest account of views and positions within the

community; to accomplish it we considered a flexible strategy of crowd data collection, going across different formats, instruments and devices, and thinking mostly about being inclusive. The main goal at this point was to be persuasive and stimulating, therefore the approach involved adopting experience design and gamification elements.

According to the data gathered and its consequent visualization, the fourth step consisted of analysing the data in order to get preliminary conclusions and to identify the possible scenarios and subjects that would enable experimentation. The initial objective was to craft a few *experience prototypes*, namely, a form of simulation of the service or user experience. This allows designers to predict some of the critical interactions and elements of the object-system-service to project, while performing operations through the representation of the specific physical touchpoints and timeline involved in the setup with the closest approximation to the real users/actors (Buchenau and Fulton 2000). Although perfectly common in the world of scientific research, engineering, interaction design and product design, the idea of user testing and experience prototyping is virtually unknown to the world of performative art (Birringer 2004) and participatory art/design. The data analysis carried out in this fifth step was a flexible part of the whole process, though one of the resulting projects required collecting specific data or complementing the existing one, gathered collectively in the previous stage. Consequently, the visualization and analysis were present throughout most of the project with different intensities and emphasis.

The conclusive stage of the process consisted of enacting a series of urban experiments in public spaces based on collective ideation sessions and the data gathered and visualized beforehand. The series of proposals enacted in the public space followed a cooperative *abductive reasoning* method, that is, shaping the most likely explanation to a given problematic through simple and collective logical inference and brainstorming as a means to outline a participatory strategy and a series of experience prototypes. An addendum to the project's five steps was to gather the documentation and registry of the whole process to present the most significant conclusions and insights in publications for the community and the stakeholders, aiming at giving continuity to the whole initiative from a perspective of autonomy and sustainability.

Process

Operationally, a frictionless point of departure was to adapt quotidian practices with bonding and cohesive effects in the community. After a simple exercise of observation it was noticed that, given the area's predominant rural background, its residents socialize actively around food through an extensive network of street vendors and markets located mainly in informal settings and improvised street stands throughout the neighbourhood. These places get activated organically during the neighbourhood's peak hours and celebrations.

The *SRK*'s team planned a food bazaar as the first experience prototype and strategy to start congregating the community. The event started by creating an expectation campaign

across Belén, using posters, loudspeakers and simple folk jingles, calling for 'Belén's Picnic: Saturday Food Exchange' on 7 March 2015, which implied swapping food, drinks and recipes; the only entry requirement was to bring something to share. As a complement to the process, the team investigated inspirational references for food design, mixology, synesthetic cuisine and experience design connected with cooking and eating.

The expectation campaign ended up being quite successful and the resulting event exceeded calculations; the event had over 250 visitors during three hours, who brought all different kinds of local dishes, representing their regions and traditions. The *SRK's* team prepared a food design prototype that involved the referents studied in a montage that included games, 3D-printed utensils and devices, stimulating and unusual textures, flavours and interactions.

A meeting was scheduled for the following Saturday with those directly interested in collaboratively visualizing their neighbourhood's problematics. An existing astronomical club for children, facilitated by CasaB and led by a community leader, decided to get

Figure 1. 'Belén's Street Olympics' (2015). © Creative Commons: Attribution-NoDerivs License.

completely involved in the initiative. They were a group of fifteen children and young people from the neighbourhood, between 8 and 16 years of age, who suffered from an irregular attendance in their weekly sessions. During the meeting, it was collectively decided to hold a second event, specifically for kids, in order to integrate more of them in the process. The result of the collective decision-making was the general outline of the event 'Belén's Street Olympics', which followed a similar expectation campaign to 'Belén's Picnic: Saturday Food Exchange'. The 'Street Olympics' was a success as well, and as expected, 45 kids attended with their parents. The Games involved different stages and specific installations across the whole neighbourhood.

At this point we had the community attention but, furthermore, the kids were quite enthusiastic about the project and, from then, a consistent group of kids and teenagers attended every session. The collective agreement within the team was to take advantage of this interest, shifting the project towards this excited young audience. During the following meetings the team introduced its first experience prototype as a game. The intention was to explain simply and practically how a given territory could be understood as a multifaceted system, which can be described and represented from the perspective of human perception and emotions. As inspiration, the team contemplated the theory of Psychogeography, that is to say, an approximation to geography that considers urban scenarios as the result of conscious and subconscious collective tensions, which can be analysed by comparing a specific territory with an imagined human psyche. As an easy game, a collective drift was proposed. Specifically, the whole crew was divided into groups of four participants with the only requirement being to have residents and non-residents in each one. Every group had to be silent during the whole excursion, and had to follow a simple set of six rules that had to be played out randomly by throwing a dice. Each number implied a different instruction: one meant going straight forward, two turning left, three turning right, four following the direction of the wind, etc.

The drift game took around three hours on average. Every group strolled Belén's streets while documenting their impressions individually. At the end of the journey, there was a common session for everyone to share and analyse their impressions. As a result, each group had to recreate their experience using mindmaps, storyboards and simple cartograms to convey a collective storytelling of their impression during the journey. This first approximation to the territory led to a second game, an activity designed in detail that intended to devise specific results such as the first crowd data collection and consequent collective visualizations of Belén using maps. The game had to be carried out in at least three sessions during the course of one week, using the 'Drift Collector Data Kit', which consisted of a few graphic pieces and simple tools: an infographics manual with instructions, a few different versions of the neighbourhood map and colour pencils.

The information to be gathered required mapping using the cartograms to show those places in the neighbourhood where each person felt uncomfortable or unsafe, for any reason, using a scale of 1 to 5 to indicate their discomfort, 1 being slightly uncomfortable and 5 extremely uncomfortable. The methodology was similar to the previous game: every

Figure 2. 'Drift Collector Data Kit' (2015). © Creative Commons: Attribution-NoDerivs License.

group walked together in silence, along a predetermined path in this case, while ranking their appreciation of each point in secret; besides the socialization which followed, the information gathered was to be validated and included in a database. In addition to what we called 'Belén's urban hostility index', everyone mapped the following data: smells, sounds (these two from a perspective of contamination or discomfort), manifestations of spirituality, educational institutions, skilled jobs, professions and services offered in the area. To accomplish this, the *SRK*'s team created a series of easy-to-follow printed tutorials to collect the data according to specific protocols that allowed updating the info to online databases.

The whole system of data collection was designed carefully, and the role of the kids was to spread the game all around the community. We ended up having 327 participants,

who mapped the information required by the activity. Next, the team was in charge of updating the analogical info to a database, for which we created a simple web application using the Google Maps JavaScript API (application programming interface) through a web browser, so each participant could update his or her information following easy instructions. The custom-built web app was restricted to the limits of Belén, and allowed locating the points in a map with its corresponding numbers and additional info, using the API's *place data* feature. The Google Maps API tags each entry automatically with its GPS coordinate and allows the exporting of the information to KML format (Keyhole Markup Language), a notation system for expressing geographic information in two-dimensional maps.

After uploading the analogue data to the graphic user interface on the Google Maps API, every user exported a KML file that consisted of the points they identified, according to the different categories, its matching rating from 1 to 5 and, sometimes, an extra comment or annotation. To upload the KML or KMZ files to the database, it was

Figure 3. General average of hostile and unsafe places identified by Belén's residents (2015).
© Creative Commons: Attribution-NoDerivs License.

necessary to convert them first to CSV format (Comma-Separated Values). The team used the online free utility 'GPS Visualizer', which allows updating files and profiles with geographic data, in order to export them to a variety of popular output formats. The complete process was accessible to the community through a series of open workshops, where we showed the free software used, alongside the procedures and methods. The main objective of such activities was to promote a DIY mind-set.

From the total sample of 327 contributors, 13% were non-residents and 87% residents, as follows: 71 entries corresponded to women, 56 to men, 82 to girls, 93 to boys and the remaining 25 entries had undetermined gender. The game was anonymous but required the specification of age and gender for statistical purposes, and the discrimination between minors and adults was made based on the legal Colombian age of majority: 18 years. Once the data from the whole crowd was consolidated in a single database, the next step was to highlight the spots the community identified predominantly as dangerous or hostile, followed by the other indicators that were part of the game: smells, sounds, manifestations of spirituality, etc. The purpose of these social cartographies of Belén was to indicate the emotional perception of the neighbourhood's dwellers, by trying to identify those critical points where there was a certain consensus about its hostility or inhabitability. Four spots were recognized by a majority of the participants as unfriendly.

To visualize the numeric information attached to the GPS entries, we used the cloud-computing platform CartoDB, to first determine an average in the database of the values attributed to nearby area ranges. In this way it was possible to visualize different averages separately: minors, adults, men, women, visitors, etc. Figure 3 shows the general average of Belén's residents, and the four points that were marked mainly as hostile: a, b, c and d. A collective visit to these spots allowed us to ascertain the reasons why they were considered as such. Points a and b were the western boundary of the neighbourhood located on Carrera 4, an avenue with a lot of traffic, noise and pollution; point a corresponds to a neglected property and point b to an abandoned one. Point c is a solitary street, without traffic where numerous homeless people sleep at night, right next to Calle 7, the former San Agustin River. Point d is an abandoned lot on the eastern edge of the neighbourhood, which is flanked by the mountainside. It is used as the neighbourhood garbage dump and has a deteriorated sidewalk littered with debris.

Once the points were identified, the plan was to share the visualizations and their analysis with the community in order to ask them about possible solutions and interventions; the idea at this point was to start the participatory process by actively involving the community in the problem-solving strategy. We designed a set of three tools to collect people's impressions, proposals and open ideas regarding the public space: the first one was a kit of suggestion boxes installed at points of high footfall. They featured two simple questions: what do you feel about Belén? And what would you do for Belén? The challenge here was to go from open-ended replies and suggestions towards more convergent and deliberate propositions. Seven suggestion boxes were installed across Belén for one week; one of them disappeared for a few days but was returned

exactly as it was, before the exercise finished. The result of this tool was a large pile of papers expressing, mostly, affection for their neighbourhood and proposing a variety of improvement and beautification actions such as planting gardens, cleaning collectively, painting murals, etc.

Based on the submissions collected, we grouped similar ideas in different categories as a means to get the community involved in the following decision-making and action plan. Accordingly, the second tool was a group of seven 'backpack suggestion boards', consisting of a simple multiple-choice game to determine what were the most popular options. The *SRK*'s team members walked around the neighbourhood, gathering information during peak hours and special occasions, such as the Saturday football game and the Sunday Mass, carrying around wooden boards. First the team showed an infographic piece with the collective cartographies and the neighbourhood problems identified beforehand. Then we asked: what would be the best way to address these problems? Followed by the resulting possibilities of the previous exercise: (1) A collective

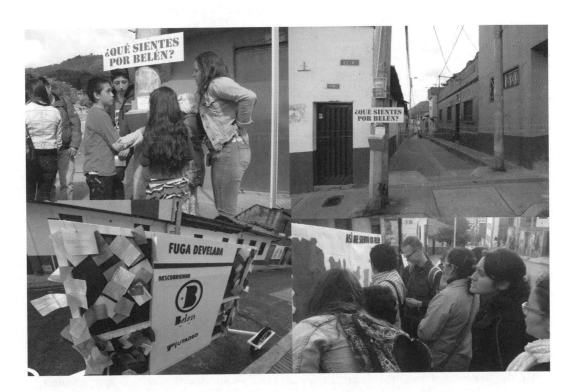

Figure 4. Mail boxes and ideation push cart (2015). © Creative Commons: Attribution-NoDerivs License.

cleanup day, (2) Planting gardens and greenery, (3) A series of happenings to change public perception of the troubled spots, (4) Collective murals and signage to beautify and warn about unwanted practices, and (5) Educational workshops to prevent further infrastructural and communal deterioration. Of course these options were not mutually exclusive; rather, the whole exercise aimed at collectively envisioning the possibility of stimulating participatory civic agency among neighbours.

To complement and strengthen the scope of the previous exercise the team designed the last tool: a 'collective ideation pushcart' that circulated for one week around the neighbourhood, offering design games that consisted of real and fictional situations to be solved within a set of options and including some given materials and organizational possibilities. These games had two versions, one for the busy passer-by that required ten minutes at most, and that had to be solved in teams of at least three participants; and the second version which was stationary, required at least twenty minutes and implied thinking about possible positive scenarios for the neighbourhood in five and ten years.

According to the information gathered, its visualization and the momentum generated during the exercise using the three previous tools, an open session was organized to determine the programme and agenda to be executed in the two following weeks. The consensus dictated the following interventions:

1. Marking the correct spots to dispose trash with stencils so as to prevent its accumulation in critical areas throughout the neighbourhood.
2. Highlighting positive practices and habits that can be a good example for the community, in connection with: the preservation of public space; the correct use of resources; and the promotion of behaviours that favour social cohesion.
3. Installing temporary gaming-devices to reward good habits in relation to waste management.
4. An event to create an urban intervention in the points *c* and *d*, where it was possible to foster direct changes with a bottom-up tactic. Points *a* and *b* required infrastructural changes beyond the community's agency.

A remarkable contribution from this session was an idea, proposed by a senior citizen, of declaring the places to intervene as sacred, thus reinterpreting them, from a perspective of respect and reverence, as protected spots. Collective action to improve these sites along with symbolic offerings and participatory enhancements would upgrade these troubled spots to their new status.

Kids and teenagers joined the following sessions during weekdays right after school and adults after their workday. The team started by creating the slogan *cada basura en su lugar/each piece of litter in its place*, inviting everyone in the neighbourhood to use the designated areas for disposing waste. First we spotted those areas appropriated erroneously as dumps and marked them with the campaign symbol and slogan. The same neighbours of those areas were in charge of painting the stencils, which gave validity to

Figure 5. Floor stencils and Tejo game (2015). © Creative Commons: Attribution-NoDerivs License.

the intervention and ended up signifying an invitation rather than a public sanction. Then we identified the correct disposal areas with symbols and encouragements. Those actors and practices recognized by everyone as exemplary were also stenciled in the pavement, sometimes with specific names, as if to reward specific persons socially for their outstanding behaviour. The sentences stenciled included phrases such as: 'Mrs Maria Posada has the best collection of nutritious and easy-to-follow recipes, which she is eager to share and exchange. Hurrah for Maria!' 'Mr Ramiro Perez holds an open jam session at his yard every second Tuesday at 7 p.m.; it includes always a music lesson. Cheers for Ramiro!' Besides constituting a community reward, these phrases sought to strengthen and socialize local knowledge at several levels.

The next step in the agenda was a set of temporary gaming-devices, located in the correct areas for disposing trash, where neighbours could get a collection of plastic caps to play Tejo, a traditional popular sport in Colombia consisting of throwing a metal puck or disc across an alley at a distance of approximately twenty metres, onto a board covered

with clay. Naturally, the use of plastic caps involved reconsidering the dimensions of the game and the board as well. Belén's residents ended up collecting their plastic caps at home, waiting for the chance to throw their trash at the right spot, to play a Tejo match with a neighbour. Those who brought their trash bags but had no plastic caps to play were able to get them at the closest shop around the designated areas. The game ended up becoming viral and paved the way for the final interventions.

The concluding urban interventions were intended to happen in the points *c* and *d*, on a Saturday two weeks after the programme started. The plan was to host an event in the two places, one after the other, where neighbours would gather to clean up and improve these spots, installing a vertical garden and leaving behind some offerings in a ceremony, to define these sites as sacred, in a ritual of activation. To prepare the event the team started a campaign for sharing and exchanging plants – many of the senior citizens had extensive knowledge of local greenery, which they contributed gladly to the group. Parallel to the sharing campaign the *SRK*'s team organized three open workshops about green walls and vertical gardening. Since no one knew about this technique, we learnt alongside the community, in a self-taught process.

As mentioned before, the 'Drift Collector Data Kit' included mapping the manifestations of spirituality in the neighbourhood, which consisted of identifying churches, congregations, ritual sites, cult images, etc., according to three main categories: formal, informal and appropriations of public space. Such mapping of the neighbourhood let us notice obvious tensions, especially between Catholics and Protestants, therefore it was considered as indispensable to organize several exchanges of views around the definition of the term 'sacred' in order to prevent conflicts that could set back the whole initiative.

Since its foundation, Belén has been a predominantly Catholic community, which grew around La Parroquia de Nuestra Señora de Belén/Parish of Our Lady of Bethlehem. However, in the last three decades there has been a constant incursion, in the whole country, of Protestant churches, mainly Baptist, Presbyterian and Lutheran, together with Mormons, Jehovah's Witnesses and some other religious denominations. The fundamental tension in the case of Colombia is located around the figurative representation of saints and other religious figures. While Catholics have a special reverence for their human representations, *Evangélicos* (the generic name attributed to Protestants in Colombia) reject such practices inflexibly.

To avoid this kind of irreconcilable conflict, we decided to shift the discussion towards a definition of sacredness closer to the concept of patrimony; that is, those fundamental material things and practices that universally deserve exceptional respect and preservation. The community agreed that the offerings were going to be written and presented according to a modular design decided upon collectively. Accordingly, the *SRK*'s team facilitated a session where a geometric module, capable of configuring different polyhedrons, was defined as the standardized format to convey the written manifestations of sacredness. These modules were circulated around the neighbourhood in the week prior to the

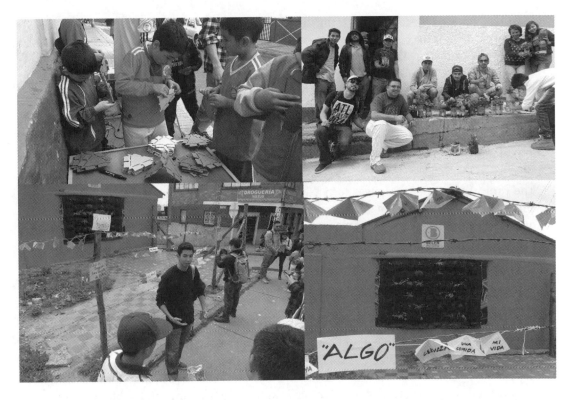

Figure 6. Geometric module, plants' exchange and vertical garden (2015). © Creative Commons: Attribution-NoDerivs License.

intervention, and every member was supposed to bring them back on the day of the collective installation.

Everything was ready for the final intervention on Saturday, 16 May, but everything ended up being delayed a couple of hours due to a heavy rain; nevertheless, as soon as the shower dwindled a bit there was a great turnout. The intervention started with a cleanup session, accompanied by live music and followed by the installation of the vertical gardens and the planting of local greenery at each spot. Once the two places were worked on and embellished, we performed a closing ceremony at point *d*, where different community members discussed their impressions of the process and their reflections about the new sacred spaces for the vicinity.

A diverse sample of community members congregated for the event; many of them had been living nearby for a long time without having spoken to each other, and that day they got together to improve their shared spaces. Several participants commented that

they had noticed obvious changes in their neighbourhood since the beginning of the project, four months before, but, moreover, they worried about how long these changes were going to remain. One month later, a visit to the project spots, together with a series of short interviews, allowed us to attest that the transformation of these two former problematic sites had persisted and, furthermore, neighbours had continued some of the practices started during the project.

Conclusions

The project's main purpose was to put into practice creative activities that could bring about consequences of accountability in Belén's community. The research, in the long run, intends to prove how artistic, design and humanistic appropriations of public space can inspire collective agency and positive transformations of neglected scenarios. The physical interventions, rather than being the main goal of the research, represent an excuse for activating a given social dynamic.

The role of the *SRK*'s team of designers, artists, researchers, etc., was as the facilitators and producers for a larger group of participants. Our main task was to use our skills and expertise to support the community's ongoing processes by aiding their communication, decision-making and technical problem-solving. The sustainability and long-term impact of these kind of initiatives can be measured in the continuity of the process, beyond the dependence on external actors or institutions. The ideal of a participatory project with a social scope is to promote practices that can lead to self-governance and public autonomy. Accordingly, a further stage of the research carried out in Belén would be to monitor the long-standing effects of the civic games developed with the community, in order to identify the catalysers, wildcards and perils of the new forms of occupation and reinterpretation of the territory, which could be triggered by the different interventions.

Several contemporary authors who work with similar or tangential subjects and approaches (Birringer 2011; Brower et al. 2005; Bishop 2012) underline the significance of working with technologically aided forms of interaction and expression for widening the impact and extent of the result. Within the project, it was necessary to review this premise carefully. Initially, the team thought of employing digital technologies from the beginning, which would have made the data collection and further analysis easier, but a simple observation of the context dictated a totally different strategy in order to be inclusive and integrative.

Another common query in this kind of project concerns the method of identifying practical solutions to the boundaries between disciplines and professional identities. Within the project, the creative and practical response to such division of labour was the concept of hybrid practices, that is, integrations of knowledge and modus operandi where several skill sets, technological appropriations and extra-disciplinary possibilities contribute to a constructive approximation of the context. Consequently, the terms cultural agency and public humanities were devised to refer to a diverse range of activities

that contribute to society, including pedagogy, activism, research, design and the arts, among others, focusing on the connection between creativity and social change.

References

Bench, H. (2010), 'Screendance 2.0: Social dance-media', *Journal of Audience & Reception Studies*, 7: 2, pp. 183–214.

Birringer, J. (2004), 'Interactivity: "User testing" for participatory artworks', *Design and Performance Lab Magazine*, http://people.brunel.ac.uk/dap/user.html. Accessed 29 May 2014.

—— (2011), *Performance Technologies and the Social*, Cambridge, MA: MIT Press.

Bishop, C. (2006), 'The social turn: Collaborations and its discontents', in T. Griffin (ed.), *Artforum*, February, pp. 178–83.

—— —— (2012), *Artificial Hells: Participatory Art and the Politics of Spectatorship*, London: Verso.

Bourriaud, N. (2009), *Relational Aesthetics*, London: Altermodern.

Brower, J., Mulder, A., Nigten, A. and Martz, L. (eds) (2005), *aRt&D: Artistic Research and Development*, Rotterdam: V2 Publishing/NAi Publishers.

Buchenau, M. and Fulton Suri, J. (2000), 'Experience prototyping', *Symposium on Designing Interactive Systems, DIS '00*, Brooklyn, New York, 17–18 August, New York: ACM.

Cortés Ahumada, E. (1982), *El Barrio de la Candelaria*/The Candelaria Neighbourhood, Bogotá: Banco Central Hipotecario.

Hewitt, A. (2005), *Social Choreography: Ideology as Performance in Dance and Everyday Life*, Durham and London: Duke University Press.

Murrain, H. (2009), 'Cultura ciudadana como política pública: Entre indicadores y arte' 'Civic culture and public policy: Between indicators and art', in E. Sánchez and C. Castro (eds), *Cultura Ciudadana en Bogotá: Nuevas perspectivas*/Civic culture in Bogota: New perspectives, Bogotá: Cámara de Comercio de Bogotá, Secretaría de Cultura, Recreación y Deporte, Fundación Terpel y Corpovisionarios.

Rancière, J. (2004), *The Politics of Aesthetics: The Distribution of the Sensible* (trans. Gabriel Rockhill), London: Continuum.

Saldarriaga Roa, A. (1994), *La Candelaria: El centro histórico de Santafé de Bogotá*/ The Candelaria: The historic centre of Santafé in Bogotá, Bogotá: Corporación la Candelaria.

Sommer, D. (2006), *Cultural Agency in the Americas*, Durham and London: Duke University Press.

—— —— (2014), *The Work of Art in the World: Civic Agency and Public Humanities*, Durham: Duke University Press.

Taylor, P. (1993), *The Texts of Paulo Freire*, Buckingham: Open University Press.

Vargas, J. and Zambrano, F. (1988), 'Santa Fe y Bogotá: Evolución histórica y servicios públicos (1600–1957)/(Santa Fe and Bogata: Historic evolution and public services (1600-1957)', in P. Santana et Julián Vargas, Fabio Zambrano, Juan Díaz, Vincent Goueset, Fabio Giraldo, Hernando González, Néstor López and Irma Andrade (eds), *Bogotá 450 años: Retos y realidades*/Bogata 450 years: Challenges and realities, Bogotá: Foro nacional por Colombia e Instituto Francés de Estudios Andinos, pp. 11–92.

Vulliamy, E. (2015), 'Colombia: Is the end in sight to the world's longest war?', *The Guardian*, 15 March, http://www.theguardian.com/world/2015/mar/15/colombia-end-in-sight-longest-running-conflict#comments. Accessed 29 May 2015.

Chapter 11

Read or follow? Designing with mobile technologies and digital space

Natalie Rowland

Introduction

This chapter examines the relationships between mobile technologies and the city environment, with reflection upon the work and experiences of the author in the field of digital choreography. A mediated approach to architecture and planning will be discussed, with a particular focus on how these technologies can complement and enhance the movement of people in the city. With a wealth of information and opportunities for engagement now at our fingertips through the use of mobile Internet-enabled devices, we are presented with the ability to add an exciting new layer to the geography of our cities.

While the buildings and travel networks expand and grow around us, so the virtual world also develops. With so much of our daily lives now affected by and in rhythm with the virtual world, it follows that the physical world must accommodate the changes in our behaviours and requirements that this elicits. Elizabeth Grosz suggests that the most significant effect of the increased use of the chip and screen in day-to-day life is the way that our 'perceptions of materiality, space, and information' (Grosz 2002: 76) are changed. Each of these aspects is inherently linked to our purpose, use and navigation of the city. How we perceive space and distance will impact decisions about transport, about comfort and security. Grosz asserts that the chip and screen 'is bound directly, or indirectly to affect how we understand architecture, habitation, and the built environment' (Grosz 2002: 76).

Navigating the digital

Taking navigation as an example, developments in technology have fundamentally changed the way many people encounter and explore the city. One behaviour in particular has inspired this chapter, namely the way that people are beginning to look down more than they do up. This behaviour is beautifully illustrated in the anonymous Tumblr blog entitled *We Never Look Up* (weneverlookup 2014) which is a photographic account of society's preoccupation with handheld devices. The pictures show hunched over figures isolating themselves in their own kinesphere, oblivious to what is going on around them. Amongst the more poignant images there is a couple sat across from one another at a table in a cafe, each with their eyes and bodies focused intently on their phones. Another photograph depicts a man in an art gallery, his back turned to a sculpture hunched over

reading his phone. While these images may suggest a closed minded and unsociable aspect to mobile technology, there is an alternative viewpoint. Taking the gallery image as an example, we can imagine being in a gallery and using our phones to find out more about an exhibit. Our mobile devices can enhance our experiences and many museums and galleries are beginning to make use of this through QR (quick response) code links and augmented reality apps. Augmented reality often uses GPS (Global Positioning System) location or image recognition to display an alternative view or add objects to a camera view. The Museum of London has developed an app called *Streetmuseum* which allows users to hold their device up to a London street and view the street as it would have been in the past. The multifunctionality of our handheld devices is providing more opportunities for their use and in turn affecting our physical encounters with the world. The implications of this are perhaps most explicit in changes in navigation.

Virtual navigation

We look down.

Into our phones, into tablets, at Sat-Navs.

Always looking at information in a small frame.

Navigation is now a word more commonly associated with movement through web spaces. The architecture of a website is crucial to how and where it can be viewed and the ease to which it can be used. The success or failure of this architecture is often most evident in the application of Satellite Navigation or 'Sat-Nav'. While we are finding our feet in the virtual architecture, we try to relate the information found to the real world. Two worlds collide – sometimes more effectively than others – but for many of us in the twenty-first century, we look down into our devices in order to navigate. When visiting a new city, our first instinct is to find a Google map or type the postcode into a Garmin. We stare intently at these devices, putting our trust in them and are often left feeling vulnerable or angry when the virtual world does not fully prepare us for the real one!

This virtual navigation trend is completely at odds with how most of us were taught to navigate and how we learned to explore spaces. We were taught to read the map. The use of the verb to *read* is important. We do not *read* a Sat-Nav, we *follow* it. The former suggests an examination of information and interpretation, while 'follow' implies an unquestioning obedience. The change in verb illustrates the significant change in behaviour. The traditional map provides a representation of the area and relates strongly to the environment. Finding your way using a map involves reading the symbols and using them to position yourself within the real environment. You are required to identify features of the landscape or landmarks and work out where you are, where you want to go and how you are going to get there. This type of navigation is often referred to as 'wayfinding' and it causes you to be continually present and focused on looking up

and looking around as well as referencing the map. Compare this to the use of the Sat-Nav and you find we look down and keep looking down and looking at the blue arrow or other icon that tells us where we are. And it is because the icon tracks our location, meaning we don't perceive the need to, that 'paying attention is no longer as present in the user' (Hansen 2009: 10). The following action of Sat-Nav use produces a very different behaviour and condition of awareness to that of wayfinding. Hansen further articulates the difference, stating that navigation (using the point A to point B approach of Sat-Navs) follows 'a predefined sequence' while wayfinding creates 'a sequence based on a number of selections' (Hansen 2009: 10). Following a Sat-Nav has the potential to isolate the user from the environment, keeping them looking down into the device.

Figure 1. Looking down at a live music event, 2013. © Natalie Rowland.

But when do we look up and see where we really are?

The answer is often when we have to.

There is a car horn beeping at you, you've lost GPS signal or for some reason you don't believe that the Sat-Nav that is telling you turn left is correct because you are knee-deep in mud. You look up and you ask, 'where am I?' because you don't actually know – you have placed all your trust into a 2D rendering of the environment which is a completely different kind of architecture to what you are faced with in reality.

Digital spaces as layers

The example of navigation sets out very clearly potential problems of using the virtual world to inform our encounters with the real world. However, we cannot continue to consider these as discrete when business and social use of the Internet continues to grow. The popularity of mobile devices as tools for communication, information sharing and social interaction indicates that the material environment – including the built environment – must learn to accommodate and work with these technologies.

The architecture of the city is no longer simply bricks and mortar, but also levels and layers of content, providing information (such as mapping or local facilities), alternative views, historical context or even role-playing. These layers build a further virtual dimension into our cities. The challenge facing those working in the built environment is how to incorporate the virtual in a way that is inclusive, practical and beneficial.

Michel de Certeau discussed two perspectives of the city in the text *The Practice of Everyday Life* (2002 [1984]) which Hansen articulates as 'from outside through the map or from within as a pedestrian' (Hansen 2009: 5). The developing layer of mediated content and interaction in our cities introduces another perspective which, although somehow intertwined with de Certeau's embedded and elevated views, doesn't sit comfortably within either category. A virtual view of the city suggests a completely separate world that sits apart from the real, a charlatan if you will. Discussions of virtual reality in the late 1980s and early 1990s when the technology first became mainstream seem to focus on a utopian ideal of a separate world space. However, this is not what virtual and interactive media has provided for the city. While some do still choose to use the web and gaming technologies as a place to escape to, the mainstream impact of web and information technologies has been in areas that assist or engage with our everyday lives. Lev Manovich suggests that there are currently three main technological applications: 'surveillance, cellspace, electronic displays' (Manovich 2006: 220) and that these applications 'make physical space into a dataspace: extracting data from it (surveillance) or augmenting it with data (cellspace, computer displays)' (Manovich 2006: 220). The notion of a dataspace suits the current focus of technology and its very nature. Particularly in the city where our needs are often information-driven (locating facilities, conducting business, engaging socially), the dataspace pervades every street and building through mobile

devices as well as installations. The prevalence of mobile devices presents the dataspace with an even more global reach, an almost Certeaulian elevated status as we are no longer dependent on wired, physical links between points. Wi-Fi and Bluetooth technologies are non-linear and have an omnidirectional reach. However, the dataspace is not restricted to nor defined by its reach and elevated view: it delivers an individual experience as well. Within the microcosm of the personal mobile device, the user encounters the dataspace in his or her preferred manner. The development of the graphical user interface (GUI) and particularly touch-related control of these interfaces enables the dataspace to become personal, adaptable and accessible. Mark Sample recognizes the importance of this, reminding us that, 'the technology of post-modernism is technology that, as Stirling puts it, "sticks to the skin, responds to the touch"' (Sample 2014: 76). The tactile interface is perhaps the key in developing relationships to the dataspace that do not isolate it from our experience of physical space and encourage wayfinding behaviours.

Designing with the dataspace

With the emergence of the dataspace comes a whole new challenge for those designing and planning for the city. How can our built and designed spaces accommodate and integrate the dataspace which is both global and personal in a way that works alongside our real spaces rather than continuing this trend of everybody looking down? How can the dataspace be incorporated into the experience of the city? What form should interfaces take in order to maintain both access and awareness? Professor of Film and Television at Goldsmiths, University of London, Sean Cubitt, raises our awareness of the potential risks in standardization, suggesting that the result of this is 'a culture that constrains us to innovation within parameters already historically established and steers us away from inventing the disturbing and exciting new' (Cubitt 2014: 4). While technological developments can generally be considered to hold a genealogy born mainly in the name of necessity or accessibility, in looking outside of the existing paradigms we may open up pathways to new experiences and interfaces that foster the relationship between the analogue, digital and the virtual. In discussing digital light (we may consider the LCD (Liquid Crystal Display) and OLED (Organic Light Emitting Diode) screen to be a form of this) a symposium held in Melbourne in 2011 proposed that 'carefully matched workspaces and workflow management [by] these dominant companies [...] produces a normalization of visual culture' (Cubitt, Palmer, and Walkling 2012: 38). This statement explicitly expressed fears that the current trend for digital interfaces and workflow to be normalized by dominant players in software and hardware industries will impact on the creative application of such technologies.

Amid a proliferation of companies offering intuitive, what-you-see-is-what-you-get products it is easy for the designer to select the market favourite, or normalized interface. When faced with a population that has adopted mainstream, prescriptive products such

as the iPhone or Facebook, how do we offer or create new experiences of our city that can transcend the boundary of the screen?

Lev Manovich talks of an 'augmented space' which is 'the physical space overlaid with dynamically changing information' (Manovich 2006: 223). The most obvious example of this is the use of large display screens on buildings. But there is the potential for this augmented space to include the mobile devices, wearable technology and built-in technology that is beginning to fill our daily lives.

Mobile technologies in particular can provide an essential interface and a new way for us to navigate the architecture of our city. They can offer different experiences and opportunities in navigation from Sat-Nav or traditional maps which use cartographic symbolism and representation. Through digitally embedded opportunities for interaction, digital 'tactics' (to use de Certeau's term) could enable the user to 'escape the control of material and abstract institutions and create their own interpretations or writings of the city' (Jensen and Ulv, cited in Hansen 2009: 7). By integrating the dataspace into design, the personal experience of the city can become even more tailored rather than generic. Advertising companies are already taking advantage of the personalized dataspace. You need only to look at the relationship of the banner ads you see to your browsing history to see this in action. As we design spaces and encounters within our cities, can we find ways to embrace and cultivate not only the personal dataspace, but also the social dataspace? Though it can be argued that the microcosm the personal device creates is an alienating space, there are ways that these personal dataspaces might be choreographed to provide opportunities for social or business encounters, for example.

Virtual Reality (VR), Augmented Reality (AR) and applications with a similar interactive approach can open up new methods and methodologies in engagement with the city through targeted content. They also provide a new creative medium for artists across many disciplines including, but not limited to, film, gaming, dance and performance. Randall Walser saw the potential for mediated spaces, suggesting that 'Print and radio tell; stage and film show; cyberspace embodies [...] The film-maker says, "Look, I'll show you." The spacemaker says, "Here, I'll help you discover"' (Walser, cited in Rhinegold 1991).

The opportunity for the spacemaker to facilitate discovery is an exciting one and through mobile technologies and the dataspace we have the tools to create spaces that are multidimensional, not just physically, but also digitally encouraging layers of experience where the visitor may simply pass through or choose to engage with the space at a different level. These mediated spaces allow for dissemination of multiple visual and information layers, a truly augmented space in Manovich's definition.

The many spaces within the city can be discovered or augmented through technology. Shelley McNamara and Yvonne Farrell assert that 'What we build as Architects is in fact the New Geography' (Farrell and McNamara 2011), drawing on notions of persistence of the built environment and legacy. In the growing area of Information Architecture, we see a 'new geography' and alternative opportunities for navigation evolving in the content and usage of the World Wide Web.

Furthermore, as we begin to better understand the ways information within the dataspace can travel, the planner has greater tools at their disposal for choreography of movement within the city. GPS-enabled apps allow for the tracking of crowd movement, authorized persons and even the occupants of a building. Utilitarian uses of this information include development of safety and security provisions and energy-saving procedures. The dataspace is directly informing and changing the physical space and as we further understand and explore the potential uses of this pervasive dataspace we can build a more integrated relationship between the spaces of our cities.

The language and nature of this relationship is constantly shifting. The bidirectional nature of communications technology has expanded exponentially with the advent of social media such as Twitter and Facebook. Utilizing a multi-platform approach, advertising and promotional campaigns have been able to reach an even larger audience and interact with them, receiving instant feedback, interest and responses. As designers, being able to respond to these opportunities for development and cultivating an explorative attitude enables the users of the city to contribute and feed the experience of our spaces. If we fail to embrace and utilize these opportunities, we risk our spaces becoming out of sync, or even relevant to our users. Elizabeth Grosz suggests that 'The Net not only speeds up and enhances information storage and retrieval and communications structures, but it threatens to disrupt or reconfigure the very nature of information, communication, and the types of social interaction and movement they require' (Grosz 2002: 86).

There are many pressures that the Net or the dataspace places on the architecture of our city, but there are also many opportunities. The opportunities to engage with mobile device users and enable a greater level of interaction with our city promise to enrich communications, business and social paradigms. Within my own field of the arts, the possibilities are seemingly endless.

Choreographing with mobile technologies

As a choreographic artist an interest and engagement with mobile devices has helped in devising a teaching strategy that challenges students' ideas about choreography and movement. Through analysis of the small screen and mobile Internet as a performance space, notions of perspective, space, time and privacy can be discussed – pertinent issues both in personal and social spheres. What the mobile device seems to provide is an opportunity to explore the dataspace through a lens which allows both a micro (personal) and macro (social) viewpoint. In the summer of 2013, a project engaging a diverse group of dancers on developing choreography harnessed the small screen and the use of mobile technologies. The resulting works presented an array of different experiences and means of connecting with the environment and movement through the mobile device. The process began with an exploration of the issues and themes that surfaced when considering the multifunctional use of the mobile device. The key

issues raised included privacy, information, entertainment and time. Each issue was investigated by a different group. How these projects developed illustrates the various opportunities the dataspace provides for engagement and exploration at a macro (social) and micro (personal) viewpoint. One group investigated a way to portray the history of a particular room on the university campus. The room E124 had been a command centre during the D-Day landings and the choreographic response by the group involved dense research coupled with a personal response – a marriage of macro and micro viewpoints. The project culminated in an interactive space installation where visitors were invited to explore – and more importantly experience – the research (Figure 2).

The space was laid out as though it were the remnants of an explosion: scattered papers, photographs and objects, suggestions of the space that had been. Among the debris were a number of QR (Quick Response) codes which linked to soundbites, images and movement footage created by the group, which visitors were encouraged to scan and discover through their mobile devices. When the space was full of visitors, if you stepped back for a moment, the combined effect of all the mobile phones playing back the soundbites created a dense soundscape which was incredibly evocative. When you yourself were engaging with the codes and the information, the nature of the small screen and the handheld device made the information somehow more intimate and invited a more personal response. It is easy to see how such an interactive environment might be used in a museum or exhibition environment. However, the concept of creating a macro and micro dataspace with the potential to offer social and personal experiences of a space, topic or entertainment can be carried across into the design of other spaces within our city environment.

Both in teaching and research in the area of technology and movement, it becomes repeatedly clear that a phenomenological approach, privileging bodily experience, often facilitates the meeting of the digital and analogue. The importance of this is iterated by Professor of Communications Brian Massumi, who suggests that 'digital technologies have a connection to the potential and the virtual only through the analog' (Massumi 2002: 138). The potentials of augmented realities and dataspaces within our city spaces rely on the interfaces and interactions with the physical spaces and the analogue in order to be realized.

Experiencing the digital

A more recent practical research project we can discuss here, involves the potentials for interacting and interfacing with digital light in performance and architectural applications. In seeking to develop creative methodologies for working with digital light that does not rely on or become shaped by the normalized industry practices, this research has begun by exploring the experience of digital light sources. Focusing on LED (light emitting diode) sources, the practical exploration of this type of lighting

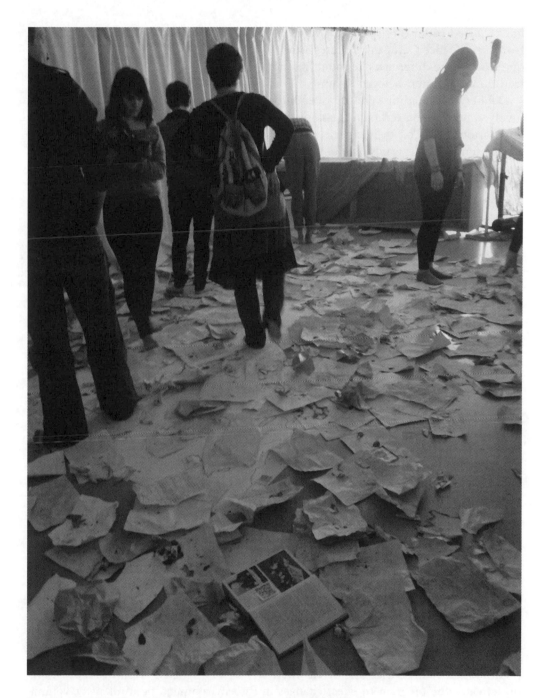

Figure 2. Choreographic installation in development, 2013. © Natalie Rowland.

has required the use of software and mobile devices. However, working with dancers from Drift Dance Company (Figures 3 and 4), an experience-led approach has sought to question where differences lie in our relationships to digital light when compared with traditional tungsten-halogen lighting.

Deliberately avoiding a prescriptive approach to the explorations, the initial workshops involved wayfinding techniques, asking the dancers to make their own discoveries and associations based on their experiences of light and their intuitive responses. The group all had tendencies towards playful interaction, an approach that appears to support the findings of performance and technology researchers such as Sita Popat and Scott Palmer, who propose that 'playful interaction between the technological and the artistic should, in theory, lead to understanding and synthesis in the creative product' (Popat and Palmer 2005: 50). Through initially exploring the lighting technologies and the lit environment without any form of control interface, the dancers revealed their instinctual associations and bodily responses free from prescribed modes of interaction. Performance theorist and practitioner Susan Kozel works extensively with a phenomenological approach to technologies, and states that 'A role for the tangible, the tactile, the haptic, is essential for any account of our physical encounter with digital media' (Kozel 2007: 38). This was very much found to be the case with Drift Dance Company's exploration of LED lighting. Although control interfaces were not used in the early workshops, the dancers' responses revealed that notions of texture, proximity and an ability to move the light source were pertinent to their relationships with the technology.

The dancers noted in particular that they were aware of trying to create the space or define it themselves when improvising with LED light, while more focused tungsten-halogen fixtures dictated a space for them in a beam that seemed more tangible. The privileging of experience and wayfinding as an approach to technology highlights our instinctual needs with regard to interfaces. So often our normalized workflows dictate that we should have certain buttons or controls, but perhaps the mobile device could help facilitate the experience of space through an approach that focuses on experience and wayfinding? Kozel suggests that 'we can regard technologies not as tools, but as filters or membranes for our encounters with others' (Kozel 2007: 70). The author's workshops with Drift Dance Company have encouraged me to design a mobile device-based interface for future explorations between dancers and lighting, rather than use existing applications for this very reason.

Mobile devices and experience of space

Existing applications for the control of lighting and sound in environments are predominantly single-user orientated. There will be a designated person who programs or activates the program to effect changes in the environment, be it intensity, volume or content. This has developed directly from the normalized workflow and software

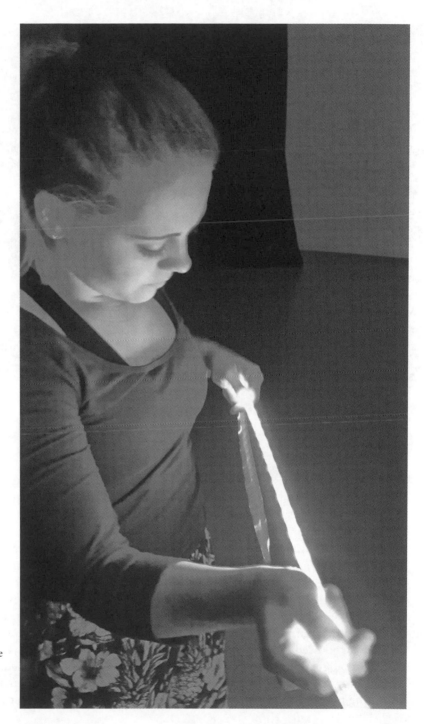

Figure 3. Drift Dance
Company working
with LED light-
ing, 2015. © Natalie
Rowland.

Figure 4. Drift Dance Company working with LED lighting, 2015. © Natalie Rowland.

developed for these industries. However, the mobile device offers the potential for wider encounters and group experiences due to its ability to create and interface within both personal and social spheres, micro and macro environments (as previously discussed).

We are beginning to see the social potential of mobile devices as interfaces for experiencing lighting through systems such as PixMob and the mass pixel-mapping of the London Olympic Stadium by Tait Technologies and Avolites Ai in 2012. PixMob use the tagline: 'Connect crowds. Reinvent rituals' (PixMob 2015) on their website, which succinctly describes the aim of their interface which provides control of LEDs within bracelets or other wearable devices that can be used to create mass-lighting effects within large groups of people. First brought to mainstream attention by the band Coldplay who used the system for audiences attending their 'Mylo Xyloto' tour in 2012, this technology foregrounds the experience of being part of a mass cultural event. The wearer becomes an integral part of the lighting design, joining thousands of others in becoming part of a collective creating a unique environment of lit space and movement.

Susan Kozel's exploration of phenomenology as a dynamic to open up our encounters with technology brings her to consider Merleau-Ponty and the notion of the 'seeing-seen'. This idea resonates strongly with the experiences discussed here, where the wearer of the LED device is both spectator and participant, seeing and seen. Kozel articulates that 'this dynamic helps rework the relation between bodies and media technologies by overturning the suggestion that the digital image is merely a visual representation of the world' (Kozel 2007: 36). In this case the digital image that is mapped across the devices cannot be expected to generate a representation of a coherent image, due to the movement of the crowd and the continuous flux of this body or surface. The digital content is shared and re-envisioned by the analogue space: the dataspace working with the physical space in order to create a unique shared environment. Movement is a key player in this environment and as cultural theorist Nicolás Salazar Sutil suggests, 'technological intervention transforms the representation of movement; representation in turn transforms the way we move or what we understand by movement' (Salazar Sutil 2015: 1). The choreography of the lit space – including the light that emanates from mobile devices such as smartphones and tablets, is a choreography only beginning to be explored. It is complex and involves analogue, digital and virtual spaces. The resonance of the movement interacts with and defines the present physical space, but also has the potential for further reaching temporal and environmental repercussions.

Participation in a mediated event such as the Coldplay concerts is not only a unique experience at that time, but becomes a creation shared by those present that can provide a talking point and reference for further social media interactions for time to come. PixMob's website provides examples of the Twitter traffic generated by those who have experienced events that used the companies' technology, demonstrating the social, geographical and temporal impact.

Engaging and objective relationships

In its ability to be both personal and social, the dataspace creates a unique opportunity for both engaging and objective relationships. It is possible to consider this property as a development of de Certeau's embedded and elevated views. The dataspace is primarily concerned with communication – it exists as transference of information – and as such the perspectives available to us dictate the nature of our relationship with it. Engaging and objective viewpoints echo the embedded and elevated, but make concrete the existence of an information-based relationship. And as the technologies associated with the dataspace develop, Grosz's belief that 'It is central to the future of architecture that the question of time, change, and emergence become more integral to the process of design and construction' (Grosz 2002: xix) becomes all the more pertinent.

Through a consideration of the bodily experience of the dataspace, these concepts can be elucidated and used to inform a practice of interactivity that can enliven spaces and

our relationships with them. Art historian Katja Kwastek has written on the aesthetic and nature of interactive digital art, considering methodologies for creative relationships with technologies, exploring both the artist and participant's contributions. She notes that 'The recipient has the task of realizing spatiality within the structures provided by the system. When such a realization takes on manifest, physical form, it immediately acquires the quality of a performance' (Kwastek 2013: 104). This makes clear the relevance of interactive technologies to the arts; but does an experiential, wayfinding approach to the dataspace have relevance to our everyday encounters with the city? Through the research discussed here, clear connections have been made with the need to foreground awareness of the bodily response to technology in order to gain understanding of the potentials of technologies. Although these practices mean that research in this area is approached from a choreographic and movement-informed perspective, it is feasible to agree with Kwastek's recognition that 'the virtual becomes one domain among others that can be rendered perceptible through bodily sensitized action' (Kwastek 2013: 61) and that experience-based practice has much to offer the creative development of technologies. In considering the writings of Michel de Certeau, Kwastek identifies his understanding of the 'activation of certain places by means of presence, and in the construction of relationships between places and spaces through one's own movement' (Kwastek 2013: 104) – again highlighting the importance of movement to relationships with space. With our mobile devices not only capable of moving with us, but also providing other layers of movement such as locative operations, virtual tours and movement of text, image and light, these devices offer much potential in the embodied and cultivated experiences of our city.

Conclusion

Manovich suggests that one of the largest issues with creating a completely augmented space is how to 'incorporate different symbolic systems in one spatial construction' (Manovich 2006: 231). The multiple languages and semiotic paradigms that are present in multimedia and multi-period spaces are potentially conflicting. But perhaps rather than seeking to find one overarching language and becoming trapped by normalized workspaces, we should be accepting of the different times and spaces that collide in our city and seek instead to facilitate conversations between them? Some of us are more at home in a large space than a small one, some of us are happier using text than Skype. Could the key to a mediated city lie in acknowledging the prevalence of not one but several 'spaces' and developing the interfaces between them? In which case one could suggest that mobile technologies are perfectly placed to act as an interface, and movement-based practices a medium for developing creative approaches. Mediating between the social, business and communications requirements of our lives, these devices are capable of navigating the large and small journeys, conveying information

about locations and providing a window of access to data supporting our knowledge and enjoyment. They also impact our behaviours, movement and experiences both on a macro and micro level.

In conclusion, mobile technologies and their associated information architecture are not only utilitarian in purpose, but can also help us to explore and discover spaces, be they physical, social, temporal or personal, through a mediated approach to the spaces within our cityscape. Through consideration of the engaging and objective experiences of the dataspace, as illustrated in my own work with choreography students, an environment (or perhaps a geography?) may be created in which the movement of the space-user can be affected by, or may itself lead, changes in the data; thus making the space an environment that may be experienced as well as observed, found as well as navigated. And through the discussions that this exposes, promote a more sociable and experiential engagement with the mediated city than the constant looking down.

References

Certeau, M. de (2002 [1984]), *The Practice of Everyday Life* (trans. Steven Rendall), Berkeley: University of California Press.

Cubitt, S. (2014), *The Practice of Light: A Genealogy of Visual Technologies from Prints to Pixels*, Cambridge, MA: MIT Press.

——— ——— , Palmer, Daniel and Walkling, Les (2012), 'Reflections on medium specificity occasioned by the symposium "Digital Light: Technique, Technology, Creation", Melbourne, 2011"', *Moving Image Review and Art Journal*, 1: 1, pp. 37–49.

Farrell, Y. and McNamara, S. (2011), 'Architecture as the New Geography', *Yale School of Architecture Public Lecture Series,* Yale: Yale University.

Grosz, E. (2002), *Architecture from the Outside*, Cambridge, MA: MIT Press.

Hansen, L. (2009), 'Lost in Location – on how (not) to situate aliens', *International Journal of Performance Arts and Digital Media*, 5: 1, pp. 3–22.

Kozel, S. (2007), *Closer: Performance, Technology, Phenomenology*, Cambridge, MA: MIT Press.

Kwastek, K. (2013), *Aesthetics of Interaction in Digital Art*, Cambridge, MA: MIT Press.

Manovich, L. (2006), 'The poetics of augmented space', *Visual Communication*, 5: 2, pp. 219–40.

Massumi, B. (2002), *Parables for the Virtual: Movement, Affect, Sensation*, Durham and London: Duke University Press.

Museum of London (2014), *Street Museum* [App], http://www.museumoflondon.org.uk/Resources/app/you-are-here-app/home.html. Accessed 9 January 2014.

PixMob (2015), *Connect Crowds: Reinvent Rituals*, http://www.pixmob.com. Accessed 18 July 2015.

Popat, S. and S. Palmer (2005), 'Creating common ground: dialogues between performance and digital technologies', *International Journal of Performance Arts and Digital Media* 1:1, pp.47-65.

Rhinegold, H. (1991), *Virtual Reality*, New York: Summit Books.

Salazar Sutil, N. (2015), *Motion and Representation: The Language of Human Movement*, Cambridge, MA: MIT Press.

Sample, M. (2014), 'Location is not compelling (until it is haunted)', in J. Farman (ed.), *The Mobile Story*, New York: Routledge.

weneverlookup (2014), *We Never look Up* [Tumblr], http://weneverlookup.tumblr.com. Accessed 9 January 2014.

Chapter 12

Musing publics: Arts and ideas in motion

Michael Jemtrud

Introduction

The following investigation proceeds upon the assumption that the relation between urban media, cultural production and the contemporary environmental paradigm is intricately intertwined. It is asserted that these phenomena are primary driving forces of our urban existence that enable the public realm to be collectively co-produced through informal and formal micro and macro practices of everyday life and cultural expenditure. Urban media is an inclusive term and refers to the ongoing process by which digital technology is increasingly interwoven with daily life. Martijn de Waal's (2014) definition of urban media as a collective term that includes 'media technologies that in one way or another can influence the experience of a physical location' forms the starting point. Cultural production is seen as the manifestation of any artefact, whether mundane or spectacular, in terms of encounter, experience, art or event. It is further argued that the contemporary environmental paradigm is the single, most important ontological force in human history. Our awareness of and response to global warming and the ecological crisis is the single greatest cultural endeavour global humanity has encountered. It is practically and philosophically inseparable from the technological and economic regimes of the twenty-first-century city.

As such, there is a pressing need to reframe our understanding of the relation between technology, environment and sociocultural values as they are expressed and co-produced in the public realm. This collective activity is an imaginative, albeit a largely tacit, unpredictable yet ordinary dynamic and exchange that actualizes the urban fabric. Urban life is inscribed within a technical system that constitutes embedded social values reflecting our collective attitude toward environmental and cultural viability, sustainability and long-term prosperity. Reciprocally, such embedded values enable and determine the productive nature of this inherently dynamic system.

The following scholarly research-creation inquiry is designed to interrogate these relationships. The initial theoretical framing for the design and prototyping of the 'Mobile Urban Stage' (MUSe) is the research-through-design component of the 'Arts and Ideas in Motion' (AIM) research programme. As such, the AIM-MUSe programme is a form of inquiry based on the power of fabricative knowledge to reveal unique insights into questions concerning the interrelation between cultural production, technological mediation and our ecological understanding of urban life relative to specific sites within a city. MUSe is designed as an interactive interface-object that is installed in the city

to investigate the technics of collectivity and our capacity to be public. It is therefore both an operative technical object and an event-scenario intended to have heterogeneous iterations and manifestations, such that, throughout this iterative exploratory process, MUSe is the medium against which scholarly speculations are discovered, juxtaposed and tested. Following a discussion on the contemporary mediated city and a brief summary of the AIM research programme, a selection of theoretical and practical features driving the design, configuration and programming strategies of the MUSe object-event prototype are presented.

The mediated city: Technology–culture–ecological thought

Contemporary cities are technologically mediated in a manner that is radically reconfiguring the public sphere and how we inhabit the urban realm. One expression of this phenomenon is that with pervasive computational and electronic communication networks, the breadth and depth of information received, manipulated and produced within personal and public realms are altering our relation to others and to the physical and (meaningful) cultural worlds. As such, a substantial transmutation of the public realm is occurring relative to environmental, economic and sociocultural relations within the urban fabric. Whether overt or subtle, streetscape imagery and lighting, soundscapes, wayfinding mechanisms and technologically-enabled transportation systems today use mobile apps to orient users in ways that are transforming the surfaces, spaces, function and temporality of urban environments, thus, affecting the manner in which we live, work and play. These technologies constitute the so-called 'Internet of things' dependent on a new form of connectivity qualitatively divergent from the networks of streets, city centres, rail networks and sewer systems. The array of sensors, cameras, Wi-Fi, mobile apps, multimedia, telepresence and smartphone devices form an essential if largely invisible animate layer within the dense and polysemous urban palimpsest. As Mark Shepard states,

> Imbued with the capacity to remember, correlate and anticipate, this near future 'sentient' city is envisioned as being capable of reflexively monitoring its environment and our behavior within it, becoming an active agent in the organization of everyday life in urban public space. (Shepard 2009: 20)

Easy and continual access to information, data and technologies create a paradoxical realm of experience that has the potential to simultaneously enhance and to dull our attention to the environment and to others.

In his essay entitled 'The City Is a Medium' (1996), Friedrich Kittler asserts that the city is, and always has been, a technology of communication, transport and commerce; a space for cultural memory, for gathering and for civic discourse and performance; and

Figure 1. MUSe, Architecture as Stageset (bricks and pixels) using projective mapping technology: an architectural facade acts as a screen for an interactive video projection.

a device for knowledge production and storage that 'forms the masses' in geographically and culturally distinct ways. In the contemporary city, the oscillation between our everyday modes of distraction and attention shares the same technological platform: mediating devices and the informational sphere generated by those devices. Furthermore, it is through this ubiquitous computing and media-saturated realm that artistic, cultural, social, political, economic and ecological territories are mediated, emerge and find expression. To what degree does this informational sphere and accompanying devices transform the meaning and materiality of the artefacts of our cities, such as the buildings, programme-specific districts, monuments, murals and public squares? Malcolm McCullough's notion of the 'ambient commons' (2013) refers to this newly constituted

and mediated urban reality through which we find political, cultural and artistic expression. The following research programme posits that, through concerted design and research-creation inquiry, an active and participatory intervention within this evolving technological realm is necessary to a critical understanding of how dynamic publics interact with and meaningfully constitute the space of the city.

Arts and ideas in motion

The city as such is the exploratory setting for the 'Arts and Ideas in Motion' (AIM) research programme which concerns itself with the mechanisms of being public and our individual and collective capacity to be attentive while existing physically and virtually within the drifting currents of the mediated city. It enacts a hybrid methodology that strategically entwines scholarly and research-creation activities. Through the concerted meshing of artistic production and multi-modal intellectual inquiries, methodologies and expertise, researchers investigate how and why ideas move among people and places, how that movement creates new public spaces for collective creation, discussion and action, and how it makes new communities, often across barriers of language, class, race, sex, age and nationality. It is presumed that within the context of the contemporary mediated city that cultural expenditure has the capacity to subvert our state of distraction and to engender a level of awareness and intersubjectivity not otherwise present in our self-interested habitual lives. The wager for the inquiry is that the information and technologies embedded within the mediated city paradoxically hold immense power to what Viktor Shklovsky (1990) refers to as art's role in the process of 'defamiliarization' or 'estrangement' when activated through an aesthetic experience that in turn can augment our awareness of the public sphere, our intersubjective relations and our tacit understanding of the urban environment. Relatedly, we will see later that Timothy Morton's (2010a; 2013) notion of the 'strange stranger' can affect a similar aesthetic experience when information engenders an awareness of the extent to which our everyday activity has on the environment at a temporal and spatial scale equivalent to geological time, now referred to as the anthropocene. Suffice to say, the ethics of urban participation – with, through, in spite of the contemporary state of hyper-mediation – is critical to our survival as a global collective. Within the mediated city, the critical and affective capacity of art and cultural production in its relation to technology is intensified and amplified.

The inquiry is concerned with the implicate order of the city which operates at a vast and often disconcerting range of temporal and spatial scales from the embodied and local to global and ecological. A fundamental assertion is that cultural manifestation and ecological thought are indissoluble one to the other in the era of globalization, consumption, tourism, global warming, information and the so-called knowledge economy. It is claimed that concern for an equilibrium between cultural and environmental well-being finds its most poignant and potent expression in artistic activity ranging from architectural

and urban design interventions and 'living labs' that enable the productive coincidence of art and technology with that of perennial festivals, urban art programmes, museums, sports, protests and improvised public events that manifest the will of mutable publics. Reciprocally, cities mediate cultural sagacity through their technologies of mnemonic, political and cultural expression that include memorials, designated quarters, graffiti and mural art programmes, smart buildings, city-specific mobile apps, and ephemeral but powerful social media technologies. The primary concern of the research programme is to investigate, instigate and elucidate the relation between the culture-technology-ecology triad as it pertains to our capacity for creating and nurturing the public realm. The binding research-creation component around and through which scholarly activity occurs is the installation-based, performative 'Mobile Urban Stage' (MUSe) project that simultaneously acts as the experimental context and material for the integrated research axes.

The mobile urban stage

MUSe is designed as a deployable, sentient and responsive object that has a number of functions such as the capacity to sense its immediate environment and interactively respond through sound, light and movement. It can utilize and express real-time simulation and modelling information (ecological, social, economic) as it communicates with an associated web artefact and social media network. As an architectural object it claims and structures physical space for performances and public gathering. Its conception loosely draws from Nicolas Bourriaud's (1998) notion of 'relational aesthetics', which refers to a set of artistic practices in which the artist, rather than performing at the centre of a static audience, is perceived as the catalyst of a multifaceted dynamic exchange. Such artistic practices take the given social, political, vital and physical context as a point of departure in order to produce intersubjective encounters in which the audience participates in the co-creation of the work.

The inspirational precedents for MUSe are (1) the 'Tycho Monolith Anomaly (TMA-1)' in Arthur C. Clarke's novel and Stanley Kubrick's film of the same title, *2001: A Space Odyssey* (1968), hybridized with (2) the wagon-stage in Terry Gilliam's *The Imaginarium of Doctor Parnassus* (2009). As a device, MUSe is designed to operate variously as a tool and portal or interface for collective participation. Like the monolith, it is devised to trigger collective transformation or 'human evolution', and like the wagon-stage, it is designed as a mobile figure that moves through the city and whose strange presence affects an imaginative response and mutation of the given context. As a figure in the city that appears and reappears, MUSe is intended to establish an event-ground through its movement and persistence, one that incorporates a larger informational and communicative sphere that expands the temporal and spatial scale of the collective experience.

Arthur C. Clark referred to the monolith as 'the alien Swiss army knife' and the configuration of MUSe intends to embody such conceptual and technical flexibility

(LoBrutto 1999). As a condensed analogue to the contemporary mediated urban milieu, it is configured as a data-driven, reconfigurable device that includes interactive sensing and multimedia technology, structuring and enabling *in situ* public events. Performance and multimedia artists, architects and urbanists work together to create performances and events intended to reimagine and transform the urban context. Through various scenarios, this technological object yields unique insight into how arts and ideas constitute a city and its diverse publics by fostering dynamic exchange. The design, construction and deployment of MUSe as an ecological artefact is dependent upon the interaction between its technical capacities on the one hand, and its programmatic intentions and event-scenario design on the other. In *The Ecological Thought*, Timothy Morton states:

> There are three directions for ecological art. The first emphasizes automated processes such as evolution. Art that uses algorithms fit into this category: serialism, diastic poetry, even abstract expressionism. This is the art of letting be (German: Gelassenheit): 'Let the chips fall where they may'. The artist sets up some parameters, starts the process, and watches what happens. The second approach emphasizes consciousness, being caught in the headlights of our awareness of the mesh. The art is ironic, full of darkness and unfathomable depths and deceptive shallows. The third approach is about the ruthless way in which mathematics and other sciences are now able to model so-called Nature: think of modern cinematic special effects. These three approaches could manifest in the same work of art. (Morton 2010a: 105–06)

The technical configuration for the prototype has been specified in collaboration with the accomplished experience design atelier, Réalisations Inc. Montreal. The integration of multiple computation, media, communication and network technologies are choreographed by a software platform that allows MUSe to understand itself relative to its surroundings through sensors, artificial vision and two-way communication devices. The same platform coordinates an expansive set of actions and responses with hardware components (sound, light, projection, recording, movement) by way of interactive and/or algorithmic control. It can observe, capture and computationally translate human movement as well as environmental conditions such as daylight, humidity, pollution, noise, temperature, and so on. This data informs and feeds into the design and performance of the event-scenario, either through on-site ambient feedback or uploaded web content. It also communicates with an associated web artefact that allows one to participate in performances remotely. Lastly, by way of its built-in communication network, it can receive real-time information relative to local and global environmental, social and political activity through openly accessible databases and forums.

As mirror and stage, MUSe functions as a condensed, bi-directional analogue of the mediated city. In his essay 'On Machines' (1995), Félix Guattari's attempt to rethink the relationship of the machine to subjectivity, and hence intersubjectivity, figures notably into the initial conception and the object's cyborg-like relationship to its interlocutors,

Figures 2a and 2b. The monolith in the 'Dawn of Man' sequence from *2001: A Space Odyssey* (Kubrick, 1968) and the wagon-stage from *The Imaginarium of Doctor Parnassus* (Gilliam, 2009).

from artists to participants. As Guattari states, 'Alongside the proto-machinic tool and technological machines there are also concepts of social machines. For example, the city as a mega-machine; it functions like a machine' (1995: 9). Guattari also considers the machine-as-interface to include an order of proto-subjectivity in that there 'is a function of consistency in the machine, both a relationship to itself and a relationship to alterity' (1995: 8). The machine as a technological assemblage is a closed system *and* open to the environment in its ontogenetic, evolutionary and functioning regimes. For

Guattari, machines (like communities, cities, the Internet, citizens) are *both allopoietic and autopoietic*.

In the words of Murphie and Potts (2003: 197), machine-systems 'maintain some sense of processual core' that changes over time and simultaneously have 'a certain relation to alterity – to other things' that form a dynamic, ontogenetic symbiosis. In the 'mechanology' of Gilbert Simondon, this open–closed relationship includes the causal entangling of the technical, social and vital realms. As Barnet (2004) states in her analysis of Simondon:

> The uses and functions of a technical object can never be known, these will only be realised in the evolution of the object itself. The technical object is not concrete, it is not determined in its uses. This is why the influence of 'working prototypes' on the engineering community is so important; the fabricating intention has little relationship to the object itself, and it is the object as a working prototype that will engender new structures and functions. (Barnet 2004)

Inspired by these insights, MUSe has a set of burgeoning theoretical influences that inform (1) its heuristic approach to prototyping as a technical object; (2) its programming as both a narrative construction for collectively experienced event-scenarios; and (3) as an operative-investigative device within the larger research programme. The activity of prototyping technical objects is analogous to the continual transformation and ontogenetic co-production and invention of cities and publics. Together, the object and event are designed to catalyse and interrogate the relationship between cultural production, technological mediation and our ecological understanding of urban life. MUSe is positioned within specific urban sites and effects a sort of festival intended to actively transform time and place like Doctor Parnassus's 'Imaginarium'. Events are public and inherently transgressive, thus testing the limits and hence the very possibility of being collective. As discussed below, however, questions of subjectivity and collectivity across diverse temporal and spatial scales are further problematized by the theoretical imperatives provoked by competing notions of cultural and environmental sustainability.

Mesh and hyperobjects

A juxtaposition of vastly different temporal and spatial scales and locational understandings are explicitly at play in the conception of MUSe, for our understanding of climate change is now dramatically determined by the informational sphere, its data and computational power, in which case it is now possible *to see* the effects of climate change in real time. These spatial and temporal scales transcend our previous phenomenological understanding of environmental processes and states.

Because MUSe is both object and event – *res intellectus*, the thing that thinks – media, computation, data, communication and responsive sensor networks figure prominently into its technical capacity to enable multiple modes of interface. Beyond the local realm of a specific urban site, MUSe attempts to operate within this *implicate order* where all things are interconnected. It seeks to bring awareness of what Timothy Morton calls 'the mesh', wherein temporal and spatial scales are confounded in the juxtaposition of the local and non-local. Morton evokes the form of the noir film to describe this unexpected awareness: 'The noir narrator begins investigating a supposedly external situation, from a supposedly neutral point of view, only to discover that she or he is implicated in it' (Morton 2010a: 16–17). This is a key ethical function of the MUSe intention and programme. As such, MUSe is founded upon a desire for multi-lateral interactivity between objects, artists, community actors and participants. It is conceived to actively explore differences in the technics of collectivity, the awareness and impact of the implicate order, and the making and unmaking of publics.

Furthermore, Morton's notions of 'mesh' and 'hyperobjects' act as conceptual framing devices in thinking the form, materiality, configuration and programme of the object-interface. Morton (2010b) defines the mesh as:

> a total interconnectivity that goes beyond normative vitalist images of the web of life to include, for example, non-living-beings, or beings that do not easily fall on one side or the other of life – nonlife boundary, such as viruses and artificial life. (Morton 2010b: 4–5)

Hyperobjects are things such as plutonium, Styrofoam, climate change, earth and the atomic bomb whose temporal and spatial scale and position within the reticular structure of the mesh are beyond daily and historical comprehension, such that they 'eat away at the person–nonperson boundary in highly disturbing ways [...] Nonlocality means that phenomenona are far more deeply interconnected even than the *mesh* concept [where] things are deeply contiguous and symbiotic' (Morton 2010b: 5, 6 [original emphasis]). Morton also warns that:

> hyperobjects are contradictory beasts. Moreover, the aesthetic-causal realm in which hyperobjects appear to operate is in some sense nonlocal and atemporal. Or at any rate, such gigantic scales are involved – or rather such knotty relationships between gigantic and intimate scales – that hyperobjects cannot be thought as occupying a series of now-points 'in' time or space. They confound the social and psychic instruments we use to measure them – even digital devices have trouble. Global warming requires tremendous computing power to model in a realistic way. [...] Hyperobjects compel us to think ecologically, and not the other way around. (Morton 2013: 47–48)

How and the extent to which things are interconnected is brought to the fore. The presence of hyperobjects fundamentally disrupts quotidian and phatic discourse, thus revealing an *implicate order* of sublime magnitude and consequence in time and space.

Contextual mutation

As stated previously, the urban domain is a supersaturated agglomeration of artefacts – buildings, parks, monuments, transportation, power, water and sewer systems – layered within historical, cultural and social milieus further entangled with a massively distributed informational, media and communication apparatus. Latour's riff on Koolhaus' statement that 'context stinks' because it 'stays in place too long and ends up rotting' is taken as an

Figure 3. MUSe, Interactive Ground Animation sited at a busy pedestrian thoroughfare; a 3D time-of-flight camera captures peoples' locations and movements; MUSe tracks the action then complements these movements with laser-light projections rendered in various hues and animated geometric patterns; various sound effects, musical or environmental (such as the sound of splashing water), are coupled with the animations.

imperative in the design and programming of MUSe events (Latour and Albena 2008: 87). Even in its supersaturated state, the city quickly becomes familiar, habitual and even more so in our contemporary distracted lives of headphones, texting and gaming on mobile devices. Looking up and around has become the anomaly. As a receiver, emitter and processor of information and media, MUSe events aspire to activate, filter and augment the inherent latency of immediate everyday urban experience. These events exist within venatic time – that is, the ritual occasion of the hunt – in which case MUSe is pursued through the city like Doctor Parnassus's wagon-stage, activating contextual mutations through the same mobile devices and informational realm.

Relatedly, any consideration of the collective formation and movement of arts and ideas –culture and publics – must consider the relation between cultural excess and consumption relative to the predominant ecological milieu. Awareness of a given urban context increasingly exists at a temporal and spatial scale that is ecological and beyond the immediate or even historical. Undoubtedly, culture, economics and ecology are the primary forces determining the evolution and design of our cities. From 'Cities of Culture' and 'Cities of Design' to initiatives such as '2030 Districts' and other sustainable-cities programmes, the tension between excess and limits is paramount. Whether it falls within the rubric of sustainability, resiliency or other variations of environmentalism, the predominant character of ecological thinking is one of crisis, austerity, and the continual calculation of limits, whereas cultural expenditure is commonly seen within the realm of consumption and excess. In other words, the logic of mere survival embedded in notions of sustainability is diametrically opposed to collective cultural enthusiasm and exuberance. Whereas cultural production is an ecstatic, transgressive and excessive expenditure of energy, conservation of resources and austerity in regard to environmental degradation is one of continually defining limits and exercising restraint. A primary question in the inquiry concerns this seeming paradox between cultural expenditure and environmental stewardship as tacitly embodied or overtly expressed in urbanity, inclusive of festivals, protests, impromptu events, parkour and other forms of collective formation and urban performance.

Delirious collective expenditure (without return)

Engagement with a festival, museum exhibition, urban event or protest requires an enthusiastic and playful effort outside of one's habitual, *purposeful* work life. These occasions situated beyond mere utility or prosaic servitude entail, in the words of George Bataille, an 'expenditure without return', or 'sacrifice' in the most affirmative sense of the term (Bataille and Stoekl 1985: 116). Bataille reserves the word 'expenditure' in the truest sense for 'unproductive' forms of artistic productions in contrast to mere consumption as a means to the end of production. Bataille states:

Figure 4. Scene from Terry Gilliam's *The Imaginarium of Doctor Parnassus* (2009).

From the point of view of expenditure, artistic productions must be divided into two main categories, the first constituted by architectural construction, music, and dance. This category is comprised of real expenditures. Nevertheless, sculpture and painting, not to mention the use of sites for ceremonies and spectacles, introduces even into architecture the principle of the second category, that of symbolic expenditure [as in literature, theatre]. (Bataille and Stoekl 1985: 119–20)

It is this notion of the intermingling of real and symbolic expenditure in the spaces, artefacts and experiences of the mediated city that is of key interest and influence in the design and deployment of MUSe as well as the associated philosophical inquiry. Relatedly, Allan Stoekl's interpretation and extension of Bataille's theory of expenditure is relevant to thinking of the economy and circulation of arts and ideas within the cultural sphere and its relation to environmental sustainability. Stoekl's reading suggests an inversion of survival as a means, not an end, wherein 'expenditure [becomes] a limitless insubordinate act – a real *end* (that which does not lead outside itself)' (Stoekl 2007b: 261 [original emphasis]). He endorses Bataille:

in this primacy of the delirium of expenditure over the simple exigency of personal or even social survival. […] This does not preclude, however, a kind of ethical aftereffect of Bataille's expenditure: *survival for this reason can be read as the fundamentally unintentional consequence of expenditure, rather than its purpose.* (Stoekl 2007b: 261, original emphasis)

Conclusion

By expending we conserve. Bataille's utopian ethics foresees a society that creates, builds, and grows in order to waste, but by doing so, maintains the indefinite continuation of a human culture whose very humanity is inseparable from that general – collective and ecstatic – expenditure. The raison d'être of the society, so to speak, will lie in the very unreasoned logic of its excessive and transgressive expenditure. This highest value will be maintained and known through recognition of limits, which is ultimately reasonable, but to which the act of expenditure cannot be reduced.

(Stoekl 2007b: 265)

In conclusion, our question becomes: how does MUSe facilitate Bataille's 'glorious expenditure'? How do arts and ideas circulate and gain currency within the productive 'general economy'? How can we be collective, attentive to each other, and gain a greater awareness of limits and our 'carrying capacity'? Once more, Stoekl reminds us that:

the very notion of a 'general' economy means that individual, isolated interest is in principle left behind, and that instead, a larger perspective is embraced, one in which the individual's concerns and worries are no longer paramount. Replacing them are the larger energy flows of the subject, of society, and of the universe. (Stoekl 2007b: 266)

MUSe is a device intended to mediate transgression, to test limits. It is a strange object, strangely placed in the city. It exists immediately in a state of transgression, and by implication, so do those who engage it. As an active-sentient, two-way interface, MUSe is seen as a form of cognition and affect that is installed within the city as a means to reconfigure relations and to transform a given site. MUSe senses the encounter through an array of sensors, lenses, algorithms and networks, and signals a 'something is happening' that defamiliarizes one's habitual experience of the city (on-site or virtually through the web artefact), thus producing memorable contextual mutations.

As simultaneously a technical assemblage, object-interface and structured event, it is an active interrogation of the present and future status of the mediated city; firmware for the urban environment. It is designed to generate and enable multiple forms of understanding from the situational and aesthetic to the cognitive and contemplative through a variety of choreographed mediated urban experiences of a diverse nature. As

Figure 5. Travelling wagon-stage in *The Imaginarium of Doctor Parnassus* (Gilliam, 2009). MUSe events exist within venatic time – that is, the ritual occasion of the hunt – in which case MUSe is pursued through the city like Doctor Parnassus's wagon, activating contextual mutations through the same mobile devices and informational realm.

such, it functions as a potent interface to collectively imagine and co-create alternative urban futures in the era of the Anthropocene wherein urban media, cultural expenditure and environmental awareness are inextricably intertwined and mutually dependent.

References

Barnet, B. (2004), 'Technical machines and evolution', *CTheory.net*, http://www.ctheory.net/articles.aspx?id=414. Accessed 11 July 2013.

Bataille, G. and Stoekl, A. (1985), *Visions of Excess: Selected Writings, 1927–1939*, Minneapolis: University of Minnesota Press.

Bourriaud, N. (1998), *Relational Aesthetics*, Paris: La Presse du Réel.

Dumouchel, P. (1995), 'Gilbert Simondon's plea for a philosophy of technology', in A. Feenberg and A. Hannay (eds), *Technology and the Politics of Knowledge*, Bloomington: Indiana University Press, pp. 255–71.

Genosko, G. (2001), 'An introduction to singularization and style: Shin Takamatsu in conversation with Félix Guattari', *Parallax*, 7: 4, pp. 128–30.

Guattari, F. (1995), 'On machines', in A. Benjamin (ed.), *Complexity, JPVA: Journal of Philosophy and the Visual Arts*, Issue 6, pp. 8–12.

Ihde, D. (1983), *Existential Technics*, Albany: State University of New York Press.

Kittler, F. A. and Griffin, M. (1996), 'The City Is a Medium' in *New Literary History* Vol. 27, No. 4, Literature, Media, and the Law, pp. 717–29

Latour, B. and Albena, Y. (2008), 'Give me a gun and I will make all buildings move: An ANT's view of architecture', in R. Geiser (ed.), *Explorations in Architecture: Teaching, Design, Research*, Basel: Birkhäuser, pp. 80–89.

LoBrutto, V. (1999), *Stanley Kubrick: A Biography*, New York: Da Capo Press.

McCullough, M. (2013), *Ambient Commons: Attention in the Age of Embodied Information*, Cambridge, MA: MIT Press.

Morton, T. (2010a), *The Ecological Thought*, Cambridge, MA: Harvard University Press.

———— (2010b), 'Materialism expanded and remixed', http://newmaterialismconference.blogspot.ca/2010/01/materialism-expanded-and-remixed.html. Accessed 28 January 2010.

———— (2013), *Hyperobjects: Philosophy and Ecology after the End of the World*, Minneapolis: University of Minnesota Press.

Murphie, A. and Potts, J. (2003), *Culture & Technology*, New York: Palgrave Macmillan.

Shepard, M. (2009), 'Sentient City Survival Kit: Archaeology of the near future', *Proceedings of the Digital Arts and Culture Conference, After Media: Embodiment and Context*, Irvine: University of California Press.

———— (2011), *Sentient City: Ubiquitous Computing, Architecture, and the Future of Urban Space*, Cambridge, MA: MIT Press.

Shklovsky, V. (1990), *Theory of Prose* (trans. B. Sher), Urbana-Champaign: Dalkey Archive Press.

Simondon, G. (1980), *On the Mode of Existence of Technical Objects* (trans. N. Mellamphy), https://www.sfu.ca/~andrewf/simondon(1).pdf. Accessed 15 July 2015.

Stiegler, B. (1998), *Technics and Time 1: The Fault of Epimetheus* (trans. R. Beardsworth and G. Collins), Stanford: Stanford University Press.

Stoekl, A. (2007a), *Bataille's Peak: Energy, Religion, and Postsustainability*, Minneapolis: University of Minnesota Press.

———— (2007b), 'Excess and depletion: Bataille's surprisingly ethical model of expenditure', in S. Winnubst (ed.), *Reading Bataille Now*, Bloomington: University of Indiana Press.

Turkle, S. (2012), *Alone Together: Why We Expect More from Technology and Less from Each Other*, New York: Basic Books.

Vaccari, A. (2009), 'Unweaving the program: Stiegler and the hegemony of technics', *Transformations – Bernard Stiegler and the Question of Technics*, 17, http://www. transformationsjournal.org/journal/issue_17/article_08.shtml. Accessed 15 August 2013.

Waal, M. D. (2014), *The City as Interface: How New Media Are Changing the City*, Rotterdam: nai10 Publishers.

Epilogue

Edward M. Clift

Cities are more than a conglomeration of buildings, roads, bridges and other bricks-and-mortar manifestations. They exist symbolically in our psyche as a referent point for individual identity and culture writ large. Politics, health, commerce and many other sectors of society take on a different dimension when operating in a city environment, and are often more experimental and productive in a literal sense. Urban sites collect the energies of everyone in their zone but also transcend them to become the representation of a greater form. They take on a symbolic life of their own that exists far beyond the physical confines of the city walls. The Fall of Rome in 410 CE signified the much more encompassing metaphorical decline of a Roman Empire that had run its course.

As reflected by this volume, the unique and varied perspectives of artists are relevant to analysing the nature of the image in relation to cities. Image is not simply a re-presentation of a physical reality; rather, it is the end result of a more layered and complex negotiation between multiple fields of internal and external meaning. Representations of cities are thus no longer tied solely to their physical geography, local culture or supposed durability in time. They have been let loose from these constraints in part by imaging technologies that allow new pictures – and sets of interactions – to emerge. Indeed, one of the artists represented here, Kevin O'Brien, has a practice of literally setting fire to older representations of the city such as territorial maps in the awareness that they might be holding back more adaptive ones or concealing unspoken truths. Furthermore, it is not just through representation, or specifically representations of the city, that artists engage with the built environment – the metropolis itself is a source of inspiration that leads to multiple explorations, thoughts and projects that leave the physicality or visual simulation of the city behind.

The common thread of what this collection represents lies in the recognition of the artists engaged with it, that imaging is a highly consequential act in the formation of meaning. Representations – both of the existing and inspired by the existing – ultimately cohere into a mental image of some kind that always has an imperfect or partial relationship to the object described or parted from. Artists usefully contrast the mental image of a city constructed through representations and the image that exists in our memory built up through lived experiences. They also urge us to move one step further, away from categorical thought, in order to better embrace a holistic phenomenological sensorium that can form the basis of creative reconstructions in the future. In each case, there is a deeply self-reflective understanding of the role that representations play in constructing

the meaning of cities, places, thoughts and behaviours through the formation of the mental image. Meanings are created in a nexus formed by objects, representations and images that precede or accompany the creation of forms or buildings just as often as they follow it.

This triadic dynamo becomes especially intriguing when artists examine, engage with and misuse new techniques of city representation, such as Google Earth. They often succeed in adding a destabilizing element to our understanding of place in which the ambiguity of reference becomes striking given the high degree to which our mental image relies on such partial perspectives. Artists working this terrain ensure one's sense of place shifts from the tangible arenas of space and time onto the media platform itself.

How do the meanings set into motion by media affect our conceptions of cities? Google Earth, Google Maps and a multitude of new mobile apps open up this field to the mind and activities of the artist. In one case expounded in this volume, for example, an app has been developed that allows viewers to access the city of the past through historical images, geolocation tools and detailed narratives. The city that emerges is from another time but achieves a presence and lived immediacy through the actions and perceptual interface provided by the user of the application. It is a retelling of the city though the re-combinatory possibilities of a new media form.

Thus, we come to know a city through the imaging that surrounds and emerges from it. In fact, city municipalities are beginning to more consciously brand themselves through sophisticated use of images in their marketing messages. The artists documented and presenting in this volume acknowledge the human motivations behind this quest for meaning and identification, and explore it in both conventional academic texts and more speculative stream-of-consciousness considerations. They complicate our understanding of cities themselves in order to view this process critically with an eye to the future. Cities bring networks of strangers together in shared places to live and work, providing the collaborative space necessary to exercise the creativity of our human potential within a social community. This generalized purpose of the city can shed new light on the transformative possibilities that lie latent in our imaging practices.

Artists and those designers of cities working with or through art are clearly at the vanguard of such collaborative experiments. In this volume we have seen some examples of it: explorations of urban media as a form of collective expenditure articulating a community-based approach to understanding the imaging process; and experimental dance films that have the potential to revivify urban space in the same manner by focusing on the value of physical artistic expressions. These perspectives transport us to a new realm in which images no longer represent the world but actually create it and the city itself becomes a medium that translates the human energies it contains. Few segments of contemporary urban life in fact are immune to the prevalence of experience design.

Communication tools have helped foster the growth of cities since their earliest appearance but that influence has been compounded even further by the pervasive adoption of smartphones and other new imaging technologies. The digital revolution is

certainly on par in this respect with the invention of one-point perspective in the pre-Enlightenment period of the late fifteenth century and, in both instances, it is possible – indeed necessary – to highlight the role of artists. That is what this volume does. Each of the authors in one sense or another makes a similarly strong claim for the impact of shifting representational strategies on the images we have of others, ourselves and the world around us. This MindSpace, as Terry Flaxton refers to it, has the potential to radically transform our cities as well as the parameters of space and time in which they are constructed. We can steer these changes in a positive direction only by remaining conscious and self-reflective – as the work of artists obliges us to do – in regards to the imaging practices that bring them about.

Notes on Contributors

Series editor

Graham Cairns, has taught at universities in Spain, the UK, Mexico, South Africa and Gambia. He has worked in architectural studios in London and Hong Kong and ran a performing arts company, Hybrid Artworks, with a specialism in video installation and performance art. The author and editor of five books, he has presented papers at international conferences and has published on architecture, film, interior design and advertising. Currently, he is Principal Editor of the scholarly journal *Architecture_MPS* and director of its research arm AMPS (Architecture, Media, Politics, Society). He is also Senior Honorary Research Associate at the Bartlett School of Architecture, University College London.

Editors information

Edward M. Clift is President of Brooks Institute, a private and independent visual arts college located in Ventura, CA. Prior to joining Brooks, Dr. Clift was a communication professor and founding dean of the School of Media, Culture & Design at Woodbury University. He is a graduate of the Master's degree programme at the Annenberg School of Communication (U. Penn) and holds a Ph.D. in communication from the University of Utah. In addition, he holds a Master of Fine Arts (MFA) degree in photography from the Savannah College of Art and Design and a BFA from the Tisch School of the Arts in New York City. He has published articles on the rhetoric of economics and edited a book on the subject, entitled *How Language is Used to Do Business* (Edwin Mellen Press, 2008). In addition to his work as an educational entrepreneur, he has served as Chair of the Burbank Cultural Arts Commission and as Education Director for the Burbank International Film Festival. Dr. Clift is a graduate of California Connections, a professional development programme sponsored by the Southern California Leadership Network.

Steve Hawley is Professor and Associate Dean for Research at the Manchester School of Art, Manchester Metropolitan University. He is an artist who has been working with

film and video since 1981, and his work has been shown at video festivals and broadcast worldwide since then. His tape *Trout Descending a Staircase* (1990), commissioned by BBC2 TV, was awarded a German VideoArt prize in 1994 and in 1995 his experimental documentary on artificial languages (made with Tony Steyger) and commissioned by the Arts Council was broadcast on Channel 4 TV.

More recently his work has looked at new forms of narrative, in such works as *Love Under Mercury* (2000), his first film for the cinema, which won a prize at the Ann Arbor Film Festival; and *Amen ICA Cinema* (2002), a palindromic video which won the prize for most original video at the Vancouver Videopoem Festival. 'Manchester Time Machine 2012', made with the North West Film Archive is the first ever iPhone app to combine archive film footage and GPS and is part of a project looking at the nature of the city, including *Not to Scale* (2009) (filmed in a series of model towns). His video with Tony Steyger *South Home Town* filmed in Southampton was premiered at the New York Independent Film Festival in September 2015.

Kevin O'Brien is a practising architect. In 2006 he established Kevin O'Brien Architects (KOA) in Brisbane and has completed architectural projects throughout Australia in Queensland, New South Wales, Victoria and the Northern Territory. In 2012 he directed the *Finding Country Exhibition* as an official Collateral Event of the 13th Venice Architecture Biennale, Venice. He was an invited Professor of Design at the Queensland University of Technology (QUT) from 2013 to 2015, teaching the *Burning City Studios* to Masters of Architecture students.

Contributors

Lawrence Bird is a practising architect, working mainly on transit-oriented infill urban design. He has a visual art practice focusing on the image of the city and its geography. This work has been screened or projected at RAW: Gallery, Winnipeg; Furtherfield Gallery, London; and Greenwich Royal Naval College. Spaces addressed by his design work and his artistic practice frequently intersect: hybrids of city and geography, infrastructure and dwelling. Trained in architecture (B. Arch. McGill, 1991), urban design and social sciences (M. Sc. 2000, London), and history and theory of architecture (Ph.D. McGill, 2009), he has taught at McGill University; University of Manitoba; Harvard Kennedy School of Government; and Kanazawa International Design Institute, Japan. His writing has been published in *Critical Planning*; *Chora: Intervals in the History of Architecture*; and *Leonardo.*

Dirk de Bruyn currently teaches Animation and Digital Culture at Deakin University, Melbourne, Australia. He has made numerous experimental, documentary and animation films, videos, and performance and installation works over the last 35 years. He was a

founding member and past president of MIMA (Experimenta). Recent publications include: 'Recovering the hidden through found footage films', in *Carnal Knowledge: Towards a 'New Materialism' in the Arts* (eds E. Barrett and B. Bolt) (I.B. Tauris, 2012); and 'The Unwantedland artist statement', in *The Unwantedland: Stories of Migration* (ed. K. Zijlmans) (Museum Beelden Aan Zee, 2010).

Ivan Chaparro is an associate professor in the Faculty of Arts and Design, Jorge Tadeo Lozano University, Bogota, Colombia and creative director at Resoundcity Art Lab, Stockholm, Sweden. His artistic practice is located in the space between art, architecture, design and social research. His means of analysis consider technological media as wide, open-textured tools that help to reveal the relations between material production and culture. Chaparro's work encompasses architectural interventions, theoretical reflections, narrative texts, and experiments with illustration, sound and computer graphics. In addition to his artistic practice, Chaparro has worked as design teacher, international lecturer and guest professor.

Riet Eeckhout is a partner of the Architecture Project (AP), an architecture practice with offices in Malta, London and Croatia. Prior to this, she worked as Design Director for Dr. Ken Yeang. In 2009 she received a Research Master's in Architecture from the Invitational Postgraduate Program for Design at RMIT University in Melbourne under the supervision of Professor Leon van Schaik. In 2010 she was asked to continue her research 'Process Drawing' as a Ph.D. as part of the Invitational Doctorate Program at RMIT, which she is currently finishing. She currently teaches and holds a research position at KU Leuven's Department of Architecture (Brussels and Gent).

Terry Flaxton is Professor of Cinematography and Lens Based Arts and Director of the Centre for Moving Image Research at the University of the West of England. Previously at the University of Bristol, in collaboration with BBC R&D, Flaxton led the capture of the first higher-dynamic-range, higher-resolution and higher-frame-rate experiments to measure which combination of these developing parameters of image capture would best engage the audience.

Previously, Flaxton had been one of the only artists working as a cinematographer in the UK film and television industry where he shot features, concerts, commercials and documentaries.

In 2007 he undertook the first practitioner-led research into the properties of high-resolution images before commencing a Knowledge Exchange Fellowship, and in 2013 Flaxton joined the University of the West of England, Bristol.

Heron–Mazy (US/UK) is an architectural adventure studio producing (anti-) projects, scripts and films exploring radical visual imagery and digital art hybrids, radical cartographies of the absolute, and other contrarian wizard unknowns in a belated

architectural dreamland. Starting with *Pulping the City* (2003), over a decade different films and slashed versions of each subsequent project and film become versions of the future (past).

Frank Heron has taught for over three decades in Canada, Finland, India, Pakistan, Sweden and the United States.

Jan Mazy is an associate professor of architecture at the University of Texas.

Michael Jemtrud is Associate Professor of Architecture at McGill University and Faculty Fellow in the Institute for the Public Life of Arts and Ideas.

His research focuses on redefining the contemporary understanding of techniques relative to the models and metaphors by which we productively reconfigure the world from the computational and fabricative to the emergent and environmental.

Ephraim Joris is a partner of the Architecture Project (AP), an architecture practice with offices in Malta, London and Croatia. As a young architect he worked in Malta and Malaysia where he joined the office of Dr. Ken Yeang. In Kuala Lumpur he set up his own studio to work on projects involving sound, theatre and performance before moving to London to set up AP-London with Riet Eeckhout and the four founding partners of AP-Malta. He has lectured at multiple universities such as RMIT Melbourne, Syracuse University London and Westminster University London. He currently teaches at Brighton University and holds a research position at KU Leuven's Department of Architecture. He has published a number of articles and presented papers as part of his ongoing Ph.D. research at RMIT on the 'Practice of (Architecture) Practice'. His work focuses on the construction of social space in architecture discourse through different representations of space as modes of production. He currently holds a research position at KU Leuven University.

Natalie Rowland is a digital choreographer and lighting designer. She has worked in live theatre and concert events providing design and technical support for a wide variety of genres. Specializing in dance, Natalie completed an MA in Performance at the University of Chichester with distinction and was awarded the Valerie Briginshaw prize for Dance Writing and Academic Excellence.

Natalie's research is focused on digital choreography and lighting control, with an emphasis on the ways in which light can become part of the choreographic environment. Research to date has investigated the relationships between lighting and the dancer and the choreographic process, as well as exploring the development of mobile technologies as a performance and choreographic tool.

Joshua Singer is a graphic designer and Associate Professor and Coordinator of the Visual Communication programme at San Francisco State University. His work examines and explores intersections of design practice, design research, theories of design, the urban landscape, and experimental and critical methodologies. He is particularly interested in how graphic language shapes culture and how critical practices can counter ingrained perceptions.

Jelena Stankovic is based at the University of Dundee, College of Arts and Social Sciences, School of the Environment (Architecture) where she is a Ph.D. student. Her research is based on the maps and mappings of her hometown Banja Luka, Bosnia and Herzegovina. The idea of the research is to show that besides physical geography, which is usually a part of each map, Banja Luka, like other cities with a volatile history, is also composed of an imaginative geography which is not revealed by those maps. The principal aim is to bring them together into a single map mediated by other people's memory, thoughts and ideas.

Sylvie Vitaglione investigates location shooting and site-specific practices in contemporary dance films. Her next project explores the use of video as a tool for training the body in movement and fitness practices. She teaches classes on Choreography and the Moving Image, the History and Aesthetics of Music Videos, and Documentaries and the Visual Arts. She has programmed screenings, panel discussions and workshops on the Tiny House movement, definitions of experimental film, and dance and documentary form for New York University, Gibney Dance Center and the Dance Films Association. Currently she is completing her doctorate in the Department of Cinema Studies at New York University. She is a certified yoga instructor and was trained in ballet and contemporary dance in Monaco, San Francisco, London and New York.

John Zissovici teaches architecture and related matters and immaterialities at Cornell University. His output includes built works of architecture, installations, films and writings. His work was exhibited at the Herbert F. Johnson Museum of Art in Ithaca, New York; at the Phoenix Museum of Art, in Phoenix, Arizona; and at the Burchfield Penney Art Center in Buffalo, New York, among others.

Index